EGYPTIAN REVIVAL
JEWELRY & DESIGN

Dale Reeves Nicholls
with Shelly Foote and Robin Allison

Schiffer Publishing Ltd®

4880 Lower Valley Road, Atglen, PA 19310 USA

A tea set in lusterware from Japan, n.d., by the Takito company. Marked on bottom with T T (inside a double diamond mark) HAND PAINT MADE IN JAPAN.

Library of Congress Cataloging-in-Publication Data:

Nicholls, Dale Reeves.
 Egyptian revival jewelry & design / Dale Reeves Nicholls ; with Shelly Foote and Robin Allison.
 p. cm.
 ISBN 0-7643-2540-X (hardcover)
 1. Jewelry--History--19th century. 2. Jewelry--History--20th century. 3. Decoration and ornament--Egyptian revival. 4. Decorative arts--Egyptian influences. 5. Egyptian revival (Art) I. Foote, Shelly. II. Allison, Robin. III. Title.

NK7309.2.E38N53 2007
739.27--dc22 2006024092

Designed by John P. Cheek
Cover design by Bruce Waters
Type set in Lydian Csv BT/Zurich BT

ISBN: 0-7643-2540-X
Printed in China
1 2 3 4

Other Schiffer Books by Dale Reeves Nicholls:
Antique Enameled Jewelry, with Robin Allison

Published by Schiffer Publishing Ltd.
4880 Lower Valley Road
Atglen, PA 19310
Phone: (610) 593-1777; Fax: (610) 593-2002
E-mail: Info@schifferbooks.com

For the largest selection of fine reference books on this and related subjects, please visit our web site at **www.schifferbooks.com**
We are always looking for people to write books on new and related subjects. If you have an idea for a book please contact us at the above address.

This book may be purchased from the publisher.
Include $3.95 for shipping.
Please try your bookstore first.
You may write for a free catalog.

In Europe, Schiffer books are distributed by
Bushwood Books
6 Marksbury Ave.
Kew Gardens
Surrey TW9 4JF England
Phone: 44 (0) 20 8392-8585;
Fax: 44 (0) 20 8392-9876
E-mail: info@bushwoodbooks.co.uk
Website: www.bushwoodbooks.co.uk
Free postage in the U.K., Europe; air mail at cost.

Dedication

This book is dedicated to the memories of
Donald W. Foote
1920-2002
and
Robert G. Reeves
1920-1995
Devoted husbands, loving fathers, honored soldiers,
among the finest of "the greatest generation"

May the king grant a boon, Osiris, the lord of Busiris, to the blessed dead, of all good things: a thousand of bread and beer, of cattle and geese, of linen and fine linen.

Egyptian offering inscription

Acknowledgments

I am exceedingly grateful for the assistance I have received on this project, assistance without which this book would not have been possible. First of all, from the two friends, one old and one new, who are also the two co-authors of this book: collaborator and fellow jewelry enthusiast Robin Allison, whose knowledge and collection have greatly added to this book as they did to our first venture together (our book on antique enameled jewelry); and former college roommate Shelly Foote, recently retired as Assistant Chair of the Smithsonian Institution's Department of Costume and Social History, whose research on the Egyptian revival in America has provided crucial information for this work, adding background material and context in which to set Egyptian revival in the decorative arts.

Also very much appreciated is the assistance of Wedgwood enthusiast Bart Phelps, who so helpfully offered photographs of Egyptian revival pieces in his collection, as well as background material on Wedgwood's long tradition of Egyptian revival decorative ware. Thanks are also due to Mark Slotkin, of Antiquarian Traders, for his permission to use his photographs of two stunning Egyptian revival clocks and garnitures. To Lorenzo (Tony) Salani, of Salani Antiques, who graciously allowed the use of his photograph of a beautiful Royal Doulton *rouge flambé* vase. To Malcolm Logan, of Nelson Rarities, for his permission to use his images of a wonderful Giuliano Renaissance revival pendant and two incredible Egyptian revival pharaoh pieces. To Joseph Murawski, of Joden World Resources, for allowing us to use his photograph of a beautiful Newark Egyptian queen pendant. And to Anne Trodella, who sent wonderful photographs of Egyptian revival items auctioned by Skinner, Inc. Thank you all! This book is much richer for your help.

Sol Varon, generous and knowledgeable, again very kindly lent items from his collection to be used in this book. Thank you very much.

And to Stephanie Wenger, friend and fellow Egyptian enthusiast, thank you as always for the encouragement, advice, and friendship—and for the photographs of Egyptian revival pieces from your collection.

And thanks are also due to Nancy Schiffer at Schiffer Publishing, who accepted the proposal for this book, along with Doug Congdon-Martin, who offered much-needed advice on photography and took the photographs of most of the silverware. (The bad ones, it goes without saying, were *not* taken by him).

And to Mark Scattergood as well, for putting up with all of the Egyptian revival pottery, silverware, candlesticks, tea sets, and other material gathered for this book; and who devised lighting setups that made the photography actually doable. Thank you. You made this book possible. Thanks also to talented artist Katherine Scattergood, for the beautiful illustrations.

As the Chinese saying goes, a journey of a thousand miles begins with a single step. This is as true of metaphorical steps as it is of physical ones. In this case, two steps began a journey into the past and ended in this book.

The first step was a phone call to a college friend and roommate. Shelly Foote and I had taken our first Hebrew classes together,

A drawing of two herons, sometimes identified by the ancient Egyptians with the *benben* bird, or phoenix. From The Book of the Dead, a drawing by Katherine Scattergood, talented artist and terrific friend. Thank you for the wonderful art work.

and together we sat through an amazingly dull class on Biblical archaeology. Would you be interested, I asked Shelly–by then an expert on costume and jewelry at the Smithsonian Institution's Department of Costume and Social History–in doing a book on Egyptian revival jewelry? She wasn't, but recommended that I contact Schiffer Publishing. I took her advice, and Schiffer very kindly accepted my proposal for a book on antique enameled jewelry.

The second step was an email to a collector whose web site I greatly admired, Robin Allison. Would you mind, I wrote, if I used some of the pieces on your web site for a book on enameled jewelry? As Robin later put it, she was hooked from the word "Hello." In the end, her collection added so much to the book on enameled jewelry that we decided it should be a collaborative effort. Robin and I enjoyed our first collaboration so much that we decided to try yet another.

Meanwhile, Shelly and I had met again at a college reunion (not going to say which reunion, but it's a high enough number that in the Yanomamo counting system, which uses three numbers–one, two, and more-than-two–it would definitely be more-than-two). Shelly, whose wonderful father had recently passed away, was now retired from the Smithsonian so she could spend more time with her mother. At the reunion, she offered me the research from her master's thesis, which just happened to be on Egyptian revival in America. Well ... Who could refuse an offer like that?

So this book is really a collaboration of friends. None of this would have been possible without their help and support. Thank you, Robin! Thank you, Shelly! As the ancient Egyptians would have said: *ankh wadja seneb*–life, prosperity, health!

Contents

A 19th century drawing of a painting by American artist Elihu Vedder entitled The Questioner of the Sphinx. The painting dates to 1863, and is currently in Boston's Museum of Fine Arts.

Foreword

Each must Interpret for himself the Secret of the Sphinx
Amelia Edwards, *A Thousand Miles Up the Nile*, 1877

These words, written by Amelia Edwards over a century ago, evoke the mystery and wonder with which Americans and Europeans viewed ancient Egypt in the nineteenth and early twentieth centuries. In this day and age of instant messaging and electronically transmitted images, it is difficult to imagine the impact the rediscovery of Egyptian monuments and artifacts had on the public's imagination. In the last fifty years it has fallen to museum exhibitions, movies and political events to popularize things Egyptian.

The decorative goods manufactured and sold to capitalize on this fascination with ancient Egypt is the subject of this book, the first of its kind. Interestingly enough, when the exhibition The Treasures of Tutankhamun toured the United States from 1976 to 1979, it sparked a more scholarly and historical look at the Egyptian Revival. Museums mounted displays on nineteenth and twentieth century objects produced in the Egyptian style, including some jewelry. The first in the United States of which I know was Egyptomania at the Metropolitan Museum of Art in 1979. The Hudson River Museum did a more in-depth exhibit a few years later. *Égyptomanie* opened at the Louvre in Paris in 1994 with an accompanying large catalog.

While a few articles on decorative arts in the Egyptian style appeared in the magazine *Antiques* in the 1960s, more lengthy treatments only came out after the exhibition tour. Richard Carrott's *The Egyptian Revival: Its Sources, Monuments and Meanings 1808-1858* was the first serious study of Egyptian Revival architecture in the United States. It was published in 1978 although he had written it several years earlier as his dissertation at Yale University. England's James Steven Curl published *The Egyptian Revival: An Introductory Study of a Recurring Theme in the History of Taste* in 1982. There were a few others such as *The Egyptian Revival in Bohemia* by Hana Navrátilová, which also concentrated on architecture. In many ways this volume will add to this history as its publication coincides with the current exhibition touring the United States, Tutankhamun and the Golden Age of the Pharoahs.

This is very much Dale Reeves Nicholls' book. Her background in Egyptology makes her uniquely qualified to write it. Dale and I discovered our mutual interest in the ancient world when we met as freshmen at Scripps College in California many years ago. She pursued an advanced degree in Egyptology while I remained an interested amateur. Later we discovered our mutual interest in jewelry. She was an avid collector. I curated the jewelry collection at The National Museum of American History, Smithsonian Institution. In the last few years, we have discussed jewelry often, especially Egyptian Revival jewelry. I was pleased to learn that Nancy Schiffer encouraged Dale to explore the subject of Egyptian Revival jewelry more fully. Bringing her considerable expertise to bear she tackles the thorny problem of identifying just what makes a piece Egyptian Revival and what differentiates Egyptian Revival pieces from those produced in other archaeological revival styles. And finally, the extensive collection of Robin Allison makes this book a valuable addition to the literature.

Shelley Foote
California, 2006

Preface

A brooch in 18K gold, enamel, diamonds, and pearls, probably late 19th century of French origin. The brooch shows an Egyptian queen in profile, painted in Limoges enamel against a guilloche background. Like many Limoges enamels, this one uses foil accents, here adding highlights to the queen's vulture crown; very small diamonds also accent the filet across the crown and the vulture's head and tail, and form a necklace. It has an old c-clasp, is unmarked, and measures 1.25" in diameter. It was purchased for approximately $3700 in an online auction.

Two Egyptian revival pieces in 18K gold, moonstones, diamonds, and enamel. The winged pharaoh's face is carved in moonstone, and flanked by two gold serpents. The wings are beautifully fashioned of carved gold feathers at the top, ending in diamonds above champlevé feathers in alternating red, blue, and green. Although this is an extremely fine example of a winged pharaoh, a number of others were made in silver, with faces carved from crystal, lapis lazuli, or other stones. The second piece, a pendant with the profile of a (presumably) king's head in profile carved in moonstone, wears a royal headdress in gold and enamel set with a band of diamonds and a single ruby; a strip of the headdress enameled in green and black hangs down at the side. The king also wears a broad collar. Five lotus blossoms in champlevé enamel and an enameled bail complete the piece. *Courtesy of Nelson Rarities, Portland, ME.*

Someone once noted that Egyptian revival runs the gamut from the absurd to the sublime, with every shade in between covered. Of course, a lot of this is subjective, and one person's absurd may be the next person's sublime. For example, the Czech glass revival pieces can be viewed as over-the-top or adorable, depending on one's aesthetic sense, or perhaps one's sense of humor. Some people find some of the mid-century revival costume jewelry a bit gaudy, while others collect it fervently and pay top prices for it.

From the ridiculous ... One (of a set of three) wooden pull toy in the form of the Egyptian god Horus. The falcon-headed Horus is signed with the hieroglyphic drawing of a falcon, and Horus Dalton ©. About 10.5" tall. All three (including the goddess Hathor and a sphinx) were purchased for $5 in an online auction.

...to the sublime. A pendant in 14K gold, enamel, and diamonds, probably by the Newark, New Jersey Alling Company. The pendant depicts an Egyptian queen wearing the vulture crown associated with the Great Royal Wife (the pharaoh's principle wife and mother, usually, of his heirs) with a blue cloth beneath it and covering her hair. Otherwise, she is identical, down to the eyelashes, to Alling's Byzantine women (for more on which, please see chapter two, page 104). While Byzantine women appear with some frequency at auction and through dealers, Egyptian queens are almost unknown. This one was sold for $8000, probably reflecting its scarcity as much as its considerable artistic merit. *Courtesy of Joden World Resources, West Middlesex, PA.*

Among other things, I have found, while collecting Egyptian revival and writing about it, that one's significant other can be relied on to voice an (often annoying) opinion that might tend to err on the conservative side. Thus, one day Mark opened a kitchen cupboard where I had stashed some pieces Egyptian revival china, and literally recoiled in (unfortunately not feigned) horror.

"What is *that stuff* doing in there?" he asked.

"Well, it is china," I replied, as if that fact somehow would lessen his aversion to things in the Egyptian style. "And some of it's pretty nice," I added, defending with faint praise.

And it was nice, or so I thought. Among the pieces were a cute Limoges teapot with a winged scarab decoration, a Doulton Lambeth pitcher with applied hieroglyphs and a pharaoh spout, and a Wedgwood flow blue plate with an ancient Egyptian temple scene. All perfectly respectable, and totally unobjectionable, right?

Well, maybe.

It is, ultimately, all a matter of taste. Although all three of this book's co-authors do have certain preferences–or perhaps even biases, which, I must hasten to add, do not always overlap–I have chosen to include as many examples of the various genres as possible. So whether or not your taste runs more to the somewhat restrained Victorian Gorham silver or Wedgwood cameoware patterns, or to the more eye-catching costume jewelry pieces, it is hoped that the information in this book will be of assistance.

The prices in this book reflect the highly collectible (and sought after, and therefore sometimes pricey) nature of some Egyptian revival items, especially those made by well-known manufacturers or designers. This seems to be as true for objects with little intrinsic value–that is, costume jewelry, or cast iron bookends–as it is for items made of gold and silver. Many of the Czech revival glass costume pieces, for example, bring $200 or more in online auctions; pieces in 14K or 18K gold sometimes sell for as much as $5000 at auction. On the other hand, the determined collector can find great bargains, online as well as offline, especially when armed with a little knowledge. For example, it is helpful to know, if collecting in a fairly narrow category–such as Egyptian revival silver–makers' marks as well as hallmarks from various countries. Because this book covers such a large range of materials, a list of makers' marks would of necessity be incomplete; however, as often as possible, the marks for items with hallmarks or other marks are described in the text or the captions.

The prices also at times reflect a fairly wide range. In general, the upper range will reflect a dealer's asking price, while a lower price often reflects an online auction, in which items usually but not always sell for less than what a dealer might ask. (However, it must be noted that some online sellers have rather unrealistic expectations. Robin tells of one seller who had checked a Bond Street dealer's web site, and priced a piece of jewelry she listed accordingly. The price was about three or four times what she might realistically have expected to obtain at auction, online or off.)

There is also what I like to think of as the "fatigue effect." This is prevalent especially in online auctions. A period of observation has shown that, as a general trend, an object that sells for a high price in an online auction will often prompt others to list items identical to or closely resembling it. Often the second piece evokes much less interest–and attracts much lower bids–than the first item. For example, the Pickard Egyptian lotus double-handled dish featured in chapter three, page 125, was purchased at auction for approximately $350. The identical piece was listed three weeks later, and received bids up to about $114. The reserve was not met, and the dish went unsold. (On the other hand, the Czech revival piece with pyramids, obelisks, sphinx, cartouches, and a winged scarab shown here was bought right before another identical piece was listed. The second seller, who knew the exact maker of the piece, received more than the first seller. This does seem to be a rather unusual case, though.) Therefore, being the first to buy a particular item may carry some risk. On the other hand, it must be weighed against the risk of never seeing a similar piece again.

Finally, it should be noted that some of the prices reflect the authors' experiences, which tend not to be uniform, and may not create an entirely reliable guide to what a fair price might be. This is especially true for one-of-a-kind or at least very rarely encountered items, such as the wooden pull toy shown above.

Introduction
The Slumbering Sphinx

For a great enchantment rests on this place from the beginning of time, as far as the districts of the lords of Babylon, the sacred road of gods to the Western horizon of On [Heliopolis] because the form of the Sphinx is a likeness of Kheper-Re, the very great god who dwells at this place, the greatest of all spirits, the most venerable being who rests upon it. ...On one of these days it happened that the king's son Tuthmosis had arrived on his journey at the time of midday, and he lay down to rest in the shade of this great god. Sleep and dream overtook him.

At that moment the sun was at its zenith. He found the majesty of this great god speaking from his own mouth like a father speaks to his son. He said, "Look at me, observe me, my son Tuthmosis. I am your father, Horemakhket, Kheper Re Atum. The kingdom of Upper and Lower Egypt will be given to you ... Plenty and riches will be given to you ... The sand of the desert, upon which I once was, now confronts me [has buried me] and it is in order to cause that you do what is in my heart that I have waited. Promise that you will do what I wish in my heart, so that I will know that you are my son."

The Dream Stela of Tuthmosis IV

Around 1400 B.C., a young Egyptian prince named Tuthmosis had a revelatory dream. In this dream, the Great Sphinx at Giza commanded the prince to clear away the sand that buried the largest statue ever created. The prince did as he was bidden, and later left a stela with his account of the dream between the statue's paws, where it remains to this day. Although the end of the stela is lost, Tuthmosis ascended to the throne, as Tuthmosis IV, so it is reasonable to suppose that he did clear away the sand and free the Great Sphinx from its sandy entombment.

In many ways, the sphinx–today still a symbol of its country–was emblematic of Egypt itself. The sphinx, in Greek mythology, posed riddles.[1] Egypt *was* a riddle. For before the nineteenth century, Egypt, like the sphinx, was buried in the sands of time and oblivion. Mysterious and mythic, known primarily from accounts of Greek travelers, Egypt slept undisturbed, and unknown.

Travelers went there, visited the pyramids and what was left unburied of the sphinx[2] and came away still largely ignorant of her history and culture.

And yet Egypt remained an object of curiosity and speculation. Renaissance scholars, newly focused on the pagan past, tried to solve Egypt's riddles. They turned to ancient sources, such as the fifth century A.D. account of hieroglyphic writing by Horapollo. They used hieroglyphs as cryptic messages, or rebuses. They unearthed or restored ancient obelisks brought from Egypt by Roman emperors.[3] The great German artist and engraver Albrecht Dürer used hieroglyphic animals as well as other symbols in his work, such as his design for the triumphal arch of the Emperor Maximilian. Italian writer Francesco Colonna, possibly inspired by Horapollo's *Hieroglyphics*,[4] added hieroglyphs of his own to his inscrutable work, *Hypneratomachia Poliphili*.[5]

A small Limoges box in the form of a sphinx, approximately 2.75" x 2.5", of relatively recent date (probably c. 2000). Signed on bottom Peint main Limoges France GR ©. These small porcelain boxes, for which Limoges is noted, sell for about $150-$200 new, but can occasionally be found online for less.

A 19th century engraving of the pyramids and Great Sphinx at Giza, from Georg Ebers' travelog book *Egypt: Descriptive, Historical and Picturesque*, published in 1878. Travel books like Ebers' were extremely popular with the Victorians, and their illustrations afforded glimpses of new and exotic landscapes. Similar pictures of the Great Sphinx and pyramids could be found in hundreds of books, from the publication of the Napoleonic expedition's *Description de l'Egypte* in the 1820s onward.

A brooch from Czechoslovakia c. 1920, very likely by Max Neiger of Gablonz, in brass, jadeite glass, and soft or cold enamel. This brooch has everything one could ask for in an Egyptian revival piece: pyramids, sphinx, palm trees, winged scarab, cartouches, and hieroglyphs; all that's missing is a camel and a mummy. Although this brooch is very much a costume piece, similar brooches have sold for as much as $200-$300. This brooch and ones with similar glass elements come up with some frequency, although the bidding in general tends to be fairly competitive.

While the Great Sphinx may be an arche-typal symbol of Egypt, Egypt's most famous historical personage is almost certainly the legendary Cleopatra. And the words William Shakespeare wrote about Cleopatra might equally well apply to the land she ruled. Like Cleopatra–Egypt's last native-born ruler, who captivated both Julius Caesar and Mark Antony with her beauty and intelligence–Egypt cast a strong spell over the West.

A plate by Sue Climpson entitled "Cleopatra." Here Cleopatra wears the vulture crown asso-ciated with Egyptian queens and the goddess Isis. Although Cleopatra has throughout the centuries been famed for her beauty, she was in fact not especially beautiful: Contemporary coins show her with the hooked nose characteristic of a number of the Ptolemies. Nor, contrary to what some people believe, was she Egyptian. Her family was of Macedonian descent, and never intermarried with their Egyptian subjects. In this portrait, she mis-leadingly appears both attractive and somewhat Egyp-tian. The reverse reads LIMITED EDITION Plate No. 04280C in the official limited edition of 'Cleopatra' by Sue Climpson in The Power of Ancient Egypt collection which is produced on fine porcelain in an edition strictly limited to a maximum of 75 firing days and crafted to the exacting standards of The Bradford Exchange. This plate is officially listed for trading on The Bradford Exchange. This plate, along with another in the set featuring Tutankhamun, was purchased for about $56. Though undated, it appears to be of fairly recent manufacture.

A tile by Minton, showing Antony and Cleopatra (with a legend that reads "ANTONY AND CLEOPATRA IV IV"; it's not clear what the two Roman numerals IV refer to, though possibly this was the day they met). In this vignette, Cleopatra is shown clasping Antony about the waist, as if to restrain him from leaving to fight the battle of Actium against Octavian (Augustus Caesar). If this is indeed what the scene is intended to represent, then Cleopatra showed great foresight: Antony lost the battle, and he and Cleopatra both committed suicide as a result. However, this image of Cleopatra as a desperate, clinging woman is greatly at odds with what is known of the proud, intelligent, determined queen. The only thing that makes her rec-ognizably Cleopatra is the vulture crown she wears; otherwise her garb and long, wavy hair seem quite unlike Greek or Egyptian fashions of the time. Signed in bas relief letters on the reverse MINTONS CHINA WORKS STOKE ON TRENT, with Minton's globe mark. Measures 6" square. It sold in an online auction for about $25.

Cleopatra

Cleopatra is arguably the most famous *femme fatale* in history. She inspired plays by William Shakespeare and George Bernard Shaw; operas by the Italian composer Malipiero (1938) and the American Samuel Barber (1966); a Cecil B. de Mille movie starring Claudette Colbert (1933); a Hollywood extravaganza starring Elizabeth Taylor (1962); and countless paintings. For artists, it seems that the death of Cleopatra was an especially enticing subject; Jean-André Rixen and Hans Makart both painted pictures entitled *The Death of Cleopatra* only a year apart (in 1874 and 1875 respectively). More prosaically, Cleopatra has also inspired a number of dolls.

Cleopatra was despised by the Romans, whose leaders either (literally) loved her–as did Julius Caesar and Mark Antony–or loathed her–as did Octavian, later Augustus Caesar, whose sister Octavia was humiliated when her husband Mark Antony deserted her for Cleopatra. After the defeat of Mark Antony's forces by Octavian at Actium in 31 B.C., Cleopatra famously committed suicide by snakebite rather than be taken as a prize by Octavian and paraded as a captive in a Roman triumph that likely would have ended with her being put to death in the forum. Her younger sister Arsinoë had suffered such a fate at the hands of Julius Caesar, and Cleopatra had no desire to repeat it.

The historical Cleopatra seems even more remarkable than the literary and movie versions. The real Cleopatra was a brilliant woman who at her father's instigation learned not only the Egyptian language (the first of the Macedonian Ptolemaic rulers to do so), but several other African languages as well.[6]

Her early family life was turbulent, with her improvident father Ptolemy XII in debt to Roman moneylenders and never secure on the throne of Egypt. Cleopatra's older sister, Berenike,[7] took advantage of Ptolemy's trip to Rome (to deal with the ever more importunate moneylenders) and with backing from powerful Alexandrians usurped the throne. Ptolemy was restored to power by Roman armies led by Pompey the Great. He executed his faithless daughter Berenike and left his precarious throne to his oldest surviving child, the seventeen-year-old Cleopatra VII (her older sister Cleopatra VI having mysteriously disappeared from history's stage), to be shared jointly with the older of her two younger brothers, Ptolemy XIII. Their co-regency was at first purely nominal: The brilliant and strong-willed Cleopatra was the real power in Egypt.

However, Ptolemy XIII, resenting his sister's dominance, conspired against her with palace courtiers and made an attempt on her life. She fled to Syria, but soon returned to Egypt at the head of an army. A stalemate between the siblings was broken by the arrival of Julius Caesar, pursuing his enemy Pompey to Egypt. Ptolemy XIII was defeated by the Romans under Julius Caesar, who immediately became Cleopatra's lover. Cleopatra had a son by Julius Caesar, named Ptolemy Caesarion, and lived openly in Rome as Caesar's mistress, appalling the more conservative citizens of Rome–Caesar was still married to Calpurnia, and Roman law would in any case have barred him from marrying a foreigner, even a highly placed one. After his assassination, Cleopatra left Rome with their son and returned to Egypt. Caesar's death was followed by civil war, with Mark Antony and Caesar's heir Octavian emerging as the two primary antagonists. Cleopatra allied herself with the self-indulgent Mark Antony, with whom she had three children and whose fate she ultimately shared.

A brooch with the profile of an Egyptian queen wearing the vulture crown, most likely intended to depict Cleopatra. Of American manufacture, probably from Newark, c. 1890. Although Newark and New York firms made crescent pins, especially those containing flowers (and known as "honeymoon pins") by the thousands, this brooch is one of only two Newark crescent pins with an Egyptian revival accent the author has seen. The other, marked for the Newark maker Crane Theurer, contained a sphinx instead of a queen, and sold for approximately $200. This one is unmarked 14K gold, and measures 1" in diameter; it was purchased for $125.

Historians for years have debated Cleopatra's motives. Did she love Julius Caesar, or was he merely a means to an end? Did she use Mark Antony as a pawn in a game, the goal of which was to keep Rome at bay and preserve Egypt's independence? Or was she the unwitting dupe of a greedy voluptuary who saw in Egypt–and its queen–unrivaled riches and an enchantingly sybaritic lifestyle? Whatever her reasons for entering into alliances with two of Rome's leading citizens, it seems clear that one of her primary aims was to keep Egypt from becoming another territory in the Roman Empire. Peter Clayton (1994: 216) perhaps summarizes Cleopatra's personality and ambitions best: "Although her beauty has been fabled in literature, Cleopatra was above all things a very clever, intelligent and political woman - she had to be to captivate two such men as Caesar and Antony in turn and endeavour to use them to maintain her kingdom."

After Cleopatra's death, Caesarion (whom his mother had raised to the throne as her co-regent, Ptolemy XV[8]) was killed by the Romans. Cleopatra's children by Mark Antony fared better; they were raised by Mark Antony's spurned wife Octavia. With Cleopatra's death, Egypt became a province of Rome–an outcome Cleopatra strove most of her thirty-nine years to avert.

An interesting brooch in silver and enamel or glass, showing three period Egyptian postage stamps, most likely c. 1920-1930. The three minute stamps contain images, left to right, of two colossal statues (against a blue background), the sphinx (against red; interestingly, in this depiction as in almost all others, the sphinx is shown undamaged), and Cleopatra (against green). Marked 800 on the reverse, with a c-clasp; very likely a tourist piece made in Egypt, though possibly the glass was imported from Czechoslovakia. Measures 1.5" across; the enamel or glass is damaged in two of the stamps, which considerably detracts from its value. Undamaged, such a brooch might sell for $35-$55, and sometimes for more in a spirited auction.

A pendant in sterling silver in the form of a cartouche, with Cleopatra's name (almost) written in hieroglyphs. The first sign in her name is missing, so the hieroglyphs actually read **leopadra**. Although this rather resembles a tourist piece, it is actually marked with a lion, the British sterling silver stamp. Such pendants are frequently made to hold their wearer's name spelled out in a modified Egyptian alphabet, and come in both silver, and 14K and 18K gold. Those in silver tend to be very affordable. This one, with a fancier bail and the cartouche itself decorated with ankhs, was a bit more expensive than usual, but even so sold for about $20, about one-tenth of what a gold one would cost when new.

The famous American doll maker Madame Alexander marketed at least two Cleopatra dolls. The 12" Cleopatra doll, with a companion Antony doll, was issued c. 1985, and cost $52 new (as did the Antony doll). In an internet auction, the pair in their original boxes sold for approximately $50, although the Cleopatra doll alone sells for about $20-$45 in online auctions. The second Cleopatra doll (shown), 10" tall, was issued c. 1998 as a limited edition doll, part of Madame Alexander's "Platinum Series." She is rather more elaborately garbed than the larger doll, wearing a gold lamé dress, a blue chiffon and gold lamé train, and gold-tone metal jewelry set with blue rhinestones, including a headdress (with the horns and solar disk associated with the crowns of Egyptian queens and the goddesses Hathor and Isis), a necklace, and a girdle complete with a winged scarab. This doll cost approximately $110 new, but has sold for as little as $40 in an online auction. Madame Alexander also created an 8" "Egypt" doll, which came with a mummy case; it was available new around 1999, and also sold for about $110. This doll has sold for between $30 and $70 in online auctions.

After Cleopatra

The Greeks, who recognized Egypt as the source of much of their own culture and knowledge, were fascinated by the ancient land, so much older than their own. Later, the Romans coveted it, conquered it, and occupied it for several centuries. The story of Cleopatra–recorded by the Greek biographer Plutarch in his *Lives*–remained vivid, inspiring poets and playwrights such as Shakespeare. And later, traces of Egypt, especially the obelisks sometimes called Cleopatra's needles, mystified scholars with their unreadable hieroglyphs, and testified to the once great civilization that had possessed the technical ability to carve monumental spires out of single blocks of stone.

> *I will put an end to the great ones of Memphis and the princes of the land of Egypt, that they may be no more. I will cast fear into the land of Egypt. ... I will set fire to Zoan, and inflict punishment on Thebes.*
>
> Ezekiel 30: 12-14

After centuries of foreign occupation, during which Ezekiel's prophecy largely came to pass, the inhabitants of Egypt were no better informed than Europeans about the former glories of their country. The mystifying religion of the ancients had long since been supplanted, first by Christianity, later by Islam.[9]

The language in which the ancient Egyptians had carved their hieroglyphs in stone and inked their hieratic[10] signs on papyri had long since been replaced by Arabic. Coptic, the last stage of Egyptian, remained in use only as the liturgical language of the Coptic Christian church, much like Latin in the Catholic church.

Egyptians found papyri by the thousands, and burned them as fuel. They stripped the bright limestone casing off the great pyramids[11] and quarried temples, with their myriad inscriptions, for building blocks.

Unknown Egypt was well on its way to becoming unknowable.

But fate, in the form of a young Corsican general with dreams of glory, changed the course of Egyptian history; and, almost as an afterthought, gave us the science of Egyptology. By so doing, the young general was about to begin a mania for all things Egyptian, and to launch Egyptian revivals that endure to this day.

A 19th century engraving of an Egyptian obelisk in Paris, n.d. Such monuments, carried off as spoils of war by both ancient and modern conquerors, were often the only glimpse Europeans had of ancient Egypt before the French invasion in 1798. The engraving is entitled "The Obelisk of Luxor in Paris," and was published by Bermann J. Meyer of New York.

It's Alive! Ancient Egypt Rediscovered and Revived

About Egypt I shall have a great deal more to relate because of the number of remarkable things the country contains, and because of the fact that more monuments that beggar description are to be found there than anywhere else in the world.

Herodotus, *The Histories*

Soldats, songez que, du haut de ces pyramides, quarante siècles vous contemplent. (Soldiers, think of it: From the top of these pyramids, forty centuries look down upon you.)
Napoleon Bonaparte, to the French army in Egypt, on
July 21, 1798, before the Battle of the Pyramids

In 1798, Napoleon Bonaparte–at that time still the young upstart general who had led the armies of post-revolutionary France to victory over her European enemies–somewhat unaccountably decided to invade Egypt. Some sources propose that Napoleon's action was based on a desire to harass Great Britain, at that particular time France's sole remaining European enemy (Adkins 2000:9). Possibly he intended to disrupt Britain's access to and trade with India, her most valuable colony. However, Napoleon himself, in his memoirs, asserted that his sole motivation for conquering Egypt was *"la gloire."* Napoleon is also reputed to have said, "We must go to the Orient; all great glory there resides."

This explanation seems more likely. Napoleon, with his dreams of dominating Europe, might have been tempted to see himself as a latter-day Caesar; and as India was the jewel in the late nineteenth century British crown, so had Egypt been the crowning jewel of the ancient Roman Empire. Thus Napoleon appears to have followed the path chosen by other great military leaders such as Octavian (later Augustus Caesar) and Alexander the Great, both of whom had added Egypt to their empires.

Although Napoleon's ultimately futile campaign did little to change the face of European politics (it did, however, have a rather more lasting effect on the fate of Egypt itself, which for several centuries had been merely one small part of the Ottoman Empire, and a distant one at that; post-Napoleonic Egypt was given more autonomy by its Turkish overlords) its consequences for those interested in the ancient world were immense. It was entirely due to Napoleon's invasion that Egypt–her language, her history, her customs, her very essence, so long shrouded in mystery and misinformation–was rediscovered.

For, in addition to the requisite conquering army (in this case more than 30,000 men strong), Napoleon, himself a recently elected member of the French National Institute, took with him a retinue of the Institute's most illustrious scientists and savants–a gesture that in many ways replicated the retinue of scholars and scientists whom Alexander the Great took with him on his Persian campaign.[1]

Napoleon's military expedition did not fare well. After such initial successes as the Battle of the Pyramids, in which French military superiority and modern weaponry defeated the Egyptian Mamelukes,[2] Napoleon's enterprise met with disaster. The greater part of the French navy, which had transported Napoleon, his troops, and his scholars to Egypt, was anchored near Alexandria. The British, who had heard about massive French naval preparations underway at Toulon, were actively seeking the French navy. Britain's Admiral Lord Horatio Nelson seems to have guessed that Napoleon's objective was Alexandria; Nelson's fleet of thirteen ships actually beat the French navy to Egypt. Finding no sign there of the French, Nelson left. However, on July 28, he was alerted by Greek fisherman who had spotted the large French fleet south of Crete, and turned back to Alexandria. In what later became known as the Battle of the Nile, fought on the night of July 28-29, Nelson destroyed all but two of the nearly four hundred French ships anchored off the coast of Egypt.

The battle was a fateful one, and fatal to Napoleon's dreams of pharaonic greatness: His army was stuck in Egypt, and would remain stranded there for another three years. Napoleon himself left Egypt a year later, never to return. Estimates vary, but according to one assessment, one in three French soldiers had died of disease, starvation, or warfare by the time Napoleon's army finally surrendered to the British. (Other accounts, such as Adkins 2000, claim that over half of the French army in Egypt died.)

The scientists and scholars, artists and intellectuals who had voyaged to Egypt fared only slightly better: Twenty-six of Napoleon's savants perished there, ten of the plague, five in battle, five assassinated, five of dysentery, and one drowned (Wilson, 1964:14). However, they at least had their assigned tasks to fulfill. They headed south. They sketched and measured and mapped as they went, recording the interesting features of the country in which they found themselves marooned. The joy of discovery, as much as anything, appears to have kept them going. As Denon (1802: 246) put it, "the fear of quitting Upper Egypt without having seen it made me brave all."

Denon's account expresses the awe and amazement the savants felt when they saw the size and number of monuments in a land where even the quarries that had supplied the stone for the temples and statues had monuments carved into them (Denon 1802: 23). At Karnak and Luxor (the ancient Thebes) they were astonished by the sheer immensity of a temple complex to which pharaoh after pharaoh had added pylons, shrines, hypostyle halls, transforming the city into Homer's "Thebes of a thousand gates." At Edfu, they discovered the large temple of Horus (which was almost completely buried under sand and had native dwellings perched atop its roof). They went as far as Philae, at the ancient border with Nubia.

By the time they were done, they had amassed a library of information and created a visual archive unprecedented in the history of exploration. The results of their survey of Egypt were published over the next two decades (from 1809 to 1828) in nineteen volumes entitled *Description de l'Égypte.*

And, almost entirely through the efforts of this amazing scientific expedition, and its effects on a young French scholar who would later become known as the Father of Egyptology, Egypt–like the mysterious sphinx, at that time buried up to its neck in sand–had emerged from the sands of time and oblivion that had enshrouded it for almost two millennia.

Egypt's secrets were about to be revealed.

Egypt Rediscovered

> I met a traveller from an antique land
> Who said: Two vast and trunkless legs of stone
> Stand in the desert. Near them on the sand,
> Half sunk, a shatter'd visage lies, whose frown
> And wrinkled lip and sneer of cold command
> Tell that its sculptor well those passions read
> Which yet survive, stamp'd on these lifeless things,
> The hand that mock'd them and the heart that fed;
> And on the pedestal these words appear:
> 'My name is Ozymandias, king of kings:
> Look on my works, ye Mighty, and despair!'
> Nothing beside remains. Round the decay
> Of that colossal wreck, boundless and bare,
> The long and level sands stretch far away.
> Percy Bysshe Shelley, *Ozymandias of Egypt*

The French artist Dominique Vivant Denon, one of the savants who accompanied Napoleon to Egypt, published his narrative account of his travels, *Voyage dans la basse et dans la haute Égypte* (*Travels in Lower and Upper Egypt*), in 1802. In 1803 it was published in Great Britain under the title *Egypt.* This book, with its illustrations of an ancient and alien country was, for many people in France and Great Britain alike, the first glimpse of a civilization that was to fascinate many in Europe and the United States for the rest of the nineteenth century–and well into the twentieth century.

Percy Bysshe Shelley wrote his famous poem "Ozymandias" in 1818, not long after the first swell of interest in Egypt reached Europe. For many, the poem is far better known than Denon's account of his arduous journey. And Shelley's poem also expresses, succinctly and memorably, the mixed emotions that seem to have accompanied the rediscovery of ancient Egypt. Such a great civilization, such feats of construction! The pyramids! The obelisks! The colossal statues of kings whose names no one now remembered and whose inscriptions no one could read. "'Look upon my works, ye Mighty, and despair!'"

A rather unusual vase in bisque ware, much in the style of Schafer & Vater although unmarked, showing a young man dressed in clothing fashionable around 1798–note the breeches and the cocked hat, so like items worn by Napoleon himself–in a cemetery. The tomb or cenotaph, though markedly Classical in style, has a very Egyptian recumbent sphinx. It is tempting to imagine that this was intended to show a young Napoleon dreaming of his Egyptian adventure, but there is absolutely no indication that such was the designer's intention. This was purchased in an online auction for approximately $45.

Egypt Described

*Lo, thou trusteth in the staff of this broken reed of Egypt;
wherein if a man lean, it will go into his hand and pierce it; so
is pharaoh king of Egypt to all that trust in him.*

Isaiah 36:6

Others, of course, had visited Egypt before Napoleon's invasion. Especially after 1517, when Egypt came under Ottoman rule and the Turkish sultan, Selim I, made Egypt safe for French merchants and travelers, a few Europeans had traveled there, most notably the French priest Claude Sicard, British explorer Richard Pococke, and the Dane Frederik Norden.[3]

However, never had so much information about a lost civilization become available before the publication of *Description de l'Égypte*. Pococke and others had written accounts of their travels, but these were modest works, the product of one individual's vision, one person's experiences. And they were published at a time when books were expensive, and possessed only by the wealthy and educated few who could both afford them and understand them. While the multi-volume *Description* was undoubtedly expensive, it was published at a time when thirst for knowledge of the past was deep and abiding.

Yet for twenty-five years after Napoleon's invasion, Egypt's history and culture still remained obscure, even opaque. What was known about Egypt's past largely came from ancient sources; and it is probably safe to say that most people knew little more about Egypt other than what they gleaned from the Bible. Even scholars steeped in the past were forced to rely on ancient and often unreliable sources. Chief among these were the histories of Herodotus, a Greek traveler who visited Egypt in the fifth century B.C.; and the *Library of History* by Diodorus Siculus, whose first century B.C. account of Egypt was preserved in Book I of his encyclopedic work. The Greek geographer Strabo (also during the first century B.C.) wrote about Egypt in some detail and with some accuracy—his account of the avenue of sphinxes leading to the Serapeum at Saqqara led the French archaeologist Auguste Mariette to its location. The myth of Isis and Osiris was known from the writings of the Greek biographer Plutarch (who wrote during the end of the first and beginning of the second centuries A.D.), while a rough chronology of Egypt's rulers survived in the accounts of the Egyptian priest Manetho, who was commissioned around 300 B.C. by the Macedonian ruler Ptolemy II to create a complete history of the pharaohs, garnered from temple records.[4] Given this state of relative ignorance, it is remarkable that Napoleon's assertion—if it is not apocryphal—that forty centuries of history looked down upon his army from the great pyramids was so close: The Great Pyramid was built in the reign of the Fourth Dynasty pharaoh Khufu, which lasted from approximately 2589 to 2566 B.C. (Clayton 1994: 42). (For a brief overview of Egyptian chronology, please see the Appendix.)

Scholars knew from the surviving fragments of Manetho's *Aegyptiaca* that the Egyptians had kept extensive historical records. They also probably knew—or at least guessed—that some of these records were quite visible: carved on the great temples, painted on tomb walls, incised on stelae. The problem, of course, was that they were completely unreadable. The last hieroglyphic inscription, written in the southern city of Philae, is thought to date from 395 A.D. (shortly after the Roman emperor Theodosius I ordered that all non-Christian temples in Egypt be closed), while the last demotic inscription is dated to 470 A.D. After that, the art of reading and writing ancient Egyptian died out completely.

Until, that is, the French Egyptologist Jean François Champollion wrote his seminal *"Lettre à M. Dacier relative à l'alphabet des hieroglyphes phonetiques"* ("Letter to M. Dacier relating to the alphabet of phonetic hieroglyphs").

The Rosetta Stone Reveals (Almost) All

*Not as their friend or child I speak!
But as on some far northern strand,
Thinking of his own Gods, a Greek
In pity and mournful awe might stand
Before some fallen Runic stone—
For both were faiths, and both are gone.*

Matthew Arnold, *The Forsaken Merman*

Of all of the discoveries made by the French in Egypt, perhaps the most important was also one of the most modest. It was not an imposing temple complex, nor a great pyramid, nor a giant stone statue such as those left by Ramesses II. It was, instead, a stela: a three-foot-high block of black basalt commemorating the coronation of Egypt's king Ptolemy V, c. 200 B.C. The stela was discovered in 1799 in the Nile delta (near the town of Rosetta, about 100 miles north of Cairo, for which it is named). The Rosetta Stone notably repeated the same inscription in three different writing systems (some might even say three different languages): Egyptian hieroglyphs, Demotic (a late form of Egyptian), and Greek.

After the defeat of the French navy and the subsequent capture of the French army by the British, the Rosetta stone was seized and sent back to England, where it still remains on exhibit in the British Museum. Not, however, before the French had had ample time to study it, and had made a rubbing that preserved the inscriptions. Among those who had access to the information on the Rosetta stone was a young professor of Oriental languages, Jean François Champollion.

Few who know the story of his too-short life doubt that Champollion was a genius. At the age of sixteen, he presented a paper before the Academy of Grenoble, where he was then a student at the *lycée*, in which he asserted that the language of the Egyptian Copts was the same language as the one spoken by ancient Egyptians. (However, it should be noted that the well-read and multilingual Champollion was undoubtedly aware of and influenced by the work of seventeenth century German scholar Athanasius Kircher, who first proposed that Coptic was not a separate language but rather the final stage of ancient Egyptian in his 1643 *Lingua aegyptiaca restituta*; Kircher also suggested that hieroglyphs might have a phonetic basis, but incorrectly identified letters in the Greek alphabet with twenty-one Egyptian signs.) At the age of eighteen, Champollion was appointed professor of history at Grenoble, and remained in that position for the next eight years.

In his letter to M. Dacier, the Secretary General of France's Académie des Inscriptions, Jean François Champollion set forth the information he had gleaned from the Rosetta stone and from an obelisk carved with Greek and Egyptian inscriptions taken to London by Italian adventurer Giovanni Belzoni. Although there were a number of Europeans vying to become the first to decipher Egyptian hieroglyphs, Champollion and a largely self-taught British physician and scholar, Thomas Young (who was the first to realize that certain hieroglyphs represented objects or ideas, and the first to identify correctly the forms of dual and plural nouns[5]) were the only truly serious contenders. Champollion (possibly with pointers from Young) recognized that names in cartouches corresponded with the royal Egyptian names Ptolemy and Cleopatra, and discovered

17

the phonetic values of twelve hieroglyphic consonants.

Champollion reported these discoveries in his letter to M. Dacier. He claimed to have deciphered twenty-six phonetic signs (fourteen of which later turned out to have been assigned incorrect values), as well as the use of determinatives–although here again he was aided by Young's insights. This brief report was followed by Champollion's 1824 book, *Précis du système hieroglyphique*, a more authoritative book upon which most later research was based.

In addition to his linguistic discoveries, Champollion also, with an Italian student[6] and funding from the newly restored French monarchy, formed the Tuscan-French expedition to tour Egypt. The result of his expedition was a survey of the history and geography of ancient Egypt based on its monuments and inscriptions.

Unfortunately, Champollion died of a stroke at the relatively young age of forty-one. His drawings and notes were published posthumously, and became the basis for future work in Egyptology and in the exploration of Egypt.

A drawing of hieroglyphs carved in bas relief on a monument. They read: (May he be) given all life and strength and power, and health; king of Upper and Lower Egypt (literally: "(He) of the sedge and the bee"), Kheperkare (the prenomen of Sesostris I, a Twelfth Dynasty pharaoh). While hieroglyphs were commonly carved on stone, hieratic was almost always used on papyrus. The Book of the Dead, which is written in rather cursive hieroglyphs, is an exception; possibly it was considered worthy of hieroglyphs, as it was a religious text.

FIG. 2. CROWN ENCRUSTED WITH CORNELIAN, EGYPTIAN EMERALDS AND LAPIS-LAZULI.

Two diadems belonging to the Twelfth Dynasty princess Khnumet, published in *The Jewelers' Circular and Horological Review*, June 14, 1895, not long after their discovery by Jacques de Morgan. *Courtesy of Shelly Foote.*

FIG. 1. CROWN OF INTERLACINGS OF GOLD FILIGREE ENRICHED WITH PRECIOUS STONES.

A postcard and stamps commemorating Champollion's decipherment of Egyptian hieroglyphs. Although his is not a household name in this country, Champollion is remembered in France and Francophone countries for his remarkable achievements in Egyptology. One South American Spanish-language comic book told the story of Champollion, presumably as an inspiration to young people.

The Age of Archaeology

If the Elizabethan age was the period of the discovery of new worlds, a period bright with all the romance and fascination of man's adventure into the unknown, out own age may be defined as the period of the resurrection of ancient worlds, and the romance of the explorations which have given back to us the buried civilizations of Assyria, Babylonia, Egypt, Crete and Asia Minor has in its own way been almost as thrilling as that which marked the discoveries of Columbus, Cortez, and Pizarro. Ancient and mighty empires, which lived for us only in the dim traditions and distorted pictures of classical historians, have risen out of the dust of the past.

They have begun to take shape and solidity before our eyes; their palaces, their temples, and their tombs have yielded us unquestionable and vivid illustration of the height of culture which they had reached in almost incredibly ancient days. It is scarcely an exaggeration to say that we know as much of the life and the customs of the leading peoples of four millenniums ago as we do of those of the European nations of the Middle Ages.

So wrote James Baikie in his article "The Resurrection of Ancient Egypt," published in a 1913 issue of *National Geographic* entirely devoted to ancient Egypt. Baikie was merely stating the obvious. By the beginning of the twentieth century, lost worlds had been rediscovered, forgotten writings deciphered, cities known only from Greek and Roman texts had been transformed from myth into history.

The nineteenth century, that amazing intellectual hothouse in which ideas bloomed and knowledge blossomed like the new varieties of pansies and orchids cultivated in English gardens, also saw the birth of archaeology as a science. Had Champollion lived, possibly his genius might have led him to undertake a close examination of Egyptian artifacts and devise a systematic way of dating them. As it was, this task was left to the extraordinary British excavator Sir William Matthew Flinders Petrie.

The First Modern Archaeologist

From the beginning he was shocked at the pillage which passed for excavation. He saw how archaeology destroys forever the meaningful context of materials. Egypt had so great a wealth of monuments that the first excavators could be very prodigal of what they found: they cheerfully ignored stone or mud walls, undecorated or broken pottery, wooden timbers, uninscribed weights, tools and weapons. Petrie made these "unconsidered trifles" important.

John A. Wilson, on Flinders Petrie, in *Signs and Wonders upon Pharaoh*

Sir William Matthew Flinders Petrie remains one of the giants of Egyptology. A man of seemingly endless energy and almost complete contempt for modern comforts, Petrie was–like his predecessors in Egyptology, Jean François Champollion and Thomas Young–self-taught and extraordinarily gifted. As a boy, encouraged by his parents, he had developed an interest in archaeology, especially in ancient weights and measures. He also had a talent for math, and taught himself geometry and trigonometry at a young age. Later, while working as a surveyor in southern England, he began a study of Stonehenge, which led to his discovery of the unit of measure used in constructing the neolithic monument. These findings became the basis for Petrie's first book, *Stonehenge: Plans, Description, and Theories*, published when he was twenty-four. It was the first of over one hundred books written by him during the course of a long and productive lifetime.

Flinders Petrie first went to Egypt in 1880, and was to spend the next forty years excavating in Egypt and Israel. When he arrived in Egypt, over eighty years after Napoleon's invasion, archaeology was still an undertaking that more resembled looting than science; excavators even resorted to the use of dynamite to facilitate the removal of noteworthy finds, most of which went to fill European museums or the pasha's pockets.[7]

From 1880 to 1883, Flinders Petrie studied the Great Pyramid at Giza, and in 1883 published *Pyramids and Temples of Gizeh*. He had spent those three years at Giza in meticulous study of each layer and each square inch of soil, and his careful analysis was to form the basis of scientific archaeology. His methodology was strict and painstaking. Each find was to be studied *in situ* before it could be moved; every discovery, no matter how seemingly insignificant, was to be catalogued and recorded. As one admiring scholar noted, "Flinders Petrie set the standard for methodology and ethics that were then adopted by later excavators." During his forty years in Egypt, Flinders Petrie and his co-workers (many of whom suffered from the privations associated with working under a man whose method of dining involved opening a variety of tinned foods, placing them on the dining table, and eating from them over the course of the next few days; more than one of his disciples came down with food poisoning) excavated thirty sites–almost a site a year. Flinders Petrie was also unusual in that he believed in publishing an account of each excavation as quickly as possible, instead of sitting jealously on new discoveries. In addition to the many publications that resulted from his excavations, Flinders Petrie wrote *Methods and Aims of Archaeology* (1904), which set forth the methodology and goals for archaeological excavation.

Among Flinders Petrie's innovations was sequence dating. After a careful study of pottery from several sites, he realized that, while he could not assign absolute dates to the various pieces, he could arrange them in a sequential order of oldest to most recent. He also honed the science of stratigraphy–looking at each layer in a given site and recording artifacts from the layers to provide some sort of historical sequence–which before his excavations had been used only once, by Heinrich Schliemann at Troy.[8]

A Brief Timeline of Important Discoveries and Events in Egypt

Once Napoleon's army of savants had completed their investigation of Egypt, others traveled there, some curious to see what they could find, others eager to carry off what they had found. Discovery followed discovery. Excavators uncovered Twelfth Dynasty jewelry, the tomb of a First Dynasty queen, royal mummies stashed together in a tomb to keep them safe from ancient tomb robbers, the famous bust of Queen Nefertiti, culminating with the discovery to end all discoveries: the largely unplundered tomb of Tutankhamun, found exactly one hundred years after Champollion first announced that he had deciphered ancient Egyptian hieroglyphs.

This timeline includes some of the discoveries and events in Egypt that fueled popular imagination around the world and led to a fascination with Egypt–known in France as *Egyptomanie*[9] that has inspired numerous revivals:

1799 The Rosetta Stone, which eventually unlocks secret of Egyptian hieroglyphic writing, found by Napoleon's army in the Nile Delta.

1802 Artist Dominique Vivant Denon, a member of the team of scholars and scientists accompanying Napoleon on his Egyptian adventure, publishes his *Voyage dans la basse et la haute Égypte (Voyage in Lower and Upper Egypt)*, published in English in 1803 as *Egypt*.

1809-1828 The scholars and scientists who accompanied Napoleon on his Egyptian expedition publish their findings, maps, and drawings in the monumental *Description de l'Égypte*.

1822 Jean François Champollion (aided by Englishman Thomas Young's insights) deciphers ancient Egyptian hieroglyphs.

1842-1845 German Egyptologist Karl Richard Lepsius leads an expedition to Egypt and Nubia, the results of which are published in twelve volumes called *Denkmäler aus Aegypten und Aethiopien*, hailed as one of the greatest studies in the history of Egyptology. The expedition also collected (and shipped back to Berlin) some 15,000 objects.

1856 The English Aesthetic Movement's Owen Jones publishes his seminal *Grammar of Ornament*, which includes, among other things, numerous plates featuring designs based on ancient Egyptian art and architecture, suggested for use in Aesthetic works.

1859 The Egyptian Antiquities Service, in its first year of operation under French archaeologist Auguste Mariette, discovers the Eighteenth Dynasty tomb of Queen Aahhotep at Dra Abu Naga, on the west bank of Thebes; her mummy is found to contain her personal jewelry, which Mariette secures for the Cairo Museum.

1869 The Suez Canal opens, and the attendant publicity creates a wave of Egyptomania in the United States.

1871 Giuseppe Verdi's opera *Aida*, commissioned by Egypt's Khedive Ismail Pasha and based on a story by Egyptologist Auguste Mariette, premieres at the Khedivial Opera House in Cairo to instant acclaim.

1894-1895 Excavations at the city of Dashur by Egyptian Antiquities Service director Jacques de Morgan reveal jewelry belonging to Egyptian princesses of the Twelfth Dynasty.

1901-1903 Egyptian jewelry dating back to the First Dynasty is found by British archaeologist Flinders Petrie at Abydos, and by American excavator George Reisner at Nag ed-Der, north of Abydos.

1904 The tomb of Yuya and Tuya (probably the parents of Amenhotep's Great Royal Wife Tiye, and thus possibly the grandparents or great-grandparents of Tutankhamun) is found in the Valley of the Kings on the west bank of Thebes; it contains a number of interesting objects, including lavishly decorated furniture.

1912 German Egyptologist Ludwig Borchardt discovers the famous bust of Queen Nefertiti in an Amarna (the heretic king Akhenton's capital city) sculptor's workshop. Due to various factors including the outbreak of World War I, the bust is not exhibited until 1924.

1914 Flinders Petrie and colleague Guy Brunton discover jewelry, overlooked by ancient tomb robbers, belonging to Twelfth Dynasty princess Sithathoriunet at Lahun.

1922 British excavator Howard Carter, backed by the Earl of Carnarvon, discovers the almost intact tomb of Tutankhamun.

The reading public was kept abreast of these new discoveries by the press. In the United State, *Scientific American* published a series of special supplements on Egypt (and other topics); but even such everyday magazines as *Harper's* carried features on excavations in Egypt. Some of these stories contained fairly detailed descriptions, especially of jewelry and other valuable items. For example, in 1896, Jacques de Morgan reported in *Harper's* the results of his excavations at Dashur. Especially noteworthy was the discovery of jewelry in the tombs of four Twelfth Dynasty princesses, which before the discovery of Tutankhamun's almost totally undisturbed tomb had provided the single largest discovery of ancient Egyptian jewelry. de Morgan described his find:

> The tombs of the four princesses were unequal in the richness of their contents, the most sumptuous being that of Khûmit [Khnumet], princess of the royal line, who, judging by her funerary accompaniments, must have occupied a very important situation at the court of Amenemhat II who probably was her father. On the mummy of this lady I found the ornaments habitual to her—a large necklace, composed of beads of gold, silver, carnelian, lapis lazuli, emeralds, of hieroglyphic signs in gold crusted with precious stones; anklets, bracelets, and armlets, and similar small objects. ... In the coffin itself to the left of the mummy, lay the sceptres, the canes, the arc, the flagellum, and the mace, ornamented with plates of gold. ...The coffin itself was of wood laminated with gold.
>
> There were crowns, diadems, necklaces, pendoloques, in gold filigree, a gold vulture, and a multitude of different gold objects ornamented with gems....

Khnumet's tomb also yielded alabaster vases, small writing tables, and a swan "of natural size" carved in wood. The tombs of the other three princesses also contained jewelry and other decorative items, but "these were less beautiful than those that had belonged to [their] neighbor in execution..."

In 1915, Sir William Matthew Flinders Petrie reported, in a supplement of the *Scientific American*, on another significant find. This included the jewelry and other items discovered in a Twelfth Dynasty burial at Lahun. Like those of the royal princesses at Dashur, the tomb–or rather pyramid–containing the coffin of Princess Sithathoriunet yielded a remarkable cache of beautifully made Middle Kingdom crowns and necklaces, bracelets and armbands. Petrie described some of these pieces:

> In the midst of the recess lay the crown: the tall plumes of gold and the three double streamers of gold all lay down flat, with the crown between them. ...The crown is a broad band of brilliantly burnished gold, with fifteen beautifully inlaid rosettes of gold around it, and in front of it the royal cobra of gold inlaid, the head of [lapis] lazuli....
>
> The next most striking objects are the great collars of gold cowries and gold lion heads. ... Two beautifully wrought pectorals are of gold inlaid with minute pieces of carnelian, turquoise, and lazuli. In the pectoral of Senusert there are 372 separate stones inlaid. ...
>
> A great necklace of long drop-beads must have been worn hanging below the other jewelry. The pendants are of gold, carnelian, lazuli, and amazon stone [amazonite]. From the middle hangs the most splendid scarab known ...in the richest lapis lazuli. ...
>
> Four wristlets each have a pair of gold lions, face to face, upon strings of gold, carnelian and turquoise.
>
> The toilet was provided for by a large silver mirror, with a handle of obsidian, and gold head of the goddess Hathor; a pair of razors with gold handles; and three jars for ointment made of black obsidian with gold mounting around the base, the brim, and the lids.

Descriptions such as these, along with photographs of spectacular new finds, filled the pages of publications such as *The Jewelers' Circular*, and fueled the imaginations of jewelry and other designers. Advertisements and other materials show the continuing popularity of ancient Egyptian motifs in everything from jewelry to architecture. Fiction, too, catered to those interested in ancient Egypt, with even such noted authors as L. Frank Baum (probably best known for his novel *The Wizard of Oz*) writing books set in Egypt.

A 19th century photograph of a fallen colossal statue of a Thirteenth Dynasty pharaoh, akin to the statue of Ramesses II that inspired Percy Bysshe Shelley's poem "Ozymandias." From Amelia Edwards, *Egypt and Its Monuments*.

21

A full page from a supplement put out by *Scientific American* in August, 1915. The page shows a number of pieces of Princess Sithathoriunet's Twelfth Dynasty jewelry found at Lahun. *Courtesy of Shelly Foote.*

An advertisement for a suite of jewelry in the Egyptian revival style by the notable New York jewelry firm Ball, Black & Company. (This company was one of the few American jewelry makers to exhibit at London's Crystal Palace Exhibition in 1851, and was at the time New York's leading jewelry firm.) The ad appeared in the September, 1868 edition of *Demorest's Monthly Magazine. Courtesy of Shelly Foote.*

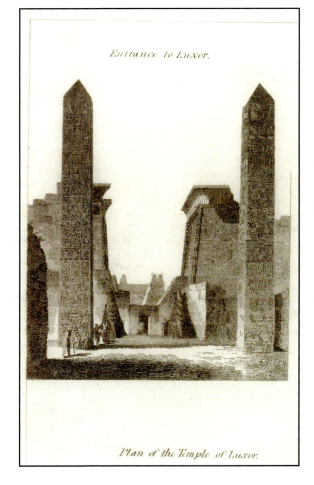

Part of a larger 19th century architectural drawing, possibly taken from the *Description de l'Égypte* published by the savants who accompanied Napoleon's army to Egypt. The drawing shows obelisks at the entrance to the Temple of Luxor; other drawings in this print show a plan of the temple and a tomb. The print was purchased in an online auction for approximately $25.

A page from what appears to be a French edition of Owen Jones' influential *Grammar of Ornament*. It is the same as his plate VI, but has a French heading and French captions. This was purchased in an online auction for approximately $48.

A drawing of Nebthys, after an element in one of the pectorals found in Tutankhamun's treasure. A pattern similar to the reticulation on her dress can be found among Owen Jones' Egyptian designs. Although Tutankhamun's tomb was discovered almost 75 years after Owen Jones published his *Grammar of Ornament*, similar net-like patterns were depicted on dresses worn by goddesses in ancient Egyptian art, such as in scenes from The Book of the Dead.

Drawings of some of the patterns from Owen Jones' *Grammar of Ornament*. These include a number of stylized lotus blossoms, as well as geometric patterns, sometimes with both combined.

Frontispiece of L. Frank Baum's Egyptian novel, *The Last Egyptian A Romance of the Nile*, published in 1908.

Icons of Egypt: Nefertiti and Tutankhamun

While each new discovery fed the obsession with ancient Egypt that gripped nineteenth and early twentieth century Europe and America, two of the most iconic discoveries were, interestingly enough, those associated with a strong-willed queen and her short-lived son-in-law. One became known through a modest–yet ultimately very compelling–limestone bust; the other through the most amazing cache of burial goods ever uncovered.

"The Beautiful Woman Has Come"

And the heiress, great in the palace, beautiful of face, adorned with the double plumes, mistress of joy endowed with favors, at whose voice when he hears [it] the king rejoices, the Great Royal Wife whom [the king] loves, the Mistress of the Two Lands, Neferneferuaten Nefertiti, may she live for ever and ever.
Paean to Nefertiti, found on the boundary stelae
of Akhenaton at Akhetaton (Tel el-Amarna)

She has been called "the second most famous woman in ancient Egypt" (the first being, as might be expected, Cleopatra). Yet very little is really known about her, as opposed to conjectured about her. With few clues to her origins (she apparently was, if of royal Egyptian blood, of *minor* royal blood), even her name, which literally means "The Beautiful Woman Has Come," lent itself to speculation: It was at one time taken as an indication that she was a foreign princess dispatched to Egypt for a political alliance with the pharaoh.

A more recent guess is that she was either the daughter or granddaughter of Yuya and Thuya, two nobles whose joint tomb was found in the Valley of the Kings in 1904. Possibly her father was Ay, whose title "God's Father" indicates some sort of connection with the royal house, and perhaps he was the son of Yuya and Thuya (and perhaps the brother of Amenhotep III's Great Royal Wife, Tiye). Or possibly, given what we know of royal bloodlines during the Eighteenth Dynasty,[10] she was the daughter of Amenhotep III and a minor queen.

Nefertiti was among the most powerful women in a dynasty noted for its strong women (including Hatshepsut, who as regent for her nephew usurped the throne and ruled as a female pharaoh). When her husband changed his name from Amenhotep (he was the fourth pharaoh of that name) to Akhenaton, abandoned Thebes and its powerful god Amun, and founded a new religion and a new capital city, she was depicted as his equal partner. In the new capital, Nefertiti appeared with Akhenaton on temple walls and in the tombs of noblemen; pillars bore her image in a "Nefertiti colonnade"; her name was engraved on the royal boundary stelae. With her husband, she adored the solar disk Aton and received its life-giving rays. She was depicted with her children; she and Akhenaton had several daughters–the third of whom, Ankhesenamun, married Tutankhamun. She wore a crown unlike any worn by queens before her: a high flat-topped blue crown thought by some to be a very modified version of the royal blue war crown. As Egyptologist Donald B. Redford notes (1984: 79):

> It is hard to avoid the conclusion that this high profile which Nefertity enjoyed in the first five years of the reign is evidence of her political importance. But beyond this simple statement of suspicion it is folly to proceed. We must admit that we know nothing about her at this point, and it is therefore idle to speculate about the nature of her power.

And then she disappeared. No one knows if she died, was supplanted, or even if she changed her name and assumed the guise of a male in order to reign with Akhenaton as co-regent. When Akhenaton died, and his heresy died with him, his name and hers were both excised in an attempt to destroy all remaining traces of their reign.

Ultimately, then, what has caught our collective imagination is really her timeless beauty, shown in the famous bust discovered in a sculptor's workshop that was abandoned when Akhenaton died and his successor Tutankhamun restored the old religion and deserted Akhetaton for Thebes.

And her name: The Beautiful One Has Come.

A group of charms in various karats of gold, of Nefertiti's famous bust in profile. Such charms, both new and vintage, are easily found online and seem to sell for $10-$120, largely depending on karat content and size.

A pair of costume earrings in the form of Nefertiti's profile, probably c. 1970s-1980s. These have minimal value, and are included merely to show how often Nefertiti's profile shows up in jewelry.

A bust of Nefertiti by the German Goebel company, which is probably best known for its figurines based on the art of Sister Maria Innocentia (Bertha) Hummel. This is the standard-issue Nefertiti, very similar to most other reproductions of her famous bust, and like them in restoring her missing left eye. Goebel is only one of a number of companies to create reproductions of this bust; others are Rosenthal (one by them sold recently for slightly under $200 in an online auction) and McCoy. This one sold for approximately $45 in an online auction. It is marked on the bottom with a stylized bee inside a V.

A brooch in silver, enamel, and marcasites, of Nefertiti's bust. Similar brooches appear frequently online, often in base metal but also in silver and, very occasionally, gold. *Courtesy of Robin Allison.*

A green-glazed bust of Nefertiti attributed by its seller to either Haeger or McCoy (the seller claimed that both had made "similar" busts), although it is unmarked. It stands about 7" high, and was bought in an online auction for $20.

A pendant in 800 silver and glass, with at the center the bust of Nefertiti, always recognizable in profile because of her unique blue crown. Here she is flanked by glass scarabs and dots in turquoise, the scarabs very likely being from Czechoslovakia. Undated, but likely mid-century or slightly earlier. Marked for silver content; measures 2.125" in diameter. This was purchased online for approximately $35.

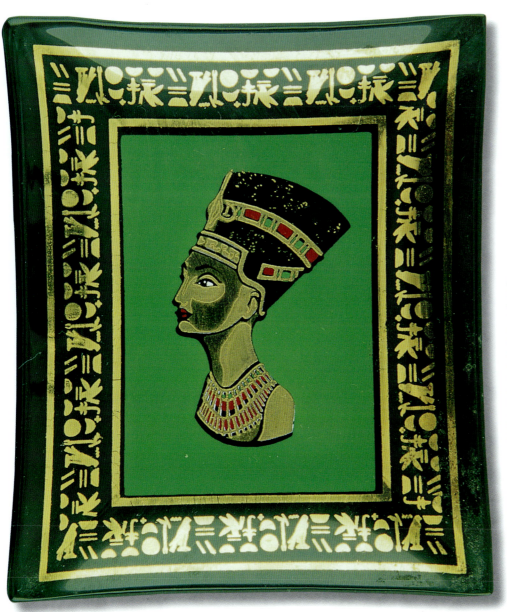

A small glass dish decorated with Nefertiti's bust, bordered by a design of hieroglyphs. This was most likely made in Egypt as a tourist souvenir, or for export to Europe or the United States. The seller, adopting the conventional wisdom of the two Egyptian revivals, assumed that this was made during the 1920s or 1930s, but it could easily be much later. Unmarked; measures 2.75" x 3.25". It has a minimal value, and was bought more to show how easy it is to find renditions of Nefertiti's portrait.

A necklace by noted costume jewelry designer Miriam Haskell, featuring a pendant in the form of the mask of Tutankhamun on a gold-plated mesh chain. Although much of Haskell's jewelry, including her Egyptian revival pieces, is very collectible, this is not representative of her most interesting work, which often includes elaborate beading, fringe, faux baroque pearls, or clusters of glass flowers. One intricate "Egyptian revival" fringe necklace by Haskell had a dealer's asking price of $1200. A reasonable price for this necklace might be in the $45-$125 range, with $125 reflecting a dealer's price. Marked MIRIAM HASKELL in cartouche on pendant's reverse.

A small charm in 800 silver and enamel, showing a seated pharaoh identified as Tutankhamun but otherwise looking much like any other enthroned pharaoh. This may have been produced as a tourist souvenir in Egypt, but this is purely a guess. Based on its style, this charm probably dates to c. 1930. Marked for silver content and approximately .875" long, it sold for about $35 in an online auction.

A pendant carved from rhodochrosite in the form of Tutankhamun's burial mask, n.d. This was sold as Art Deco, and might possibly date from c. 1930, but there is really no evidence to support this; the vendor assumed it was Art Deco merely because of the conventional wisdom about the "two Egyptian revivals." This was purchased for about $250 from a high-end dealer, but online might sell for considerably less.

An ovoid pendant by Edgar Berebi, who designs everything from fancy picture frames and jeweled boxes to silverware and stemware to costume jewelry. Here the same sensibilities at work in his ornate frames and boxes led him to create an Egyptian revival pendant with Tutankhamun's gold mask on one side, and a falcon possibly based on a pectoral from the Boy King's treasure, in gold-plated metal accented with blue enamel and a rhinestone. Although Berebi's creations seem to sell for a fair amount new, this was purchased second-hand for about $30. Signed by Berebi, measures about 1.5" in length.

Egypt Revived

The production of jewelry closely imitating the ornaments in gold and precious stones of earlier ages, is now a firmly established industry in Rome.
Alessandro Castellani, *Revival of Antique Jewelry* (1878)

In the atmosphere of 19th century jewel design, the Egyptian influence was part of a far-reaching revival of archeological styles such as Etruscan and Assyrian, a revival that had been sparked off by recent archeological finds. Today, we probably take our well-supplied museums a little for granted, but if you imagine the impact of the first astounding discoveries at Pomepii, Heculaneum, Nineveh, and Egypt, it is easier to understand this feverish passion for ancient metalwork. The craze for Egyptian revival jewels is kept alive by intriguing explorations in the early part of the 20th century, and the fashion reached its height of glory after the discovery in 1923 [sic] of Tutankhamun's tomb and the most beautiful of all ancient Egyptian jewels.
Vivienne Becker, "Egyptian Revival Jewellery" (1978)

Egypt was among the first of the ancient civilizations to be revisited by modern scholars. But by 1913, when Baikie wrote "The Resurrection of Ancient Egypt," others had joined the ranks of the rediscovered. Pompeii and Herculaneum, victims of the eruption of Vesuvius, had long since been uncovered. So had Etruscan tombs at Caere, Tarquinia, and Vulci, and the Greek colony of Cumae. British archaeologist Henry Layard had excavated in Mesopotamia (1845-1847), publishing *Ninevah and Its Remains* (and, in 1855, following that work with *Discoveries in the Ruins of Ninevah and Babylon*). Heinrich Schliemann, having found what he and the world hailed as the remains of Troy, went on to discover the "Gold of Agamemnon" at Mycenae, and in 1877 published *Mycenae*, his account of that excavation. Sir Arthur Evans had in 1900 begun his decades-long work on Minoan Crete, unearthing by 1903 among other things the great palace at Knossos. Many of these discoveries contributed to the desire for jewelry in the archaeological revival styles so prevalent during the mid- and late Victorian periods.

In some cases, poking fun at the various revivals proved irresistible, as this drawing from *Harper's*–which touts a "fall fashion" in the Egyptian style–demonstrates. The fashionably dressed Egyptian revival woman, wearing an outfit decorated with pyramids, sphinx, obelisk, temple, crocodile, and camel, is shown complete with Middle Eastern—garbed pageboy and a pharaoh hound. *Courtesy of Shelly Foote.*

The Age of Revivals

As Alessandro Castellani and Vivienne Becker noted, writing a century apart, the nineteenth century was not merely an age of discovery–it was also the age of revivals. Etruscan revival, Renaissance revival, Gothic revival, Greek revival, and Assyrian revival jewels were all created in a century that seemed, to some sensibilities at least, almost devoid of inspired design.

The fad for revival jewelry appears to have begun with the Etruscan revival pieces created by Alessandro Castellani's father Piu Fortunato Castellani, who is said to have recreated the lost Etruscan art of granulation. But he was not alone in finding inspiration in jewelry of the past. The great French goldsmith and jeweler Eugène Fontenay, together with his talented enamelist Eugène Richet, created Classical revival jewelry including a famous pendant depicting a chimera. Gothic revival jewelry was created with great care and beauty by French jewelers Alexis and Lucien Falize, working with enamelist Antoine Tard; Lucien Falize likened some of his jewels to Medieval illuminated manuscripts. Renaissance revival jewelry, somewhat lighter and airier than the Gothic and Classical revivals, was made notably by Carlo Giuliano, a former partner of the Castellanis who traveled to London to open a branch of their firm, but while there struck out on his own.

A wonderful demi-parure attributed to the great 19th century French goldsmith and jeweler Eugène Fontenay and his gifted enamelist Eugène Richet, in 18K gold, enamel, and pearls. Pendant/brooch and earrings are decorated with scenes of a Classical woman, most likely the Greek goddess of love Aphrodite, accompanied by cherubs representing her son Eros (the Roman Cupid). This set shows the fine level of workmanship achieved by jewelers who recreated techniques from ancient lands such as Etruria in their production of archaeological revival jewelry. Such a demi-parure, if it could be found today, would very likely sell for $5000 or more. *Courtesy of Robin Allison.*

A Victorian cameo set in 18K gold with enamel and pearls, with a Classical scene. Cameos, found in Graeco-Roman jewelry, enjoyed unprecedented popularity with the Victorians and seem to be the most pervasive form of Classical revival jewelry. Motifs found on these cameos range from the Classical, as here, to the Biblical, such as the popular "Rebecca at the Well" cameos, to contemporary Victorian portraits of loved ones or lost ones. Measures 2.625" across; French hallmarks. This brooch if offered by a dealer might have an asking price of around $2000-$3000. *Courtesy of Robin Allison.*

A pendant in 18K gold, enamel, ruby, and pearl, by the famed Italian-English jeweler Carlo Giuliano, in the Renaissance revival style that became popular when the fashion for heavier Gothic and Classical archaeological jewelry began to wane. This pendant, with its enameling in white shading subtly from pink through green, is eminently wearable, much lighter than other revival jewels. *Courtesy of Nelson Rarities, Portland, ME.*

A pair of earrings in 18K gold, enamel, and seed pearls, in what has been described as Etruscan revival (probably alluding to the filigree work) but also containing elements of Renaissance revival in the floral inserts. Unmarked, but very likely French c. 1880; measure 1.5" in length. These earrings might be expected to bring $500-$1200, depending on whether they are offered at auction or by a dealer.

"The Two Egyptian Revivals"

It is often said that there were two Egyptian revival periods in the decorative arts. The first, supposed to have begun around 1870, coincided with–and was inspired by–the opening of the Suez Canal. The second, which purportedly began with the discovery of Tutankhamun's Eighteenth Dynasty tomb by Howard Carter in 1922, roughly coincided with the Art Deco period. And in fact, Egyptian revival jewelry is often recognized as a distinct subset of Art Deco jewelry in general, although it should be noted that jewelry publications of that period make it clear that *all* of Art Deco jewelry in the 1920s owes a good deal to Egyptian influence.[13]

However, research done by co-author Shelly Foote for her master's thesis, with a focus on primary sources such as (primarily American) advertisements and articles written between 1870 and 1978, shows this to be an oversimplification. Decorative items in the Egyptian revival style remained popular throughout the end of the nineteenth century and into the twentieth century, long after the opening of the Suez Canal and well before the discovery of Tutankhamun's tomb. Advertisements such as the ones shown below provide ample illustration of the abiding use of Egyptian motifs such as the winged scarab. Each new find, it seems, triggered renewed interest in things Egyptian. Given the wealth of finds–royal jewels belonging to Aahhotep, Khnumet, Sithathoriunet, queens and princesses whose names had for millennia been forgotten; the interesting tomb of Yuya and Tuya; the bust of Nefertiti; First Dynasty burials at Abydos–there was never time to exhale, move on to the next big craze, and forget entirely about Egypt.

And interest was not piqued by new discoveries alone. Exhibitions such as the World's Fair in New York and the Columbian Exposition in Chicago, both of which included Egyptian pavilions; special exhibits of Egyptian jewelry at the Metropolitan Museum of Art; lecture tours by excavators: All of these fueled the unwavering flame of Egyptomania.

This tendency continued well after the Art Deco period. It outlived the Great Depression and World War II. A new burst of Egyptian revival enthusiasm, especially seen in costume jewelry, accompanied the release of the 1962 movie *Cleopatra*, with Elizabeth Taylor in the title role. Another, even more widespread outburst accompanied the late 1970s tour of Tutankhamun's treasures in the United States. The 1980s exhibit on the great Nineteenth Dynasty builder Ramesses II also provided opportunities for museums to sell, and enthusiasts to purchase, Egyptian revival jewelry. Although it may have peaked and waned during the course of the two centuries that followed Napoleon's quixotic invasion of Egypt, the use of Egyptian revival motifs in design never totally went out of fashion. Like the mummy in a bad horror movie, Egyptian revival simply refused to die.

New-York Historical Society.
LECTURES ON EGYPT: 1864
CONCLUDING LECTURE BY
PROF. HENRY J. ANDERSON, LL. D.,
HALL OF THE UNION, COOPER INSTITUTE,
Thursday, December 15th, at 7½ o'clock, P. M.

To be followed by the
Unrolling of the Mummy.
TICKETS . . . 50 CENTS.

As this advertisement for a lecture (part of a series) on ancient Egypt shows, interest in Egypt flourished before the opening of the Suez Canal in 1869. We who live in the entertainment-saturated 21st century sometimes forget that before radio, movies, television, DVDs, iPods, and computers, people turned to lectures, museums, readings by famous authors such as Charles Dickens, and concerts for entertainment. As late as the 1930s, many academics and world travelers were able to supplement their modest incomes by embarking on the lecture circuit. Learned talks such as this one on "Unrolling the Mummy" both fed and were fed by the great interest in new discoveries made during the 19th century. *Courtesy of Shelly Foote.*

A brief note, with a sketch, of Egyptian revival jewelry in *Demorest's Monthly Magazine*, July, 1866–another reminder of the interest in Egyptian motifs before the opening of the Suez Canal. The demi-parure shown here is adorned with the head of an Egyptian wearing the striped *nemes* headdress–a motif that was to appear again and again throughout the rest of the 19th and into the 20th centuries. *Courtesy of Shelly Foote.*

JEWELRY.

Egyptian Set.—This striking and entirely novel design is executed in matted gold and bands of red and white enamel. . . .

Apparently Egypt was, or so manufacturers apparently believed, a symbol of enduring good taste–as this 1906 ad for Egyptian Deities cigarettes seems to imply. Not all of this company's ads displayed Egyptian themes, but in this one the Avenue of the Ram-headed Sphinxes at Luxor is used to tout cigarettes that were "Still highest in quality; still most renowned, now, as for years, the choice every-where for connoisseurs."

The October 5, 1898 issue of *The Jewelers' Circular and Horological Review*, with the cover devoted to "Characteristics of Egyptian Jewelry." It includes, among other things, drawings of small charms or amulets in the form of gods, a winged creature that appears to be a cross between a bird and a winged scarab, and the gold flies with which pharaohs rewarded generals and courtiers. During the 19th century, many jewelers took inspiration from jewels of the past in creating their own revival pieces. *Courtesy of Shelly Foote.*

The bad news is that, given this continued fascination with ancient Egypt, it is much more difficult to date items to a specific period. This seems especially true of mid-century Egyptian revival, from c. 1935 to 1965, but is also true of earlier pieces. The tendency has been for sellers to label everything later than c. 1910 as Art Deco, and anything before that as Victorian. However, as pieces and advertisements shown below indicate, there was a flourishing trade in Egyptian revival pieces during the last four decades of the nineteenth century and into the first decades of the twentieth century. In a few cases, dates are present on objects, such as clocks and china, making age easy to establish. Some manufacturers, such as British makers of sterling silver items, dated their pieces using a set of letters stamped on the item along with a mark indicating country and city of manufacture; in the United States, occasionally a patent date is given. Often, though, it is necessary to rely on outside sources for an exact, or even an approximate, date. It appears that in some cases advertisements are one of the most useful means of establishing a date; one example is the ad for the sterling silver winged scarab brooches made by the Massachusetts-based Shepard Company (for which please see chapter three, under that maker). In other instances, where no marking or advertisements are available, one must depend on fairly flimsy methods such as overall style (often not incredibly useful in objects that reprised certain motifs over and over again); materials, such as the use of Bakelite or Galilith, which were only used during a certain period; and the presence of a c-clasp as opposed to a modern safety clasp or the use of an old-fashioned t-pinstem on brooches, to try to determine age.

A porcelain vase, labeled by its seller "Paris porcelain" though there seems to be no evidence in support of this appellation, embellished with the head of an Egyptian queen wearing the vulture headdress reserved for certain goddesses and the Great Royal Wife. Although no attribution has been made, the queen looks as if she might be based on a painting by a "Classical" artist such as Sir Lawrence Alma-Tadema, known for his paintings with Graeco-Roman and Egyptian themes. The decoration was very likely applied using a transfer (or the transfer process developed for Battersea enamels), although the seller seemed positive that it was handpainted. The dealer who sold this vase stated that "there were two surges in Egyptian revival, the first from 1860-1870 and the second c. 1920." He opined that it belonged to the second Egyptian revival–meaning that it was Art Deco. However, nothing in the vase itself, which is unmarked, or the style of the vase leads to a firm date; and presumably it could have been produced any time from the late Victorian period on into the mid-century. The aim of its maker, to create an item with an antiquarian theme, also seems to lend a certain timelessness to the vase. It measures approximately 7.5" high, with a diameter of 4.5". It was purchased for about $50 in an online auction.

A pearl ware plate, c. 1820, with a hodge-podge of Egyptian motifs in white against blue done by transfer printing. Among the motifs are a winged scarab, several versions of the sphinx (two being winged and female and thus essentially Greek), a crocodile, birds, dogs, vases and jars, a squiggly serpent, a caduceus, the head of a man wearing a Greek or Roman helmet, a reed leaf (like the hieroglyph for **i**), a possible obelisk. Perhaps some of these motifs were intended to simulate hieroglyphs. Mainly this profusion of patterns shows the inability of those first confronted with Egyptian motifs to separate them from Classical designs–at times a not unjustified mingling, as some Greek elements—such as the sphinx—were borrowed directly from Egypt. The Greek key border, borrowed from Classical design, is not infrequently found in Egyptian revival items. The plate measures 9.75" across, and is unmarked. It sold at auction for approximately $120, primarily based on its age and condition, which is very good, with only one small chip on the rim.

A wonderful bracelet in 18K gold, diamonds, emeralds, pearls, rubies, and sapphires, probably French c. 1870. The central element of the bracelet is a scarab (possibly winged, if the design in diamonds to either side of its body represens wings), its body in emeralds edged by sapphires, with ruby eyes, pushing pearl "orbs" with its front and hind legs. On either side are what appear to be stylized lotus blossoms in emeralds. The bracelet can be dated by the cut and setting of its stones and other stylistic details to the mid- to late Victorian period. If it were to come on the market, this bracelet would probably have an asking price in the $10,000-$12,000 range. *Courtesy of Robin Allison.*

An advertisement for Rogers, Smith & Company, from 1889. The ad features a lamp base (or, possibly, a candlestick or epergne base) with a sphinx (here wearing the vulture headdress associated with Egyptian queens and the goddesses Isis and Hathor).

A base for a gas lamp (or, less likely, a candlestick) in gilded cast iron, probably c. 1880s; this piece is unmarked but likely of American manufacture. It features the head and shoulders of a pharaoh wearing the *nemes* headdress and a broad collar, with a faux hieroglyphic inscription on the torso. It is decorated with four heads at each corner, possibly meant to represent sphinxes but wearing head-coverings studded with raised stars. Measures 7.5" tall and 6" across at the base, and is in excellent condition except for a piece of the glass shade lodged in the opening; it sold for approximately $250 in a spirited online auction.

An advertisement in *The Jewelers' Circular–Weekly*, October 20, 1909, featuring among other designs a winged scarab in 10K gold. This type of brooch appears fairly frequently at auction, and is usually labeled "Victorian"; however, it is clear from this advertisement that this was made almost a decade after Victoria's death. Very likely similar brooches were made over the course of a number of years. *Courtesy of Shelly Foote.*

A brooch in 18K gold and faience, with a winged scarab flanked by serpents. It is possible that many of these winged scarabs with serpents were based on winged solar disks, which often appear in ancient Egyptian art and architecture with serpents on either side. Similar brooches are found very often online, and are almost invariably described as "Victorian." However, the advertisement showing a similar brooch is from 1909, casting doubts on a "Victorian" date of manufacture. Unmarked. These brooches seem to sell most often in the $200-$350 range, though they occasionally have higher asking prices when offered by dealers.

An Arts and Crafts Egyptian revival piece in sterling silver, enamel, mother-of-pearl, and pearls, this one in the form of a very stylized winged scarab–identifiable as such by the pearl "orb" pushed by its front legs. While this pendant is unmarked, it likely dates to the end of the 19th or the beginning of the 20th centuries, based on overall style, enameling, and execution. It measures 1.75" across, and was purchased in an online auction for approximately $390.

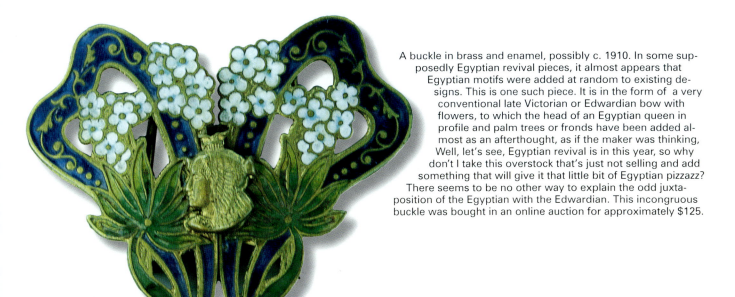

A buckle in brass and enamel, possibly c. 1910. In some supposedly Egyptian revival pieces, it almost appears that Egyptian motifs were added at random to existing designs. This is one such piece. It is in the form of a very conventional late Victorian or Edwardian bow with flowers, to which the head of an Egyptian queen in profile and palm trees or fronds have been added almost as an afterthought, as if the maker was thinking, Well, let's see, Egyptian revival is in this year, so why don't I take this overstock that's just not selling and add something that will give it that little bit of Egyptian pizzazz? There seems to be no other way to explain the odd juxtaposition of the Egyptian with the Edwardian. This incongruous buckle was bought in an online auction for approximately $125.

A winged scarab in silver, champlevé and plique-à-jour enamel, an amethyst, and small pearls. Interestingly, until recently this brooch would probably have been marketed as a "suffragette" piece, as it contains the colors green, white, and purple (or violet), the first letters of which were said to have formed an acrostic for **G**ive **W**omen **V**otes. However, an article in the *Maine Antique Digest*, available online, has challenged the assumptions and claims behind such attributions. First of all, these colors are frequently found in jewelry of the late Victorian and Edwardian periods because they happened to be especially popular at the time. Second, while these colors were used by some suffragette organizations, especially Great Britain's Women's Social and Political Union (WSPU), the colors were never intended to be shorthand for "Give Women Votes," but rather had their own special symbolic significance: White stood for purity, purple (*not* violet, as is often claimed) for nobility, and green for hope. If this were a suffragette piece, then one might assume it was made before 1919, when women finally achieved the right to vote. However, even if it is not, it still probably dates to c. 1910, when the colors found in it were very popular. And finally, it should be noted that the WSPU *did* use the Egyptian ankh–in suffragette colors–on buttons. Therefore, there is a remote possibility that they might have chosen another Egyptian symbol, the scarab signifying coming into being, to represent their cause. This brooch was purchased for $400 from a dealer online.

A stickpin in 14K gold, enamel, and an emerald, in the form of the head of a pharaoh wearing a *nemes*-style headdress, here indicated by red and white enamel and lacking the customary stripes. An emerald presumably takes the place of the usual uraeus serpent. Marked 14K MEYLING (with Meyling being a best guess, as the imprint is faint and hard to read). The pharaoh portion of the stickpin measures approximately .5" long. Although there is no date, this may be c.1900, when stickpins of this type were much in fashion, and when American makers had started to sign their pieces. This stickpin might sell in the $200-$300 range at auction, or for $400-$600 from a dealer. *Courtesy of Red Robin Antiques.*

A large Egyptian revival necklace in silver, lapis lazuli, pastes, and a pearl, attributed–probably wrongly–by its seller to Piels Frères, possibly c. 1910. The necklace, with Egyptian faces and lotus blossoms, has overall an Art Nouveau or Arts and Crafts look, thus making a date in the early 20th century feasible. It was purchased for $1200. *Courtesy of Robin Allison.*

An unusual brooch in enamel on an unidentified material (possibly silver, as it seems to be tarnished where the counter-enamel on the back has worn away), set into a frame that appears to be gold or gold-filled. The enameling depicts an Egyptian woman holding a quill and papyrus; she wears a striped headdress and a turquoise skirt done in foil (as is the quill's plume, which is a darker blue, the colors typical of revival pieces). This appears to be a hand-made piece in the Arts and Crafts tradition–the nicely detailed Limoges-like enamel, with its underlying foil, leads to this attribution–set in a decent frame that is probably not hand-made. The frame has the trombone catch that was popular during the early part of the 20th century (but which was used in same places, such as Latin America, into the mid-century), especially in non-costume jewelry. Unmarked; measures 1" in diameter. The background matte black enamel has cracked and in a few places near the edge is chipped, although this is primarily visible under magnification. It's difficult to place a price on this one-of-a-kind piece, but given the damage, it should probably sell for about $25-$50; in better condition, a price of $75-$125 would not be unreasonable.

A buckle made in the plastic known as galilith, c. 1920-1930. The buckle, in the bright colors associated with Art Deco Egyptian revival, has the face of an Egyptian wearing the striped *nemes* headdress often associated with Tutankhamun's gold burial mask, surrounded by blue and red dots and triangles. Measures approximately 2.5" in diameter, unmarked; sold for around $50 in an online auction.

Maybe it was the association with Thebes and Tutankhamun. Maybe it was the sound of the name Luxor, so similar to luxurious, so suggestive of wealth and power. Whatever the reason, the discovery of Tutankhamun's tomb led to a number of manufacturers naming products that had little to do with ancient Egypt, or Egyptian design, after the city that once was Thebes. Among these was the Alvin Company, makers of silverplated wares. Presumably here the association, aside from the inspiration derived from the art of ancient Egypt, is that of long-lived monuments with long-lasting silverplate.

Tutmania

Arguably the decade that saw the most fervent outbreak of Egyptomania was that which followed the discovery of Tutankhamun's tomb in 1922. There may be several reasons for this, including the unprecedented wealth–in terms of both number of objects and their intrinsic value–of the find; the fact that the discovery coincided with a period of affluence, the "Roaring Twenties"; the ennui that afflicted many after the end of the senseless and bloody Great War; and the sensationalism of the press. Before, the press's role had been, in many cases, as an objective reporter of discoveries, though sensationalism was also present in a number of earlier reports. However, the sudden death of Lord Carnarvon from an infected insect bite–untreated, it proved fatal in Egypt's somewhat unsalubrious climate–unleashed a riot of inventive stories about the "Curse of Tutankhamun" which, along with the sensational nature of the discovery, assured that it would not soon be forgotten.

As the advertisements below illustrate, manufacturers were not shy about listing the discovery of Tutankhamun's treasure as the source of their inspiration; in fact, it almost seems that mention of the Boy King's name added a certain cachet to the wares being advertised. New designs for jewelry, silverware, bookends, dresses, hats, buttons, shoes all emerged in the years immediately following Carter's find, many of them said to have been inspired by the discovery at Luxor.

A demi-tasse spoon by the silverware manufacturer Wallace, probably c. 1925, in their "Luxor" silverplate. The name is far more evocative of ancient Egypt than is the design, which has curlicues and small flowers that resemble lilies-of-the-valley rather than lotus or papyrus blossoms. Marked LUXOR PLATE WALLACE.

Even the well-known watchmaker Jules Jürgensen was not immune to Tutmania, as this March 23, 1923 advertisement in *The Jewelers' Circular* shows. The advertisement features "Ancient Egyptian Creations of Horological Science"–and a watch decorated with a winged goddess. Egypt was associated in the minds of many with time, as the ancient Egyptians were thought to have been exceptional astronomers (they weren't especially; however, they do get credit for being the first to develop a solar rather than a lunar calendar). *Courtesy of Shelly Foote.*

An advertisement from the April 18, 1923 *Jewelers' Circular*, for Egyptian Jewelry featuring three brooches. The largest depicts a seated Egyptian holding an ankh, in a round brooch bordered by stylized lotus blossoms. A smaller round brooch also has a design of seated Egyptians, possibly gods, while the third is a bar pin decorated with stylized lotuses. *Courtesy of Shelly Foote.*

Fashion was not immune to Tutmania, as this photograph of a woman wearing an Egyptian-inspired hat (referred to as a "tan maline turban") shows. This photograph was part of a larger spread headlined "Old King Tut-Ankh-Amen of Egypt sets the Fashion for the American Girl's Summer Gowns and Hats," and included a photograph of actress Gloria Swanson wearing a coat wrapped around her "a la mummy!" One caption in the article noted that when Tutankhamun's tomb was opened, "out flew a new silhouette and a new head dress and a whole series of new colors." It is possible that Egyptian art had even more influence on Art Deco colors and design than is generally supposed. While it is possible to find numerous examples of overt Egyptian influences in shape, motifs, and colors, it seems likely that Egyptian inspiration went beyond the mere copying, into more intangible "in the spirit of" designs, as in the necklace shown on page 43. *Courtesy of Shelly Foote.*

Richee

And this tan maline turban, wound about with gold tubing and finished with tassels of gold fringe! Agnes Ayres might have worn it in another incarnation. On the upper Nile three thousand years ago

The winged sphere, or solar disk, used in an advertisement for emblems. The ad, featuring a detailed scene of the Pylon of Edfu (Edfou) complete with bustling ancient Egyptians, focuses far more on Egypt than on the actual product being sold. *Courtesy of Shelly Foote.*

An Art Deco necklace in silver, plique-à-jour enamel, and glass. This necklace shows the influence of Egyptian revival colors on Art Deco jewelry in general; while this necklace cannot strictly speaking be said to be Egyptian revival, its red, turquoise, and green seem directly influenced by ancient Egypt. Measures 24", with the pendant 3" x 1.375". This piece might sell in the $500-$600 range, though quite possibly could bring substantially more, as plique pieces have become harder to find and correspondingly more expensive. *Courtesy of Robin Allison.*

A wall pocket, identified by the seller as by Peters & Reed though it is unmarked, with a stylized lotus blossom at the bottom and an Egyptian head–wearing a cobra diadem–as the central motif; possibly c. 1930-1940. Although unsigned, it sold for $125 in an online auction, possibly in part because of its alleged manufacturer, and in part because it is a fairly unusual item in excellent condition. Measures 8.5" long.

A piece of cloth, silk or a silk and cotton blend, with a design of stylized lotus blossoms very much in the Art Deco spirit; probably c. 1925-1930. A faint pattern of hieroglyphs occupies the background. This sold for approximately $15 a yard, slightly more than a similar piece of silk or silk blend might cost new.

"The Outlook" in *McCall's* (June, 1923) opined that "The dead Pharaoh who has been left to lie in his tomb in Egypt has stimulated clothes more than the world war did. Students may consider it solely in the light of an archeological discovery, but that episode to dress designers is a mere incident compared to the fact that it has upset the balance of fashion, a balance which was pretty well established." Featured is a dress made of material with an Egyptian revival flair, imprinted with striding Egyptians and stylized lotus blossoms. The accompanying text also touts the virtues of the cotton supposedly worn by the Egyptians for four thousand years, ignoring the fact that ancient Egyptians for the most part wore linen. However, it is fairly clear that fabric with Egyptian motifs was one result of the discovery of the Boy King's tomb.

Cleopatra–Again!

Even something as minor as the release of an epic movie starring one of the most beautiful women in the world, playing one of the most fascinating women in history, was enough to launch a minor revival. Thus the 1962 movie *Cleopatra*, starring Elizabeth Taylor and her soon-to-be-next husband Richard Burton, was enough to spur a new interest in Egyptian jewelry. Especially popular at the time were scarab bracelets, the more expensive made in 14K gold and semi-precious stones, the less costly in glass and silver or base metal. The movie also led to the creation of the bracelet shown here, purportedly designed by Elizabeth Taylor and marketed by Avon as a Cleopatra bracelet designed by Hollywood's Cleopatra herself.

A bracelet marketed by Avon, but ostensibly designed by "Hollywood's own Cleopatra," Elizabeth Taylor. The bracelet has any number of Egyptian motifs, including a winged goddess, a seated pharaoh (or god), an Eye of Horus, the god Heh (also the hieroglyph for "a million"), and a fan. Although this is strictly costume, it appears to be fairly collectible, and sells in the $100-$150 range when it comes up in online auctions. Signed by Elizabeth Taylor and Avon both.

A costume bracelet and earrings with glass scarabs. Although similar bracelets were manufactured long before the 1960s, they became extremely popular around 1963, probably as a result of the movie *Cleopatra* and a resurgence of interest in things Egyptian. These bracelets are not especially difficult to find, and come in a range that runs from gold-filled and glass costume jewelry to 14K or 18K gold with semi-precious stones. The costume bracelets seem to sell in the $10-$25 range, with the gold ones going for up to $250-$350.

Tourist Jewelry and Other Items

With the rediscovery of Egypt came tourism–and tourists, in droves. Agatha Christie, in her autobiography, describes a season in Cairo, a popular winter haven for those from northern climates or, as in her case, for those from families too poor to launch a London debut for their daughters.

And tourists shop. They buy souvenirs to bring home as a reminder of an enjoyable trip, or presents for family and friends. It's probably not unreasonable to suppose that many Egyptian revival items, especially smaller, more portable items such as jewelry and souvenir spoons, at almost any point in the last one hundred and twenty years came from Egypt itself.

Some tourist jewelry is very obviously made in Egypt. Often it combines ancient Egyptian motifs with more modern ones, such as mosques, camels, "hand of Fatima" charms (thought to bring the wearer good luck), or Arabic mottos. Other tourist items are less obviously so. The scarab bracelet shown here, though possibly more finely made than many tourist pieces, is marked 18K–but in Arabic, not in a European script.

A bracelet in 18K gold, enamel, and small diamonds, n.d. though possibly late 19th or early 20th century. Although this bracelet displays better craftsmanship than is found in many tourist pieces, it is almost certainly from Egypt, as it is marked for 18K in Arabic. It has a central enameled scarab encircled by diamonds and flanked by champlevé enamel lotuses; the band is also done in enamel. This was purchased from a dealer for $2200, but would probably bring considerably less in an online auction.

A tourist bracelet in silver or silverplate, with a medley of ancient Egyptian and modern Egyptian motifs. The glass scarabs (which may have come from Czechoslovakia) and the pharaoh heads fall into the ancient Egyptian category, while the crescents with stars and the hand of Fatima are definitely Islamic symbols. These bracelets come up fairly frequently in online auctions, and can usually be had for around $15-$30.

A tourist bracelet, identifiable as such by the Islamic crescent moon present in one of the links. Somewhat heavy, it may be in 800 silver, though possibly is silverplated. The links contain a double-handled jar with hieroglyphs, elephants, a crescent moon, a pharaoh's head in profile, a sphinx viewed from the front, and a woman holding a sistrum (a percussion instrument sacred to the goddesses Isis and Hathor). A dangle has a kneeling pharaoh holding an ankh. Unmarked; 1.125" x 6.5" excluding chain and dangle.

A wide bracelet in silver gilt, from Egypt, n.d. Each segment of this bracelet, in nicely wrought filigree that makes it a cut above many tourist items from Egypt, contains either an Arabic word for good luck, or a cut-out of an ancient Egyptian motif, including figures bearing offerings, and a winged female sphinx that is more in the Greek than the Egyptian style. The bracelet also has an unusual catch, with a pin that fits into interlocking tubes, similar to ancient Egyptian clasps. It is flared so that the top is wider than the lower edge. Measures approximately 7" at bottom edge, 7.5" at top edge; 1.75" wide. This bracelet should probably sell in the $65-$130 range in an online auction.

A tray in faux damascene work used used to depict Egyptian scenes. *Private collection.*

Chapter Two
Signs & Symbols

Egypt is the gift of the Nile, but the Nile is the gift of Osiris.
Herodotus, *The Histories*

While many of the revivals so prevalent in nineteenth century decorative arts brought back themes and terms long extinct—women wore fibulae and bullae, jewelry last in fashion during the Roman Empire–Egyptian revival brought with it motifs that were completely new to Europe and the Americas. The Eye of Horus, the girdle of Isis, ankhs, scarabs, *ba*-birds, *sa*-amulets, *was*-scepters, the uraeus serpent, the vulture crown, papyri- and lotiform columns: All of these were new additions to the lexicon of design.

Three bands in gold inlaid with stones and faience, found on the mummified body of Tutankhamun. The bands incorporate the *djed*-pillar, the symbol of the god Osiris, and the girdle (or knot) of Isis. *Drawing courtesy of Katherine Scattergood.*

KARNAK, THE GLORY OF ANCIENT EGYPT

In this picture we see the wonderful temple of the god Ammon at Karnak, restored so as to appear in all its ancient glory. It has been described as the noblest effort of architectural magnificence ever produced by the hand of man, and indicates the might and advanced civilization of the ancient Egyptians. An avenue of sphinxes led up to the doorway, and the great hall contained 134 mighty pillars, all brilliantly painted and carved.

An early 20th century drawing of the temple of Karnak, showing rows of lotiform columns. Its caption reads: "Here we see the wonderful temple of the god Ammon at Karnak, restored so as to appear in all its ancient glory. It has been described as the noblest effort of architectural magnificence ever produced by the hand of man, and indicates the might and advanced civilization of the ancient Egyptians. An avenue of sphinxes led up to the doorway, and the great hall contained 134 mighty pillars, all brilliantly painted and carved."

As Herodotus wrote so many centuries before the rediscovery of Egypt by Napoleon's savants, Egypt was indeed the gift of the Nile. The Nile was Egypt's main artery, its life force whose annual flooding and rich river silt freed Egyptians from the cycles of feast and famine so common elsewhere in the ancient world. It connected the cities and villages strung along it, making possible the development of the world's first central government. It brought prosperity, and plenty. On its banks, Egyptians built pyramids and pylons, temples and tombs. They grew the barley with which they baked bread and brewed beer. On it they fished and fowled. It was the basis for Egypt's wealth.

But Egypt was not merely prosperous; it was also protected. On the east and west sides of the Nile, away from the Black Land, called Kemet by its inhabitants, stretched forth the Red Land, the inhospitable desert punctuated only by a few far-flung oases. To the north was the Mediterranean, the sea the Egyptians called the "Great Green"–a body of water that was feared while at the same time it offered a defense against invaders from the north.

To the south were cataracts that kept Egypt safe from those who might wish to attack from that direction.

For the first millennium of its history, Egypt was relatively isolated. There was trade, especially with the south, from which came luxurious goods such as leopard skins and ebony, incense and gold. Most of this trade seems to have been initiated by the Egyptians, and promulgated for their benefit.

It is not surprising that such a people, sheltered and inward-looking, would develop their own unique culture.[1] In fact, their culture was so unique that early visitors, such as Herodotus and later Pliny, could only marvel at and record with some skepticism the wonders they saw and the tales they were told.

The symbols borrowed from Egypt are also unique, and they are finite as well. However, there is sometimes a misinterpretation of what constitutes Egyptian revival, as opposed to Greek revival or Roman revival or some other revival. In jewelry, Egyptian revival tends heavily towards scarabs, especially but by no means exclusively winged scarabs. Egyptian revival also makes great use of sphinxes. Egyptian gods and goddesses, alone or in scenes with mortals, appear. Hieroglyphs, whether as part of a larger motif such as an obelisk or a scene, or as amulets, are frequently found. Pharaohs and queens, whether a specific monarch or a generic one, are also often encountered, as are scenes from tombs or temples, such as offering scenes, scenes of pharaoh hunting, Egyptian maidens playing the harp. Nature, found in stylized lotus blossoms and the occasional papyrus plant, also occurs. So do man-made objects such as pyramids and obelisks.

This chapter discusses the motifs that are most commonly found in Egyptian revival decorative arts, as well as those that are occasionally deemed by some to represent Egyptian-inspired themes, but which in reality belong to some other culture or civilization or, in some cases, owe a great deal to invention.

Amulets and Hieroglyphs

Although jewelry, past and present, has always been a form of adornment, it seems clear that in the ancient world it was also worn to convey an impression of power or wealth, or to provide protection. In ancient Egypt, it appears that jewelry served both functions: It indicated wealth and status, *and* it served as talismans meant to guard the wearer.

The wonderful caches of royal jewelry discovered during the nineteenth century, and the wealth of jewelry found in Tutankhamun's tomb, showed jewelry that was beautifully made, thus fulfilling the requirements of adornment; of rich materials, primarily gold and semi-precious stones, and therefore an indication of status (which was also conveyed by certain emblems, such as the striped *nemes* headdress worn by kings, the cobra and vulture heads worn on pharaonic crowns, the vulture crown of the Great Royal Wife, and the gazelle heads found on diadems of lesser royal wives or princesses); and of amuletic significance, providing protection and well-being, as attested by the amulet jewelry of Princess Khnumet and Tutankhamun's numerous pieces containing, for example, scarabs and the Eye of Horus.

Among the most popular amulets in ancient Egypt were scarabs, but Egyptians also wore jewelry in the form of ankhs, the Eye of Horus, lotus blossoms (like the scarab, an indication of youth, transformation, coming into being), *sa*-amulets (from the Egyptian word for "protection"), the god Horus, and other gods such as the god of infinity, Heh.

A pair of earrings in 14K gold and faience, possibly c. 1880, with faience drops containing hieroglyphs. The drop on the right has, among others, the signs for "Son of Re"—one of the king's titles. French guarantee marks; measure 1.25" in length. These earrings sold at auction for $587.50. *Courtesy of Skinner Inc., Boston and Bolton, MA.*

A costume necklace by American designer Kenneth J Lane, probably c. 1990, with amulet charms depending from a plaque containing an Eye of Horus, the god Heh (also the hieroglyph for "million" and as such found in formulae wishing pharaoh and others a long lifetime), and a girdle of Isis. The amulets include the ubiquitous scarab, an ankh, and a *djed*-pillar. In the myth of Isis and Osiris, after Osiris was murdered by his wicked brother Set and his body dismembered, Isis pieced together the body parts and restored Osiris to life. His backbone, found at his sacred city Busiris, represents the body as a whole. (Others, including the great Sir Alan H. Gardiner, have interpreted this pillar as being not a section of the backbone but a column formed of bundled papyrus reeds, and still others see it as signifying a tree trunk—which may come from a different version of the Osiris myth, in which Osiris' body is hidden in a tree trunk, which is then chopped down and used by pharaoh as a column for his house.) As a hieroglyph, the *djed*-pillar meant "stability" or "enduring." It is one of the oldest of Egyptian amulets, having been found in artifacts dating from the First Dynasty, as well as one of the most powerful. This necklace sold for approximately $120 in an online auction after fairly competitive bidding; however, it has been offered for sale for as little as $50 online.

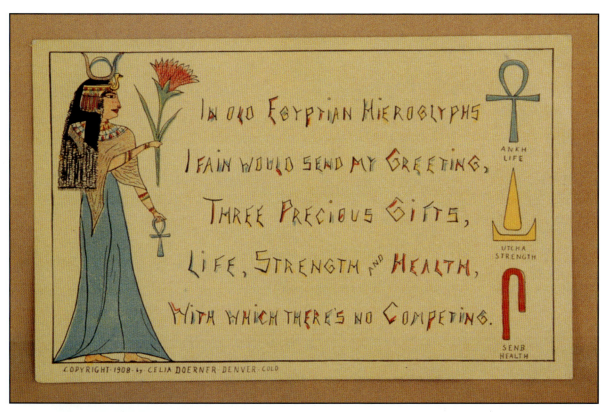

A postcard from 1908 with an Egyptian queen in the vulture headdress with disk and horns, holding a lotus blossom in one hand and an ankh in the other, with the Egyptian hieroglyphs for life, prosperity, and health. These hieroglyphs routinely accompanied the names of Egyptian kings in ancient texts, and are abbreviated l.p.h. by Egyptologists in English translations. The verse on the postcard reads: "In old Egyptian hieroglyphs/ I fain would send my Greeting,/ Three precious gifts,/ Life, Strength and Health,/ With which there's no competing." Marked COPYRIGHT 1908 by CELIA DOERNER DENVER COLO.–showing yet again the lasting influence of Egypt on popular culture long after the opening of the Suez Canal and well over a decade before the discovery of Tutankhamun's tomb.

A pectoral from Tutankhamun's tomb, with an Eye of Horus as well as other meaningful elements such as the god Heh, the tadpole hieroglyph for 100,000, and the girdle of Isis. *Art by Katherine Scattergood.*

Hieroglyphs are very much associated with the ancient Egyptian civilization. Although not exclusive to Egypt–hieroglyphs were used to write some Hittite texts, and also are the basis for the Mayan writing system–the form they took in ancient Egypt, their almost static precision, the detail with which they were carved and painted on monument walls, are truly unique, and it is hard to confuse Egyptian hieroglyphs with those from any other culture. However, it should be noted that certain decorative objects sometimes combine real Egyptian hieroglyphs with invented forms, or with signs so distorted that it is hard to recognize the original hieroglyph.

It is, though, often difficult, and at times impossible, to distinguish Egyptian hieroglyphs from Egyptian amulets. Amulets frequently took the form of hieroglyphs, such as the ankh or the *sa* sign. But even where the jewelry is a bit more elaborate, as in the inlaid Eye of Horus amulet found in Tutankhamun's tomb, it is hard to know whether a symbolic piece was intended to represent a hieroglyph or a more elaborate picture. And, in fact, the distinction may be an academic one more apparent to modern scholars than to the ancient Egyptians themselves: To the ancient Egyptians, words conveyed power, and the signs used to write their words were as powerful as any more complex symbol might have been. Additionally, hieroglyphs carved or painted on temple walls showed a great deal of detail; birds were given feathers, humans were given features, plants were given naturalistic color. Were jewels then simply more detailed renditions of hieroglyphs? Quite possibly many of them were.

When modern jewelers began creating brooches, bracelets, necklaces, earrings, and charms in the Egyptian tradition, they not unnaturally turned to ancient designs. Thus Egyptian revival jewelry is full of scarabs (discussed in a following section below)

and lotus blossoms (also discussed below). Less frequently encountered are the Eye of Horus, ankhs, and other amuletic signs, but these are present as well in jewelry and other forms of decorative art.

This section attempts to show some of the amulets/hieroglyphs more frequently encountered in Egyptian-themed decorative arts, although it is certainly not exhaustive.

ankh- Thought to represent a sandal strap, the ankh was the Egyptian hieroglyph for "life." As such, it was used in royal jewelry, such as the motto amulet of Princess Khnumet asking that "All life [and] protection [be] behind her." It is also frequently found in modern pieces, such as the twentieth century plique necklace and bracelet shown here.

A pendant in 800 silver, plique-à-jour enamel, opals, garnets, and baroque pearls. The central element of the pendant is an ankh in pink and turquoise enamel, flanked by stylized lotus blossoms. The use of chains and baroque pearls in this piece give it an interesting Arts and Crafts look, a departure from the more usual Art Deco Egyptian revival pieces. Measures 3.875" x 1.625". Plique pieces in general are becoming harder to find and correspondingly more expensive; one might expect to pay at least $1500-$2000, and quite possibly more, for a similar piece. *Courtesy of Robin Allison.*

A bracelet in 800 silver and enamel, with scenes of modern Egypt. These, however, are linked by ankhs and lotus blossoms, making this to some extent a revival piece rather than simply a "travelog" piece, although it was probably purchased as a souvenir in Egypt. Measures approximately 7.5" x .625"; marked for silver content. It was purchased from a fairly high-end dealer for $650 in the days before comparison shopping was made easy by the internet. However, these bracelets continue to sell well at auction, bringing usually about $250-$400.

ba- The *ba* hieroglyph was at times a phonetic sign representing the letters **b** and **3** (a glottal stop, also called *aleph*). It was thus used in words with these sounds.[2] However, as an ideogram, it represented a human soul in the form of a bird.

The Egyptians were firm believers in life after death (although they seem to have had competing visions of what this afterlife entailed). Given this strong belief, they also believed in the soul. In fact, they believed in several different souls, each of which had a different function. The birdlike *ba* was released after death, and in simplistic terms either flew up to meet the sun, or descended to the netherworld to be judged by Osiris.

Although the *ba* was represented by a bird, it was a *human* soul in the form of a bird, and thus the *ba* was often shown with a male human head, complete with the beard worn by mourners. On temple and tomb walls, the *ba* was often given the level of detail found in the *ba*s in the bracelets shown here.

The brooch, from the Museum Company, is possibly borrowed from a Twenty-sixth Dynasty amulet in the form of a human head atop the body of a bird with outstretched wings seen from behind.

A bracelet, in sterling silver and plique-à-jour enamel, with *ba*-birds, winged scarabs, and winged serpents. Unusually, this bracelet has the central winged scarab set with a faceted aquamarine, rather than the much more usual scaraboid cabochon in enamel or stone. Marked sterling; measures 7.25" x 1". An asking price for this bracelet might be in the $2500-$3000 range, reflecting the higher cost of pieces with plique-à-jour enamel compared with other forms of enameling. *Courtesy of Robin Allison.*

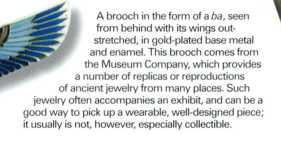

A brooch in the form of a *ba*, seen from behind with its wings outstretched, in gold-plated base metal and enamel. This brooch comes from the Museum Company, which provides a number of replicas or reproductions of ancient jewelry from many places. Such jewelry often accompanies an exhibit, and can be a good way to pick up a wearable, well-designed piece; it usually is not, however, especially collectible.

A rendering of a *ba* on a vase by Belgian ceramic artist Dubois. Here the *ba* resembles a drawing in an ancient tomb, with the soul's wings spread, and legs splayed.

A drawing of female and male *ba* souls from The Book of the Dead. While the *ba* was usually depicted as a bird with a male head, the *ba* of a woman was given female characteristics–appropriately so, as the *ba* represented the fully human nature of the soul. Interestingly, the female and male souls were placed next to a drawing of leopards–the name for which was also *ba* in Egyptian. The female *ba* is shown with lighter skin than the male *ba*; the conventions of Egyptian art called for an Egyptian woman to have light skin, while Egyptian men were usually given skin of a darker terra cotta color. Both souls wear cones of incense on their heads, and the female in addition wears a lotus in her hair. Between the leopards is the hieroglyphic sign for "horizon." *Drawing courtesy of Katherine Scattergood.*

cartouche- Although most of us think of the cartouche, if we think of it at all, as an elongated circle in which the names of kings and queens were written in hieroglyphs, it was also a hieroglyph in and of itself. Like many hieroglyphs, it had a phonetic value as well as an intrinsic meaning: Phonetically it indicated the two sounds **sh** and **n**; ideographically, it represented "all encompassing power"–and it is because of this significance that it was used to enclose royal names.

In modern jewelry, a cartouche is most often found with the wearer's name in a version of hieroglyphs adapted to write vowels. Such jewelry can be found in a number of places, online as well as off, in both the more affordable sterling silver, and in 14K or 18K gold, and is usually custom-made. However, cartouches are also found in jewelry with ancient royal names; that of Cleopatra seems especially popular, and is found in the bracelet shown here as well as in the pendant in the introduction (page 13).

A large charm or pendant in sterling silver, with the Egyptian hieroglyphic "alphabet" of twenty-four (or twenty-five, counting the two forms of **s**) consonants. This alphabet, although never used on its own by ancient Egyptians, is employed in many modern cartouches to spell out English (or other modern language) names. The hieroglyphs for aleph and ayin (the vulture and the arm hieroglyphs) are used to represent the vowel **a**; the reed leaf hieroglyph (**i**) is used for **e** and **i**; and the quail chick (**w**) is used for **o** and **u**. However, being able to read these twenty-four (or twenty-five) hieroglyphs will unfortunately contribute little to a person's ability to read ancient Egyptian, which employed over one thousand hieroglyphs. These uniliteral (single sound) hieroglyphs were used most often as phonetic complements with bi- or triliteral (two- and three-consonant) signs, although they are used to spell out royal names in some early cartouches such as that of King Khufu (Cheops).

A small silver gilt and enamel charm in the form of a cartouche containing the prenomen of Twelfth Dynasty king Sesostris II. Such charms are not unusual, and can often be bought for under $30. Marked for silver content; approximately .625" long.

A bracelet in sterling silver with links in the form of cartouches containing royal names: One cartouche has the name of the Great Pyramid builder Khufu (Cheops), others the names Cleopatra (missing the first letter of her name), Tutankhamun, and Ramesses II. The bracelet ends in stylized lotus blossoms. In ancient Egypt, the cartouche not only encircled royal names, but was also a powerful symbol in itself, with a meaning something like "all encompassing power." As such, it is occasionally found in royal amuletic jewelry as, for example, in the talons of a vulture pectoral found in Tutankhamun's tomb. Egyptian marks for sterling silver; measures 7.5" x 1". This bracelet sold for approximately $35 in an online auction; similar bracelets are available new for approximately $25-$45.

Eye of Horus- In ancient Egypt, the Eye of Horus was a powerful sign. It symbolized wholeness, completeness, and its various components were used to write fractions–adding up to 63/64ths, with the missing 1/64th presumably being supplied by magic. In one version of the myth of Isis and Osiris, in which Horus avenges Osiris's death at the hand of his brother Set, Horus loses his left eye to his evil fratricidal uncle. The eye is then healed by the god Thoth. Most modern interpretations see this as a remnant of prehistoric lunar mythology, and as an ancient explanation of the waxing and waning of the moon. Some scholars, however, believe that the Eye of Horus represented the sun, and that the myth of the lost eye represented solar eclipses.

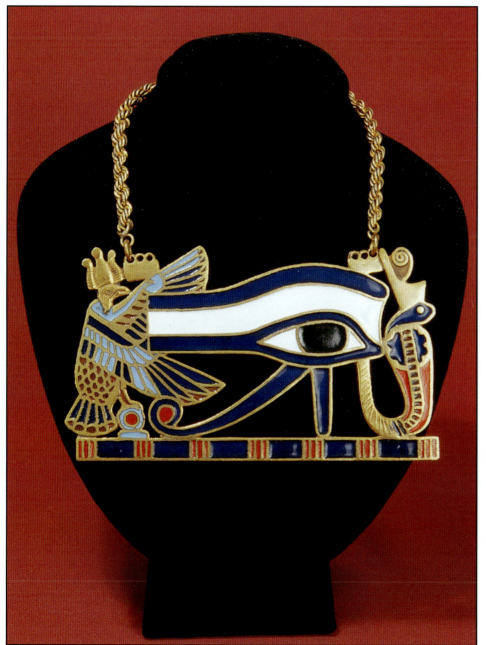

A drawing of the central part of a pectoral found in Tutankhamun's tomb, in the form of an Eye of Horus, or *udjat*. The pectoral is in gold inlaid with stones and glass; the glass has a hatchmark pattern that makes it easily differentiated from lapis lazuli. The Eye of Horus was a popular talisman in ancient Egypt: Tutankhamun's tomb contained several pectorals in which the Eye of Horus was one element, and putatively "ancient" *udjat* amulets are frequently found at auction or in stores specializing in antiquities. Most often these latter are found in faience, although they are also carved from various types of stone.

A large costume pendant in base metal and enamel, resembling an ancient Egyptian pectoral. As its central element the pendant has the Eye of Horus–also called a *udjat* or *wadjat* from the ancient Egyptian–flanked by Edjō (Wadjet), the tutelary goddess of Lower Egypt, and Nekhbet, the tutelary goddess of Upper Egypt. The vulture Nekhbet wears the *atef* crown–the white crown of Upper Egypt flanked by tall plumes–while Edjō wears the red crown of Lower Egypt. A sticker identifies it as MADE IN A. R. (A. R. standing for Arab Republic), which possibly indicates a fairly recent date of manufacture. A costume piece such as this might sell for $15-$30 in an online auction.

ka- The *ka* was the second type of soul often found in Egyptian art and writing, in invocations and spells. Written as two disembodied arms bent at the elbow and held high, it had combined the sounds **k** and **3** (aleph, perhaps representing a glottal stop in ancient Egyptian). It also meant "double"–and the *ka* was believed to be a dead person's double. As the bird-shaped *ba* flew away from the body in its tomb, the *ka* after death joined its creator who might have been the god Khnum. In reliefs in Hatshepsut's temple at Deir el-Bahri, Khnum was shown forming the queen's body and her *ka* separately on his potter's wheel. Offerings of food and drink were left at a deceased person's shrine or tomb to enable the *ka* to continue its existence, implying that the *ka* also remained present in the tomb. In fact, false "doors" placed in the tomb ensured that the *ka* could with the aid of magic flit back and forth between this world and the next. While not commonly found in Egyptian revival objects, the *ka* hieroglyph is depicted on the Monmouth ware vase shown here.

A vase by the Monmouth, Illinois Western Pottery Company, probably c. 1930-1940. Among the designs on this vase is the sign for the *ka* ("double") soul, written with a hieroglyph in the form of two raised arms. In ancient Egyptian beliefs, there were several different types of soul, including the bird-like *ba*, and the *ka*. The former is often thought to be a soul that left the body when a person died, while the *ka* stayed in the tomb and received offerings of food and drink. The actual belief was probably more complicated but, like many aspects of ancient Egyptian religion, is not fully understood.

sa-amulet- The *sa* hieroglyph combined two sounds, **s** and **3** (representing aleph, perhaps a glottal stop), and as a phonetic sign it is found in words containing those two consonants, including the word for "protection." As an ideogram, it actually meant "amulet"–and thus, as its name suggests, was a very commonly worn talisman in ancient Egypt–providing its wearer, as it implies, with protection. It occurs in some Egyptian revival jewelry, including the necklace shown here.

A necklace in 800 silver in the traditional red, dark blue, and turquoise commonly found in revival jewelry and intended to emulate the carnelian, lapis lazuli, and turquoise most often found in ancient Egyptian jewelry; with elements including a central ankh, two pharaoh's heads (in striped headdress), two *sa*-signs, and two lotus blossoms. The central ankh measures .25" x .75"; marked for silver content with numeral 1. A decent price for this necklace might be in the $250-$500 range. *Courtesy of Robin Allison.*

scarab- Please see below under *Beetle*.

was-scepter- The *was*-scepter was a triliteral sign, meaning that it combined three different sounds in one hieroglyph. The sounds were **w 3** (the *aleph*, possibly a glottal stop in ancient Egyptian) and **s**. The hieroglyph was primarily an ideogram, representing the royal scepter that gave pharaoh his power. As such, it signified "dominion" or "have dominion." It was used in ancient royal jewelry, and is sometimes found in scenes with pharaoh holding the *was*-scepter.

A milk glass vase with the painted scene of a seated pharaoh holding the *was*-scepter, n.d. This scepter was often shown with gods, including Ptah who, like Osiris, was frequently depicted as a mummiform being. In some versions of The Book of the Dead, entire rows of seated gods hold the *was*-scepter. Unmarked; 10.75" high. Similar vases come up in online auction from time to time, although as they are hand-painted no two seem to be identical. In addition to the seated pharaoh, this vase has a stylized figure in an odd, almost dance-like position, as well as the Greek key pattern occasionally found in Egyptian revival items. This vase sold for $16 in an online auction.

Animals and Plants

A pendant by designer Laurel Burch, who in the 1970s through the 1990s was known for her colorful, whimsical animal jewelry and clothing. Most of her output was, like this pendant, enameled costume jewelry, but a few of her pieces were also made in sterling silver. Although her jewelry is no longer being made, it is still available online. Marked EGYPTICATS Laurel Burch ® ©; 1.375" long. This pendant had an asking price of $25 in an online store.

To the ancient Egyptians, most animals were sacred. Many of their numerous gods and goddesses were worshiped in animal form, whether the falcon god Horus; the vulture goddesses Mut and Nekhbet; the cobra goddess Wadjet (Edjō); the evil serpent Apophis, who nightly swallowed the sun, causing darkness; the crocodile god Sobek; the cat goddess Bastet and the lion goddess Sekhmet; or the ibis and baboon sacred to the god Thoth. Plants, though not having quite the status of animals, were highly symbolic. The lotus was emblematic of Upper Egypt, as the papyrus was of Lower Egypt. Nefertem, a god of perfume and healing worshiped as one aspect of the sun god Re (Nefertem was at once the grandson of Re and Re as a baby or child), was believed to have emerged from a lotus blossom. The sedge, another symbol of Upper Egypt paralleled by the Lower Egyptian bee, lent its name to the word for "king," *nsw* "he of the sedge." Thus one would expect Egyptian art, as well as Egyptian revival decorative arts, to feature animals and other natural motifs such as plants. Expectations are not disappointed, though such natural themes seem to occur less frequently than others, such as scarabs and sphinxes in Egyptian revival.

The following brief list includes animals and plants most often encountered in Egyptian revival decorative arts.

cat- The cat, the Lower Egyptian deity Bastet (also spelled Bast), was only one among many of the animals worshiped as gods in ancient Egypt. However, despite having Herodotus's description of the Egyptians' reverence for animals other than the cat–indeed, his statement that causing the death of a falcon or an ibis, even unknowingly, carried the penalty of death, whereas causing the accidental death of a cat carried no such penalties–many people seem to believe that the cat alone was worshiped in ancient Egypt, or at least was revered more highly than other animals.

Given this fairly pervasive belief, it might be supposed that Egyptian revival cats abound. And they do. Cats are produced by Baccarat and Lenox, by designers such as Laurel Burch and Paul Cardew, and occur in numerous other Egyptian revival decorative objects.

A pendant in black stone, possibly basalt, and gold, in the form of an Egyptian cat. This pendant was acquired during an exhibit of ancient Egyptian art and artifacts. Unmarked; approximately 1" in height. Cat pendants in silver and gold are easily found new and vintage online; those in stone are much harder to find. *Courtesy of Stephanie Wenger, Austin, TX.*

A group of three gilded cat figures holding up a crystal glass ball. While many cats are described by sellers as "Egyptian," these cats, sitting in a rigidly formal position and wearing multi-banded collars, are very much in the Egyptian revival tradition. Unmarked; sold for approximately $20 in an online auction. Similar groupings are available new online as oil lamps and incense burners. The cautious shopper should beware of high shipping costs, however; these items can be very heavy, and the cost of shipping can be higher than the price originally paid.

cow- See below under *Gods and Goddesses: Hathor*

crocodile- Like other fearsome and feared creatures, the crocodile was worshiped by the ancient Egyptians, most notably as the god Sobek. Herodotus described the crocodile, noting the care with which it was treated as a cult object in Thebes and the region around Lake Moeris, and adding that not only was it not considered a sacred animal in Elephantine, but that it served as a source of meat for Elephantine's inhabitants. The crocodile appears infrequently in Egyptian revival decorative arts, and then mainly in tourist items, where it most likely figures as an animal native to the country, rather than as a former god.

falcon- See below under *Gods and Goddesses: Horus*

frog- Egyptians, whose worship often included gods drawn from nature, had a frog goddess, Heqet, although she was not especially prominent in the Egyptian pantheon. In true Egyptian fashion, however, the frog was not only an animal, but was also a hieroglyph. As a hieroglyph, it was used as a determinative after Heqet's name. The tadpole hieroglyph also stood for the number 100,000 (fitting for an animal spawned by the hundreds!). It may have been used in ancient times as an amulet and is found as an element in royal jewelry from ancient Egypt.

gazelle- Though not given the status of a god or goddess, the gazelle is found in ancient Egyptian decorative arts. Its head was placed on the diadems of minor Egyptian queens and princesses, presumably as a symbol of rank. The figure of a recumbent gazelle, in bronze, was used as a weight when precious materials were weighed. Gazelles are also found in paintings, sometimes as the prey of royal hunters in chariots. The two gazelles in the brooch shown here, however, are leaping, a form thought to have been borrowed from Minoan Crete during the New Kingdom.

hippopotamus- The hippopotamus is a uniquely African animal, and as such formed part of the backdrop against which the Egyptians lived their riparian lives. Today said to kill more human beings than any other animal in Africa (with the likely exception of the mosquitoes that carry malaria and other diseases), the hippopotamus to the Egyptians seems to have been one more animal to depict in art, and worship in private. The goddess Tausret (literally "the great one") was not a major deity in the Egyptian mythological landscape, but she was worshiped in the home as a goddess who protected women, especially in childbirth. One of the most popular reproductions of ancient Egyptian artifacts is the blue faience hippopotamus "William," the original of which resides in New York City's Metropolitan Museum.

ibis- See below under *Gods and Goddesses: Thoth*

jackal- See below under *Gods and Goddesses: Anubis*

leopard- One of the few animals known to the ancient Egyptians but not worshiped by them, the leopard was nonetheless viewed as powerful, possibly because the Egyptian word for leopard was written with the same hieroglyph used for the *ba* (although this could be due to coincidence, or the animal might have been named for its power). High priests and kings wore leopard skins over their dress when performing certain rituals. The face of a leopard, made of wood overlain with gold, was found in Tutankhamun's tomb–the brooch shown here is a fairly faithful rendition of the carved leopard's head.

One of a set of silver spoons with enameled bowls–in a design of an Egyptian queen wearing the vulture crown–and handles in the shape of crocodiles. Although these look very much like typical Egyptian tourist ware, they are in fact marked ARGENTINA 800. It is quite possible that these were exported to Egypt from Argentina, but it is also possible that they were exported directly to the United States. The set of six spoons was bought for $100 from an online dealer.

A costume brooch with a design of stylized leaping gazelles, and a border on either side with stylized lotus blossoms. While the gazelle is found in Egyptian decorative arts, most frequently on crowns and diadems of lesser royal women, these stylized gazelles are more in the Minoan style which influenced Egyptian art during the New Kingdom. JJ designed a number of cute costume brooches in the 1980s, but it appears that this one was manufactured to be sold by the Museum Company. JJ brooches can be easily found online; their Anubis brooch (shown below on page 81) comes up occasionally at auction.

A nicely-made costume brooch in base metal and enamel, in the form of a leopard's face, based on a carved wooden and gold leopard's face found in Tutankhamun's tomb–note the cartouche containing Tutankhamun's prenomen, Nebkheperure, on the leopard's forehead. This brooch was made to be sold in museum shops, which are often a good source of revival jewelry of all kinds. Although pieces sold by these shops can be "inspired by" ancient art, often they are fairly faithful replicas of objects found in excavations. *Courtesy of Stephanie Wenger, Austin, TX.*

ram- More than one Egyptian god was associated with the ram, including the powerful gods Amun and Khnum. Many of the sphinxes found in Egypt have a ram's head rather than that of a king; presumably such sphinxes pay homage to the god Amun-Re, the most powerful god of in New Kingdom Egypt and a fusion of the older solar deity Re with the local–and later principal Egyptian–god Amun.

serpent- The cobra goddess Wadjet (Edjō) was the tutelary goddess of Lower Egypt. Her head, also known as the uraeus serpent, was along with that of the vulture goddess Nekhbet one of two emblems worn on pharaonic crowns. Most depictions of Nefertiti show her wearing a blue crown embellished with a sinuous serpent. The uraeus also decorated the diadems of Twelfth Dynasty princesses such as Khnumet.

The evil god Apophis (Apep), who nightly swallowed the sun and plunged the earth into darkness, was also seen as a serpent. Living as they did in a land filled with poisonous snakes, such as the cobra and the horned viper, it is not surprising that the ancient Egyptians feared serpents. In fact, during certain periods, when it appeared in texts the horned viper–the hieroglyphic sign for **f**–was often carved on stelae and other monuments as if hacked into pieces, thus rendering it powerless to harm. Similarly, the serpent in the illustration from The Book of the Dead shown below was also depicted being slain.

A ring in sterling silver and blue glass, with a setting that includes a winged disk flanked by serpents, very much in the spirit of the silver and moonstone necklace shown here and quite possibly from about the same period. Interestingly, the solar disk appears to have a faint bas relief image of a falcon or jackal's head. This was purchased online for approximately $65.

A pendant in 800 silver in the form of a cartouche flanked by two serpents wearing solar disks on their heads; the cartouche is surmounted by a barque holding a third solar disk. The cartouche contains Tutankhamun's prenomen, Nebkheperure. Serpents in ancient Egypt were both feared and worshiped. The god Apophis, who nightly swallowed the sun on its way through the darkness, was depicted as a serpent. On the other hand, the tutelary goddess of Lower Egypt was a cobra. During the First Intermediate Period, texts containing serpent hieroglyphs (there are two snake hieroglyphs in the Egyptian "alphabet") often showed these hieroglyphs hacked into pieces. Unidentified Egyptian hallmark and Arabic mark for 800 silver; measures 1.75" x 2.125". Such tourist jewelry frequently comes up in online auctions, and seems to sell for anywhere from about $10-$125; pieces with enameling in decent condition often sell at the higher end of the scale.

This Art Deco stylized serpent bracelet could perhaps be said to show Egyptian influence instead of, strictly speaking, falling under the Egyptian revival rubric. Snake bracelets have long been popular. Snake bracelets became especially popular during the 19th century after Prince Albert bestowed one on his fiancée Queen Victoria. This bracelet shows nice Art Deco style, with its bold green and yellow enameling, and its triangular scale pattern. Similar Art Deco bracelets in Egyptian revival colors can also be found. However, it should be mentioned that snakes, like cats, are often labeled Egyptian revival even when they show very little, if any, Egyptian influence. *Courtesy of Robin Allison.*

Winged serpents flanking solar disks are not uncommonly found in ancient Egyptian art and architecture, though in Egyptian revival jewelry winged scarabs appear to be much more common (for which please see below, under *beetle*). Here, blue moonstone cabochons are set between silver links in the form of winged solar disks. A similar design is appliquéd on silver in Gorham's "Isis" pattern, which debuted around 1870 (for which please see chapter three, page 136).

A necklace in silver and champlevé enamel, with lotus blossoms, scarabs, and as its central element a queen wearing the vulture crown. The crown has a uraeus serpent, and also sports a rather abbreviated version of the horns often associated with Hathor and Isis. From the queen depends another lotus, done as are the other enameled elements in traditional Egyptian revival colors. *Courtesy of Robin Allison.*

A vignette from The Book of the Dead in which a cat kills a serpent. According to one interpretation, the cat represents the sun, while the serpent is the evil Apophis, the demon who nightly swallows the sun on its journey through the netherworld. Here the sun triumphs over Apophis, just as it was hoped the soul would triumph over the darkness of death. *Art courtesy of Katherine Scat- tergood.*

vulture- The vulture was worshiped as two different goddesses, Mut and Nekhbet. The head of Nekhbet, tutelary goddess of Upper Egypt, was worn as an emblem of kingship on royal crowns. The vulture's entire body formed the crown or headdress of the Great Royal Wife, and, like gazelle heads on crowns of lesser royal women, presumably indicated the Great Royal Wife's special status. For more on Mut and Nekhbet, please see below under *Gods and Goddesses*.

Plants

Because plants were also very symbolic, they were frequently depicted in Egyptian art and jewelry. The lotus especially, even beyond its symbolic representation of Upper Egypt, was especially important, representing in some creation myths a vehicle for an emerging god. The god Nefertem, for example, was depicted springing from a lotus blossom, as was a very young King Tutankhamun. In tomb and temple art, queens and others are shown sitting at a banquet, holding a lotus blossom and inhaling its scent.

Lotus blossoms are also among the motifs most often used in Egyptian revival jewelry, where they appear to come in second only to scarabs, and they are found as well on other decorative objects in pottery and china. The papyrus plant, less beautiful and aromatic than the lotus, is less often found in Egyptian revival; however, the American china manufacturer Pickard produced items with both lotus and papyrus blossoms (for which please see chapter three, page 125).

The rosette, identified by Flinders Petrie as an Egyptian decorative motif, is less often found in Egyptian revival objects, and when found is less definitively Egyptian because it is a motif found in other cultures. However, gold rosettes resembling those in Egyptian jewelry, such as a Twelfth Dynasty diadem, are found in Victorian jewelry. Rosettes also adorn a vintage vermeil pendant made by the Newark, New Jersey, firm Krementz Company, shown in chapter three, page 144.

A necklace, possibly c. 1910-1920 and of European origin, in 800 silver and enamel, with various Egyptian revival motifs, including the central motif of the head of a pharaoh emerging from a lotus blossom, an ankh, and two *sa*-amulets. The colors are those typical of Egyptian revival: red, dark blue, and turquoise, with the addition of a yellowish green. Marked for silver content; pendant is 1.75" x 1.125". The pendant also has a round hole on the reverse side, such as is sometimes found in Art Nouveau and later repoussé work. This necklace sold at auction for $285.

A watch pin in 14K gold, turquoise, and a small diamond, c. 1900, with an interesting symmetrical design of Egyptian heads growing out of stylized lotus blossoms, much in the way that the Egyptian god Nefertem was depicted in The Book of the Dead. This design frames a turquoise cabochon. The brooch, measuring 1.375" x 1.25", is unmarked, but the original clasp—which may have been marked—might have been replaced. A dealer price for this brooch might be in the $650-$750 range. *Courtesy of Red Robin Antiques.*

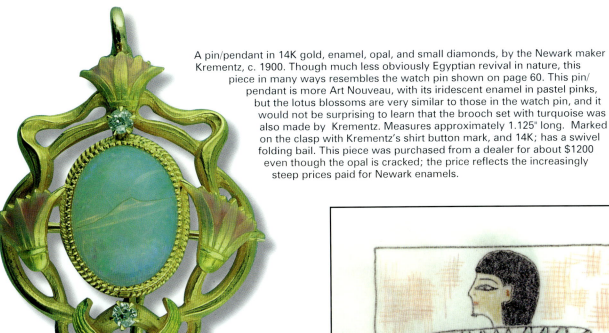

A pin/pendant in 14K gold, enamel, opal, and small diamonds, by the Newark maker Krementz, c. 1900. Though much less obviously Egyptian revival in nature, this piece in many ways resembles the watch pin shown on page 60. This pin/pendant is more Art Nouveau, with its iridescent enamel in pastel pinks, but the lotus blossoms are very similar to those in the watch pin, and it would not be surprising to learn that the brooch set with turquoise was also made by Krementz. Measures approximately 1.125" long. Marked on the clasp with Krementz's shirt button mark, and 14K; has a swivel folding bail. This piece was purchased from a dealer for about $1200 even though the opal is cracked; the price reflects the increasingly steep prices paid for Newark enamels.

The head of the god Nefertem, the youthful aspect of the god Atum (his name literally means "beautiful Atum" or youthful Atum) who in one of the Egyptian creation myths sprang from a lotus blossom that appeared on the primordial mound, which had emerged from the primordial floodwaters. In this sketch from The Book of the Dead, Nefertem is depicted growing out of a lotus bud, which may have inspired the design for the watchpin shown here.

THREE EXAMPLES OF CONVENTIONALIZED LOTUS.

1. From a wall-painting. 2. Wooden capital, from a wall-painting. 3. Bas-relief on square limestone column.

A drawing of three different versions of the stylized lotus from ancient Egypt, from Edwards, *Egypt and Its Monuments*.

A Belgian vase decorated on one side with two blue stylized lotus blossoms. The vase, which is signed on the bottom by its artist Dubois E5B, also has a small foil label on its side that reads TOURNE MAIN BUFFIO-ULX. It stands approximately 14" high, and was purchased for approximately $20 in an online auction.

A wonderful pendant in sterling silver, plique-à-jour and bull's-eye enamel, and a real or paste amethyst, that seems to hover stylistically somewhere between Edwardian and Egyptian revival. The four floral elements resemble, but are not definitively, stylized lotus blossoms. The colors, reds and greens seeming fainter because they are in translucent plique enamel, are equally typical of Egyptian revival and Edwardian jewelry, as is the geometric nature of the piece. Measures 1.75" in diameter; marked STERLING. Such pieces have become increasingly expensive, and can sell for as much as $1200, although an alert shopper can often find plique pieces online for less. *Courtesy of Robin Allison.*

A wonderful pair of earrings, possibly c. 1930-1940, in 800 silver and enamel in the form of a series of lotus blossoms, graduated in size, from which are suspended scarabs carved in rose quartz. Scarabs and lotus blossoms, both of which symbolized the emergence of the sun, are often found together in Egyptian revival pieces. Measure 2.75" x .625"; marked STERLING GERMANY. *Courtesy of Robin Allison.*

An unusual Egyptian revival pendant in 800 silver, plique-à-jour enamel, turquoise, citrine, and a baroque pearl, in the form of very stylized lotus blossoms. The outline provided by the plique cells clearly delineates these as lotuses, although the dangle at the top of the pendant is really the only typically revival lotus. Measures 4" x 1.125". *Courtesy of Robin Allison.*

A costume brooch in plated base metal, possibly c. 1910. The brooch seems fairly late Victorian or Art Nouveau in style but also has stylized lotus blossoms. Marked F.N. Co.; 2.875" x 2.25". It has in the past sold for around $20-$45 although recently it has been seen at auction with an opening bid of $75 and a reserve of over $100.

A ring in 14K gold and a green stone (jadeite, amazonite, or serpentine), in a setting that has a papyrus blossom in carved gold on one side and a lotus blossom on the other, n.d. These two plants were symbols of Lower and Upper Egypt respectively, and both were important economically as well as symbolically. The papyrus of course was used to make writing material, while the lotus scented perfumes and unguents, and was probably also the source of an opiate used as an anaesthetic.

A large (2" x 4.25") pendant in silver gilt with pearls and stones. In some ways, this pendant resembles Austro-Hungarian pieces in that it uses gold-washed silver in combination with pearls and irregularly shaped stones (here coral and turquoise) unmatched for color and size. However, each of the three lotus dangles is stamped with an Egyptian hallmark (on the front, where the marks dent the repoussé silver) for sterling silver, thus making it clear that the pendant was made in Egypt for the tourist trade or for export. A fourth lotus blossom serves as the bail. Aside from the stylized lotus blossoms, there is little of the Egyptian, or Egyptian-revival, about this pendant. It was purchased for approximately $50 in an online auction with minimal competition.

Just as all snakes are not Egyptian revival, neither are all lotus blossoms. This lotus blossom, in 15K gold, enamel, and mother-of-pearl, is in the British Arts and Crafts tradition (gold in 15K seems to have been used almost exclusively in Great Britain and Australia). Some artists working in the Arts and Crafts movement were interested in Eastern religions such as Buddhism. One Buddhist chant, *Om mani padme aum*, in translation says "Hail to the jewel in the lotus"–which this pendant, with its mother-of-pearl "jewel" set inside the lotus, perfectly represents. In case this were not clear enough, however, *Om mani padme AUM* is also engraved on the reverse of the pendant. It was bought for $600 from an online dealer.

A pendant in gilded metal, enamel, and glass, with six stylized lotus buds in champlevé enamel surrounding a blue glass oval (probably made in Czechoslovakia) with the head and torso of a pharaoh making an appearance on a balcony. The lotus blossoms are in colors a bit more muted than many revival pieces, but they do contain turquoise and dark blue, and are edged in red. The fine quality of the enameling (which shades nicely in the cells from light to dark) and its similarity to other pieces shown in reference books led the seller to attribute its manufacture to the firm of Piels Frères. However, the piece is unmarked and there is no real reason to think that it was manufactured by Piels Frères. Measures slightly more than 2.25" in diameter. A small loop at the bottom of the pendant seems to point to its having had a dangle at one point, possibly in the form of a blue glass scarab. A reasonable price for a piece like this might be anywhere from $95 to $275; it actually sold at auction for around $240.

Beetle Power

Of all of the symbols Egypt added to Western design, probably none was quite as unique–and as often used–as the *scarabaeus* beetle. Few, if any, other cultures have had so much respect for a mere insect! In fact, the Roman naturalist Pliny the Elder, when told about the reason for the Egyptians' reverence of the scarab beetle, added the words, "But of course this cannot be true."

The scarab beetle, called *Kheper* or *Khepere* (sometimes transliterated *Khepri*) by the Egyptians, was a sign of rebirth. The *scarabaeus*, which pushes its eggs before it in a sac made of dung, was thought to embody the force that pushed the sun daily through the sky. As Kheperre, it represented dawn, or coming into

An advertisement from *The Jewelers' Circular*, November 18, 1909, attesting to the continued popularity of scarabs in jewelry long after the opening of the Suez Canal and years before the discovery of Tutankhamun's tomb.

being, and as such was one of the three names given to the sun in Tuthmosis IV's Dream Stela. The scarab was used in jewelry, and could be made in gold or silver; carved from steatite, carnelian, lapis lazuli, or other stone; or made of faience. Both the rich and the poor wore scarab amulets, often inscribed on the reverse with a god's name, a wish such as "May Horus protect," the owner's name, or the name of a king. From the Twelfth Dynasty on, scarabs were used as seals to impress the clay which sealed wine jars, jars of honey, and other containers, for which purposes they were often inscribed on the reverse with a royal or other name,[3] or a person's official title.

O my heart that I received from my mother! My heart of my different ages, do not stand up against me as a witness! Do not create opposition against me among the judges! Do not tip the balance against me in the presence of the Keeper of the Scales!
Spell XXXB from *The Book of the Dead*

The scarab was also used as an amulet in funerary rites, in which guise it is known as a heart scarab. As its name suggests, it was placed over the heart (or, at times, over the throat or the thorax). This was intended to keep the heart, considered by ancient Egyptians to be the seat of intelligence and the soul, from testifying against a person during the judgment that took place in the afterlife. The heart scarab was often inscribed with a passage from The Book of the Dead exhorting it not to testify against its owner.

In the Eighteenth Dynasty, the scarab was also used as a sort of broadsheet by Amenhotep III. Amenhotep III used very large scarabs to announce various of his deeds, including his marriage to the (presumed non-royal) Tiye, who became his Great Royal Wife and the mother of his successor Akhenaton. Amenhotep III also commemorated the building of a large pleasure lake for his Great Royal Wife Tiye, his marriage to a princess of Mitanni, and a very successful day of hunting in which he captured fifty-six head of wild cattle. In his Lion Hunt Scarab, he recorded a total of one hundred and two ferocious lions killed in his first ten years on the throne.

In its winged version, the scarab was also used in jewelry, such as the winged scarab pectoral of Tutankamun, which also spelled out his prenomen *Nb-khprw-Rc* "Master of the becoming(s) of Re."

And it became one of the most familiar motifs in Egyptian revival decorative objects. The scarab, winged or otherwise, is found in jewelry, pottery, china, and silverware of the late nineteenth century; in items from the Edwardian and Art Deco periods; and in vintage decorative arts. It is still used today, and its continued use as a favored symbol in Egyptian revival items is, based on its past popularity, almost a foregone conclusion.

A winged scarab necklace sold as genuinely ancient–c. 500 B.C.—Egyptian but almost undoubtedly a fake or forgery. It was sold in an online auction supposedly by a university in the Urals, and a lengthy exchange via email with the vendor led to repeated assertions of authenticity, and the claim that the university had a large collection of artifacts excavated during the 19th century. However, a similar if not identical winged scarab was later pulled from an auction by another seller (not this time from Southern Urals State University) because of doubtful authenticity. This is not to say that the seller from Southern Urals State University knowingly misrepresented this piece; it is only mentioned to warn buyers that, without authentication and/or provenance, it is always best to assume that an Egyptian artifact is one of the many forgeries perpetrated by Egyptians during the late 19th and early 20th centuries.

A possibly ancient Egyptian scarab carved from steatite, in a vintage setting of silver and plique-à-jour enamel in the bright reds and blues associated with Egyptian revival pieces. The scarab is identifiable as possibly ancient by its hieroglyph of a falcon, representing the god Horus, which is much clearer and better delineated than hieroglyphs found on most modern forgeries. Also, it is not done in faience, as are most copies. However, it is still possible that this scarab, not having a provenance, is not genuinely ancient. Because of the quality of the scarab and the large size of this brooch (it measures approximately 3.25" across), it sold for $750, and had an original asking price of over $1000.

A scarab bracelet in 18K gold, sapphires, rose-cut diamonds, and rubies, possibly c. 1880. The bracelet is comprised of four gem-set scarabs, each "pushing" cushion-cut sapphires, set between the insects, with hind- and forelegs. It sold for $1175 at auction. *Courtesy of Skinner, Inc., Boston and Bolton, MA.*

A necklace in unmarked silver and semi-pre-cious stones carved into three scarabs, with a smooth carnelian scaraboid at the center. Such stone scarabs set into bracelets were extremely popular in the mid 1960s, although this necklace is consider-ably earlier. Measures 25", with the central scaraboid measuring 2" x .875". *Cour-tesy of Robin Allison.*

A necklace, probably c. 1900-1910, in sterling silver and semi-pre-cious stones carved into scarabs, complete with the usual marks carved into the scarab's body to give it the look of an ancient scarab. The scarabs are all in colors associated with ancient Egyp-tian jewelry, except for the amber one next to the central turquoise scarab. Measures 16" x 1.25" at its widest. The necklace, with its settings of leaves in silver, seems very much in the Arts and Crafts tradition. *Courtesy of Robin Allison.*

The fad for things Egyptian, and especially scarabs, took a rather odd turn during the late Victorian period, leading to the use of real dried scarab beetles set in jewelry–as in this suite in base metal and dried scarabs. While it's difficult to imagine wearing a dried insect (although admittedly a certain insect phobia is at work here), such jewelry is not uncommon; even the Smithsonian's Department of Costume and Social History possesses a similar scarab necklace. *Courtesy of Robin Allison.*

A stickpin in 14K gold and enamel, in the form of a winged scarab in red, light blue, green, and white. The pin is probably c. 1900, and likely of American origins, as it is marked 14K and has an unattributed maker's mark in the form of a flag. Measures .675" x .25". Although enameled stickpins have been selling for more at auction, a reasonable price for this one might be between $125 and $250. *Courtesy of Red Robin Antiques.*

An article on "Scarabaeus Jewelry" in the November 21, 1894 edition of *The Jewelers' Circular and Horological Review.* The illustrations show brooches, a stickpin, and cufflinks, all with a scarab motif. *Courtesy of Shelly Foote.*

A gold ring set with a large faience scarab in a swiveling bezel that resembles numerous rings found in ancient Egyptian tombs, which also had swiveling bezels–often in the form of scarabs–on a simple shank (see Andrews, 1990, 164 for examples). The reverse of the scarab is carved with rather obscure, undecipherable glyphs. The scarab measures approximately 1.25" x .875". *Private collection.*

A scarab ring in 18K gold that, unusually, is also a locket. The scarab swivels, the ring–like the one shown above–being constructed in the style of many ancient Egyptian rings. The scarab is also unusual in that it has been formed to resemble a stylized faience scarab, with an indented line running across the front and back of the beetle. Top of ring measures approximately .625" x .375". *Private collection.*

An 800 silver, lapis lazuli, and seed pearl necklace, c. 1890, possibly Austro-Hungarian (the silver content and the irregular, rather unfinished look to the seed pearls is typical of Austro-Hungarian jewelry of the period, though it might also hint at an Egyptian origin). Although Austro-Hungarian Egyptian revival pieces are rare, we have seen a couple, including a mummy pendant and a camel. This necklace sold for about $200 in an online auction.

A charming and unusual winged scarab brooch done in micro-mosaic set in silver. The workmanship is quite fine, and the maker even managed to find iridescent blue shell or stone, which set in the body of the scarab mimics the scarab beetle's natural iridescence. Measures 1.5" across. *Private collection.*

An unusual scarab brooch in porcelain, c. 1900, that has been painted to resemble metal–possibly the dark spots on the background are intended to resemble hammer marks. The scarab is in the usual Egyptian revival colors, with the addition of green (it seems that the green stone most commonly found in ancient Egyptian jewelry is green feldspar, though other green stones were used; and green is not uncommonly found in Egyptian revival pieces). *Courtesy of Robin Allison.*

A brooch in sterling silver and pink quartz (or, possibly, pink glass) with two carved scarabs side-by-side, n.d. though possibly 1920s or 1930s. This use of a conventional, stylized motif popular for a fairly long time shows yet again the difficulties in dating Egyptian revival jewelry. However, the brooch has an older c-clasp, making it most likely an older piece. Marked for silver content; approximately 1.5" wide. This brooch was purchased in an online auction for about $35.

A wonderful winged scarab in 935 silver, plique-à-jour enamel, carnelian, and marcasites. Here the wings are again in the form conventionally associated with winged scarabs, the feathers suggested by the enamel cells, the covert feathers in marcasites–which also edge the bottom of the wings. The plique enamel picks up the color of the carnelian scarab, making this a most attractive brooch. Measures 2.75" x .625", marked for silver content. This large brooch, beautifully designed and made, might be expected to sell for anywhere between $450 and $800. *Courtesy of Robin Allison.*

A bracelet in 800 silver and champlevé enamel, with alternating links formed by scarabs and by oval plaques with stylized lotus blossoms. The scarabs are nicely rounded, as they would be if formed by stone cabochons, and done in guilloche enamel that creates a shimmer much like that in a real scarab beetle. The lotus blossoms are in traditional turquoise, dark blue, and red, with yellow in the border. Measures 6.5" x .875". This would probably sell in the $275-$550 price range. *Courtesy of Robin Allison.*

An Art Deco brooch in 14K gold and a small diamond. While this brooch is extremely stylized, it is still possible to recognize a winged scarab in the geometric lines. The gold is in two different colors, as occasionally found in European and British jewelry from the 19th and early 20th centuries, but somewhat less common in American jewelry. This sold in the $400-$500 range by a dealer.

An Art Deco (or later) winged scarab in 800 silver and champlevé enamel, in the expected revival colors. The scarab's body is a bit more detailed than ordinarily found in such pieces, with six legs attached to the body instead of just the two front ones pushing a large solar orb and the two rear ones pushing a smaller orb. Measures 1" x 1"; marked for silver content. Such scarab brooches, often with stone cabochons instead of enamel for the body, can be found anywhere from $45 to $200 depending on size and condition. *Courtesy of Robin Allison.*

A page from *McCall's* (May, 1923) showing Egyptian influence on fashion. The top middle dress has embroidered winged scarabs on the pockets, showing that winged scarabs could be found almost anywhere.

A very stylized winged scarab in sterling silver, plique-à-jour enamel, a citrine, and a pearl. This pendant is so stylized that it is difficult to state with certainty that it is a scarab, except for the overall impression it gives of legs pushing a circle in front of it, a scarab-shaped body (though in a faceted citrine rather than the usual cabochon), and the wings meeting at the tip. Measures 1.5" x 1". It is hard to put a price on such a unique piece, especially as it is in the increasingly hard-to-find plique enamel, but in an online auction would likely bring well over $200, and possibly as much as $400-$500. *Courtesy of Robin Allison.*

A wonderful scarab necklace in sterling silver, plique-à-jour enamel, amazonite, and turquoise. This interesting piece has at its center a scarab carved in amazonite, flanked by creatures that seem to have the bodies of serpents and the heads of vultures, and having as well a tail. In fact, this necklace almost looks like it has combined the two tutelary goddesses of Egypt, the serpent goddess of Lower Egypt and the vulture goddess of Upper Egypt. The plique enamel complements the bluish green stone, being in shades of turquoise blue and green. Measures 2.75" x 1.5". This might sell for as much as $800-$1000 as it is an unusual and very decorative piece. *Courtesy of Robin Allison.*

Another very stylized scarab, this one a stickpin in silver and enamel. The wings, though less ornate as would be expected in a smaller piece such as this, are also scalloped at the edges, but the body is the usual scaraboid one (here in enamel rather than a cabochon stone) and the front and rear legs hold the conventional solar disks. Measures .5" x .5"; marked GK SILVER. A stickpin like this one, in silver but with plique-à-jour enamel, should probably sell for $75-$200. *Courtesy of Robin Allison.*

A necklace in sterling silver, plique-à-jour enamel, and lapis lazuli featuring a winged scarab carved out of lapis, curved wings flanking bodies and heads very similar to those in the piece shown above, and a vulture's tail. Two lapis drops finish the piece. The enamel in this piece, like the enamel in the similar piece, complements the stone rather than reprising typical Egyptian revival colors; it is in blues and greens that shade to lavender. Measures 3" x 2.125". It might be expected to sell for $850-$1200 at auction, and very likely for more in an upscale shop. *Courtesy of Robin Allison.*

A wonderful festoon necklace in sterling silver and enamel, with a scarab depending from stylized lotus blossoms in the revival colors red and blue. Interestingly, the dangles hanging from the necklace are in yellow plique-à-jour enamel. Scarabs and lotus blossoms are occasionally juxtaposed, as in the scarab and lotus blossom bracelet shown above, and in the Blackinton purse and brooch shown in chapter three, page 140. Center festoon section measures 5.75" x 4". *Courtesy of Robin Allison.*

A more conventional winged scarab in 935 silver, plique-à-jour enamel, and peridots. In this brooch, the feathers are clearly delineated, with the covert feathers in rounded cloisons. The colors of the enamel complement the peridots that make up the body of the scarab as well as the solar orbs between front and back legs. Measures 3.375" x .875". Brooches such as this one often sell for around $400 in online auctions, more if bought from a dealer. *Courtesy of Robin Allison.*

A winged scarab brooch in plique-à-jour and champlevé enamel, 800 silver, turquoise, and seed pearls, c. 1920-1930 and most likely of European origins. The colors, though muted due to the translucence of the plique enamel, are those often found in Egyptian revival jewelry: red (here appearing pink), turquoise blue, and dark blue (seen especially in the champlevé covert feathers). The plique shades from darker to lighter turquoise at the tips of the wings, as is common in older plique pieces. The old c-clasp and t-pinstem point to an older manufacturing date. Measures 1.75" x 1.375", and is marked 800 for silver content. The plique-à-jour enamel, increasingly hard to find in older pieces, makes this a more expensive than usual silver piece, with a price range of about $250-$450.

An Art Deco winged scarab pendant in sterling silver, plique-à-jour enamel, chrysoprase, marcasites, and pastes. Again the scarab, its body formed by a chrysoprase cabochon, is very stylized, with the scallop-edged wings (trimmed with marcasites) more suggested than defined, but recognizably a winged scarab nonetheless, with the joined legs in front and back holding red paste solar disks. Unusually, the scarab appears to have a small tail. A small dangle, resembling a stylized lotus blossom, finishes the piece. Measures 2.625" x 1.25"; undeciphered maker's mark. *Courtesy of Robin Allison.*

A winged scarab pendant in silver, vitreous enamel, amethyst, and a small pearl, c. 1920. The scarab is enameled in dark blue and a vivid green, something of a departure from the usual Art Deco Egyptian revival colors. The scarab itself is a very light purple amethyst. This might possibly at one time been sold as a suffragette piece, given the presence of the amethyst and pearl, but it is much more likely that the colors were used simply because they were popular. Undeciphered mark on reverse; measures approximately 1.375" x 1.5" including bail. A reasonable price for a piece like this, with all enamel intact, would be between $200 and $350.

At times it seems as if Egyptian themes were so popular that makers added them, apparently almost at random, to other designs that also enjoyed popularity. It's hard to think of another explanation for this bracelet, which combines carnelian scarabs with oval links in sterling silver and enamel that have a floral design in non-Egyptian revival colors of purple and green. Marked STERLING; 6.5" (not including clasp) x .25". This sold for approximately $45 in an online auction.

A pair of earrings in 18K gold (unmarked but tested) and lapis lazuli, in the form of scarab beetles suspended from lotus blossoms. Quite possibly these earrings were made in Egypt for the tourist market, but they are more finely crafted than many tourist pieces, down to small folded legs on the scarabs' underside; they are strongly reminiscent of a gold scarab pendant inlaid with lapis that belonged to the Eighteenth Dynasty queen Aahotep. No discernable marks; measure 1.25" from the top of the lotus blossoms. A decent price for these might be between $400 and $650, though they were purchased for more.

A winged brooch in sterling silver vermeil and enamel, probably c. 1930. This brooch is very typical of Art Deco Egyptian revival jewelry in its bright colors, here a bit of a variation on the standard red, turquoise, and dark blue. Marked STERLING; measures approximately 2.5" across. Such enameled pieces, while still fairly plentiful, have gone up in price recently, and now can be expected to bring upward of $100-$150, depending on size and condition.

A costume piece in the form of a pectoral, similar to but not obviously copied from a winged scarab pectoral found in Tutankhamun's tomb. Here, the scarab–actually a cross between a scarab and a falcon–carries cartouche amulets in its talons, with ankhs below its wings. The soft enamel is in the usual Egyptian revival colors. If this necklace were signed Hattie Carnegie or Miriam Haskell, it might be expected to sell in the $200-$300 range in an online auction; as it is, it should probably sell for less than a quarter as much.

A bracelet comprising seven faience scarabs set in what appears to be silverplated base metal, but which could possibly be a lower grade of silver. The seller was quite insistent that these were genuine ancient Egyptian scarabs–each is slightly different, and each is pierced for stringing–but it is far more likely that these are forgeries manufactured some time during the late 19th or early 20th century, when forgery was almost a cottage industry in Egypt. Wilson, in *Signs and Wonders upon Pharaoh*, recounts some of the tricks used by Egyptian forgers, including feeding scarabs to turkeys so that their digestive tracts would "age" the fake. Unless a scarab is discovered *in situ*–that is, unless it is found during an excavation in which it is given context—it is very difficult to say for certain that it is an ancient artifact. Unmarked; 7.25" x 1".

Daily Life

Well is it with this good prince, whose goodly destiny [death] has come to pass.
Bodies pass away, and others remain since the time of those who went before.

Ancient Egyptian "Song of the Harper"

It has been said that the ancient Egyptians were obsessed with death, so much time did they spend preparing for eternity, perfecting mummification techniques, building tombs intended to last forever, creating the spells and pictures that formed The Book of the Dead[4], taking with them not only this text meant to help them enter the hereafter and spend eternity there, but as much in the way of material goods as possible. While an Egyptian monarch very likely spent his life in a palace built of mud bricks, his tomb was built to last. It was made either of stones piled up to form pyramids or carved deep into the living rock in the Valley of the Kings. However, one way of looking at this preoccupation with the afterlife, which was supposed to be a fairly exact replica of life on earth, is that Egyptians enjoyed life so much that they wanted, hoped, or even expected that they would enjoy it eternally.

During the Eleventh Dynasty, at the end of the First Intermediate Period and the beginning of the Middle Kingdom, local rulers equipped their tombs with charming models of daily life carved in wood. In these models, sailors sail in miniature boats equipped with masts and oars, Egyptian women grind grain for bread at small tables set with mortars and pestles, soldiers bearing spears and shields march endlessly, cowherds herd their cattle, bakers bake, brewers brew. From the Middle Kingdom on, royal tombs were decorated with the painted scenes of daily life that replaced the tomb models. Still later, in the New Kingdom, tombs of nobles and others who could afford them were similarly decorated. Ordinary, everyday life is shown in great detail in these scenes, which depict not only memorable events such as battles and funerary rites, but commonplace occupations such as harvesting grapes, sailing, banqueting, hunting and fishing and fowling, dancing and singing and playing musical instruments. All of these vignettes of ancient life were intended to recreate life as the tomb's occupant had known it, so that he or she could continue to live it for a million years, *djet er neheh*–forever and ever.

Because these scenes are so evocative of ancient customs and manners, they are not infrequently used in Egyptian revival decorative arts. Perhaps the motif most often found is that which shows ancient Egyptian maidens dancing, playing musical instruments, or simply looking decorative.

A bracelet in 800 silver and enamel, with scenes of Egypt including pyramids, the Great Sphinx, obelisks, and temple ruins. Marked for silver content; measures approximately 7.5" x .5". This bracelet, in excellent condition, was purchased for approximately $550 at auction; similar bracelets seem to run the range from $225 to $650. Like many so-called Egyptian revival items, this bracelet really falls into the category of "travelog" jewelry rather than revival, which would use motifs inspired by ancient Egypt rather than scenes of contemporary Egypt.

A bracelet in 800 silver gilt and enamel, with scenes of ancient Egypt. While tourist bracelets such as this are not uncommon, most have either pictures of more modern Egypt or of ancient motifs (as in the other bracelet shown above). This one is unusual in that it has scenes of ancient Egyptians that might have come straight from tomb walls: bakers bake, scribes write, mourners mourn, pharaoh hunts in his chariot and makes ritual offerings. These scenes on the walls of the tombs of ancient kings and nobles were intended to create for the tomb's occupant a world almost exactly like the one left behind in death. These scenes became fairly common during the Twelfth Dynasty; in the Eleventh Dynasty, nobles put charming wooden models of everyday life activities in their tombs: boats complete with sailors, armies of marching soldiers holding spears and shields, bake houses with women grinding grain, cows and milkmaids, breweries and brewers. This bracelet measures 7.25" x .375". *Courtesy of Robin Allison.*

A scene from The Book of the Dead–the poorer Egyptian's version of earlier texts intended for those who could afford a lavishly decorated tomb. (However, a richly illustrated copy of The Book of the Dead was also clearly a luxury that not all Egyptians could afford.) Although the people represented in The Book of the Dead were deceased, they were depicted in pursuits that they might have enjoyed in life. In this vignette, the papyrus's owner and his wife are shown offering bouquets of flowers, presumably to a deity. *Drawing courtesy of Katherine Scattergood.*

A Belgian vase decorated with the picture of a kneeling Egyptian woman holding a bowl, perhaps containing food as she wears a cone of incense on her head. Such cones were worn at banquets by men and women alike, and presumably melted as the meal went on, releasing perfume. Banqueting scenes are quite frequently found on tomb walls, on which Egyptians depicted themselves and their loved ones enjoying the pleasures of life; and what more pleasurable than a banquet, with roasted beef and geese, onions and leeks, bread and sweet cakes, pomegranates and dates, beer and wine, dancing maidens, singers, and musicians? Frequently in these scenes, women hold lotus blossoms to their noses, inhaling the scent, and wear their finest sheer linen robes, their most sumptuous broad collars. This woman, however, seems to have been a servant. The vase, signed on the bottom by its artist Dubois E5B, also has a small foil label on its side reading TOURNE MAIN BUFFIOULX. It stands approximately 14" high, and was purchased for approximately $20 in an online auction.

A brooch from Bohemia, probably c. 1930, in (probably) brass, glass, and soft enamel, with a woman musician. This brooch is similar to one made by the Czech maker Max Neiger, in the town of Gablonz, and may either be by him, or else use the same glass components manufactured elsewhere in Bohemia. These Czech brooches come up fairly frequently in online auctions, but nevertheless sell for a considerable amount, up to around $250.

A cigar box with a scene of an Egyptian woman listening to a musician, probably c. 1910. This was purchased in an online auction purely for its decorative and historical interest, and has a fairly minimal value otherwise.

A reproduction on canvas of a painting by the prominent 19th century painter Sir Lawrence Alma-Tadema. Alma-Tadema, sometimes linked with the Aesthetic Movement, was best known for his paintings with Classical themes and settings, such as *The Baths of Caracalla* and *A Dedication to Bacchus.* He also painted several paintings set in ancient Egypt, such as *Antony and Cleopatra*, *The Discovery of Moses*, *An Egyptian Widow*, and, in this reproduction on canvas, *The Chess Game.* Despite the title, under way is a game of *senet*, a board game considered by many to be a forerunner of modern backgammon. The game was popular with ancient Egyptians including Tutankhamun, who was buried with three *senet* boards. The game is thought by some to have had ritual significance, perhaps as an aid in moving through the afterlife. These reproductions are sold by a number of online dealers, usually for about $25-$30. The game of *senet* itself can also be found.

A small statuette of a young Egyptian woman carrying a container on her head and a jug in one hand, passing by a stela. Although clearly engaged in a burdensome task, she is wearing a fillet with a uraeus and two hanging decorations perhaps meant to represent the pharaonic *nemes* headdress. Her hair, though, is believably Egyptian–straight and somewhat flared, with what appear to be dangles at the ends. Signed SIMONELLI DEPOSE ITALY 124; about 8.375" tall, including the marble base. It sold for approximately $25 in an online auction.

A pen holder and accompanying paperweights in the form of sphinxes in gilded metal, probably spelter, perhaps c. 1910-1920. The central figure is a kneeling woman, here wearing what appears to be a royal headdress of the type reserved for pharaohs, not queens, along with a kilt also usually associated with Egyptian men rather than women. Unmarked; measures 6.625" across; sphinxes are 1.75" high. This set sold for about $50 in an online auction..

A plate in faux damascene, almost certainly a tourist item from Egypt, decorated with a scene showing a man wearing what appears to be the blue war crown poling himself among lotus blossoms in a small skiff with an antelope prow. At first glance the man appears to have a serious skin ailment, but closer inspection reveals that he is wearing what looks like a leopardskin top. Flying-saucer-shaped clouds float in the sky above him, while pyramids, obelisks, and pylons can be seen in the background. Unmarked; approximately 7.75" in diameter. It was bought for about $12.

A modern small statuette of an Egyptian woman made in opalescent glass from original c. 1920 molds used by the Sabino art glass company. Sabino, located in France, produced glass that is sometimes mentioned in the same breath with that of Lalique. The woman, about 5" tall, is dressed in a flowing Egyptian gown, and holds a fan or leaf in either hand. Although this is a replica, it was still rather pricey, around $150. Larger statuettes by this company are offered for as much as $800.

A belt in silverplated metal and enamel, with links alternately showing three scenes: a winged goddess and a seated pharaoh; two musicians, one playing a harp and the other a lute-like instrument; and a human–pharaoh, priest, or supplicant–bowing to a god. Measures 27" x 1"; unmarked. This sold for about $65 in an online auction.

Gods and Goddesses

They also told me that the Egyptians first brought into use the names of the twelve gods, which the Greeks took over from them, and were the first to assign altars and images and temples to the gods, and to carve figures in stone.

Herodotus, *The Histories*

Egyptian religion was never quite as simple as Herodotus and the Greeks, and at times even Egyptologists, supposed. The Greeks believed that their pantheon of twelve human, often fallible and even mischievous, gods was the same as the Egyptian array of deities. They even went so far as to conflate or identify Greek gods with Egyptian deities: Hathor was Aphrodite, Neith was Athena, Thoth was Hermes, Amun was Zeus. A more recent work[5] has proposed that the Greek goddess of wisdom, Athena, was derived from the Egyptian goddess Neith, whose symbol was a shield decorated with crossed arrows.

However, the Greek pantheon seems to have little to do with Egyptian gods and myths. Many Egyptian deities began as local gods, including Amun, the god of Thebes; Montu, a warlike god in the form of a bull, also a Theban deity; Ptah, god of Memphis; Horus, of Edfu; Neith, of the Delta town Sais; Sekhmet, also of Memphis; and Min, of Coptos. At times these gods were organized into triads, or groups of three, with a father, mother, and child. Thus Sekhmet was thought to be the wife of Ptah and the mother of Nefertem. The most famous of these triads consisted of Osiris, Isis, and Horus; this perhaps represents a fusion of two separate religious strains, that of the earth god of fertility and the afterlife, Osiris, with the solar religion's Horus.

Many, but not all, of the Egyptian gods were theriomorphic–that is, they took the form of animals or of human bodies with animal heads. Amun was sometimes depicted as a ram, as was Khnum, Anubis was a jackal, Bastet was a cat, Hathor a cow (though she is usually depicted in human form, with a cow's ears and a crown consisting of a sun disk between cow's horns), Horus a falcon, Mut and Nekhbet were vultures, Sekhmet was a lioness, Sobek a crocodile, Thoth an ibis or a baboon, Wadjat (Edjō) a cobra. On the other hand, Isis, Ma'at, Min, Nebthys, Neith, Osiris, and Ptah had human forms (although Osiris was depicted as a mummified king wearing the crown of Upper Egypt, and Ptah as a bearded mummiform figure often wearing a skullcap).

Given their abundance of local or regional gods, it's not surprising that the Egyptians also had a number of creation myths. In one, Khnum, the ram-headed potter, created mankind out of clay on his potter's wheel. In the Memphite creation myth, Ptah emerged from the primordial waters, Nun, to become the creator of all. These myths, like the gods themselves, co-existed peacefully, without religious or dogmatic strife. When one god's center became the seat of royal power, that god tended to become dominant–but usually not at the expense of other gods. Amun, for example, fused with–rather than

A drawing of the sister goddesses Isis and Nebthys from The Book of the Dead. The goddesses are virtually identical except that each wears her name as a crown: Isis' name was spelled with the hieroglyph for "throne," while Nebthys' name was written with the words for "mistress" and "temple" (or "dwelling"). Between the two goddesses is a *djed*-pillar supporting an ankh with arms, which in turn hold up the sun. *Drawing courtesy of Katherine Scattergood.*

replaced–the solar god Re, to become the powerful New Kingdom god Amun-Re.

The Egyptians also organized their gods into various hierarchies, much like the Greeks had the Titans, who gave birth to and were replaced by the Olympic gods, who then went on to create many of the lesser deities, such as the muses. The Ogdoad, a group of eight gods who existed before the birth of the sun, was one such group. It included Nun and Naunet, who represented the primordial waters; Kek and Keket, the gods of darkness; Amun and Amaunet, invisible power; and Heh and Hehet, infinity. Together, the Ogdoad created a mound on which an egg grew, out of which hatched the sun god Re (sometimes represented by Horus). The Ennead, a group of nine gods, centered around the myth of Isis and Osiris. It included the god Atum, who created himself and went on to create Shu (air) and Tefnut (moist air) from his saliva (or, in another version, his blood). Shu and Tefnut begot Geb (earth) and Nut (sky), who in turn were the parents of Osiris, Isis, Seth, and Nebthys. In this version of the creation myth, Geb (in the form of a goose) daily laid the egg from which the sun hatched.

A judgement scene from The Book of the Dead. In it, the heart of the deceased is weighed against the feather of the goddess of justice and order, Ma'at, by the jackal-headed Anubis. A fearsome goddess, half-crocodile and half-hippopotamus, waits to eat any heart that is weighed down by sin or wrongdoing, and thus does not pass the judgment. Thoth, pen and papyrus in hand, stands ready to record the verdict. The *ba* of the deceased is an interested onlooker at these proceedings.

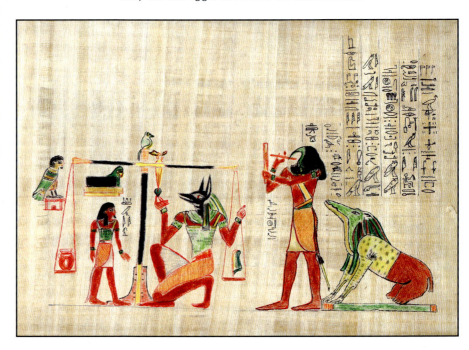

Following is a list of some of the Egyptian gods found in revival jewelry and other decorative arts:

Anubis- Anubis, the jackal god–represented either as a jackal or a human body with a jackal's head–was the god of the necropolis and of embalming. As such, he guided the deceased to the afterlife, and was often present in judgment scenes.

A charm or pendant in 14K gold in the form of the god Anubis, here represented with a jackal's head atop a human body. In Egyptian mythology, Anubis was the god of the western desert, a funerary god who conducted the dead to the underworld. As such, he is often shown in judgment scenes, where the heart of the deceased was measured against the feather of Ma'at, the goddess of truth and justice. Measures 1.375" x .5", including bail. Egyptian revival pendants and charms, some new, some vintage, are easily found, and usually bring around $50 to $150, often depending on age, size, weight, and amount of detail, including enamel or gemstones.

A large contemporary brooch (marked MCMDXXXVI, or 1986 on its accompanying card) in what appears to be gold-plated base metal and a purple glass stone, in the form of a recumbant Anubis, the jackal god of the necropolis and guide to the underworld. Measures 1.875" x 2.625"; marked on reverse ARTIFACTS ©JJ. Being relatively recent and costume, this brooch should probably be priced at around $10-$25.

A vintage pin in sterling silver and enamel, in the form of a barque conveying various figures including what appears to be the jackal-headed god Anubis, a sphinx, a bird (possibly a *ba*), and an Egyptian–possibly this was meant to indicate Anubis guiding a dead person and his soul to the hereafter. The enamel is in the usual Egyptian revival colors, with the addition of white. Marked STERLING; about 1.25" wide. While Egyptian barque pins can be found on occasion, they do not seem to be especially common. They range in price from about $125 to $300, partly depending on size and condition.

Hathor- Hathor may have begun as a local goddess–she had a powerful cult center at Denderah–but during the early dynastic period, when the king became identified with Horus, she became identified with the queen. In fact, her name means "temple (or house) of Horus." Depictions of Hathor with a cow's head are fairly late, but it seems clear that from ancient times she was identified with a cow: Her crown consisted of a solar disk between two cow's horns, and she was not infrequently depicted with cow's ears. Isis too was often shown wearing the crown with the disk and horns, as was Egypt's queen. The Greeks and Romans came to identify Hathor with Aphrodite, the goddess of love, but it seems fairly likely that Hathor was originally a goddess of music and dance. The sistrum, a type of percussion instrument, sometimes took the form of Hathor's head, complete with cow's horns and ears.

A drawing of a capital in the shape of Hathor's head. While most Egyptian columns were lotiform or papyriform, with stylized floral capitals, those with Hathor-head capitals were also occasionally used.

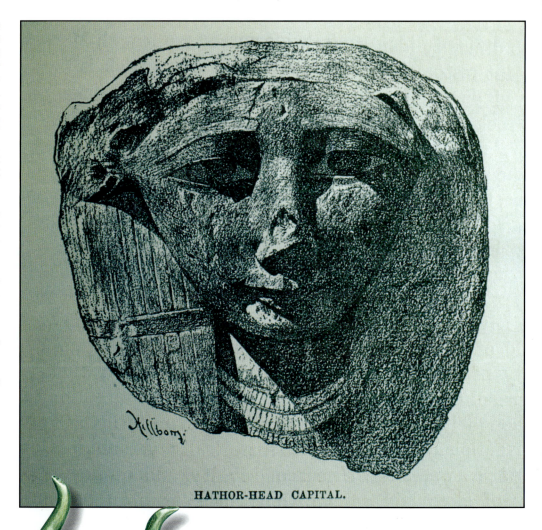

HATHOR-HEAD CAPITAL.

A fairly modern handcrafted pendant in sterling silver and glass in the form of Hathor, here wearing a crown with the solar disk between horns, and depicted with bovine ears. Hathor was one of the most important goddesses in ancient Egyptian religion, perhaps second only to Isis. As goddess of the Theban nome, she is found in offering scenes in which various pharaohs and queens pay her homage. Measures 1.125" x 2.375"; marked on reverse MELANIE STERLING. This pendant sold for $25 in an online auction, but from a dealer might go for twice that much.

Horus- Usually represented as a falcon, Horus was the local god of Edfu and was originally a solar god. He was found in the names of some of the earliest kings of Egypt, including the First Dynasty's Hor-Aha (the Fighting Horus). As the god who replaced his father Osiris on the throne of Egypt, Horus was embodied by the living pharaoh; two of the pharaoh's five names[6] were names preceded by the god Horus's name. Later, besides figuring largely in the myth of Isis and Osiris as their avenging son, Horus also became identified with the sun god Re as Re-Harakhty (which means "Re, Horus of the Two Horizons"). Re-Harakhty is usually depicted as having the body of a man and the head of a falcon.

A pendant in unmarked silver and champlevé enamel with a combination winged scarab- falcon. The scarab has a falcon's (or possibly a vulture's) tail and talons, here holding twin *shen*-amulets (cartouches), and a scarab body with a scarab's forelegs, which are not pushing the usual solar disk. This may have been made in Egypt as a tourist or export piece. It sold for approximately $65 in an online auction.

A "limited edition" (to 39,000 worldwide!) plate by Osiris Porcelain, with a winged falcon based on an amulet belonging to Tutankhamun depicted on page 84. The plate has a border of stylized lotus blossoms in turquoise, dark blue, and gold. Measures 7.375" square; marked Plate No. 2670 "THE HORUS FALCON" First Issue of the Collection "DEITIES OF ANCIENT EGYPT" ©1997 Osiris Porcelain, with the additional information stating that: "The Egyptian original was faithfully modelled on a valuable porcelain plate. With handpainting and decorated with an artistic ornamental border. Rich gold plating." This plate was also issued a Bradex number, 15-075-005-01. It sold for approximately $25 in an online auction.

An artist's rendition of a pectoral in gold, glass, and semi-precious stones in the form of the god Horus, here a falcon wearing the solar disk on his head. In ancient Egypt, the ruling king was identified with the god Horus, and was considered to be the living embodiment of the god. *Courtesy of Katherine Scattergood.*

Isis- Perhaps the best-known of the Egyptian deities, Isis was the sister and wife of Osiris, who ruled over the earth. When their jealous brother Seth hosted a banquet at which he had Osiris slain, and his body hacked into pieces that were buried up and down the length of the Nile, Isis searched the whole of Egypt until she had gathered the pieces of her husband's body and restored him to life. She was, unfortunately, unable to find his phallus, which had been devoured by a fish. Through her powerful magic, she became pregnant with and gave birth to Horus. Because Osiris, impotent without his phallus, could no longer rule Egypt, Horus took his place on the throne of Egypt, and Osiris went down to rule the underworld. As king of the underworld, Osiris presided at the weighing of the souls. According to Herodotus, Isis and Osiris were the only two gods worshiped throughout Egypt. Isis, the picture of wifely and maternal devotion, was popular in ancient Greece and Rome, and was at the center of a powerful mystery cult. In ancient Egypt, Isis was often represented as a winged goddess, and it is this representation that usually occurs in Egyptian revival depictions of her.

A winged goddess in sterling silver gilt and enamel, probably c. 1930. Although ancient Egyptians depicted numerous winged goddesses, including Hathor, Ma'at, Nebthys, and Nut, this brooch was probably intended to represent Isis, the most popular of ancient Egyptian goddesses both then and now. Aside from Hathor, usually shown with cow's ears and often carrying a sistrum, goddesses were often almost indistinghishable one from another–they were commonly shown wearing close-fitting dresses, sometimes with a reticulated pattern, and with similar features and hair–except for their names, which they often wore on their heads as a type of headdress. Isis' name consisted of a throne, Nebthys' had a basket hieroglyph (for **nbt** "mistress") and a temple or house (**hwt**), and Ma'at wore the feather of justice. Isis was also at times shown wearing a vulture crown with a solar disk between two horns–the same horns and solar disc also used for Hathor. Marked STERLING. This rather crudely fashioned brooch was purchased from a high-end dealer for $175, but in an online auction should sell for considerably less, possibly even as little as $25.

Nicely detailed pendant in sterling silver, showing a winged goddess, presumably Isis, holding aloft a cartouche with an ankh. Probably mid-century. Measures 1.75" (including bail) x 1". Marked STERLING ©, with unknown maker's mark (called by one vendor a "Navajo star"), almost undoubtedly of U.S. manufacture. Price approximately $35-$70 at online auction.

Kheper (Khepri)- See above under *Beetle*

Nekhbet- The vulture goddess Nekhbet was the tutelary goddess of Upper Egypt, and was worn next to the uraeus serpent, representing the Lower Egyptian tutelary goddess Wadjet (Edjō), on pharaonic crowns and headdresses. The vulture also formed the headdress of the Great Royal Wife. In this guise, the vulture may represent Mut, a goddess whose name meant "mother" and who was depicted wearing the vulture crown along with the White Crown of Upper Egypt. The goddess Isis was also depicted wearing the vulture crown.

A brooch in sterling silver in the form of the vulture goddess Nekhbet, here shown in flight with a feather (presumably that of the goddess Ma'at) in one talon.

Selqet- Invariably portrayed as a woman wearing a scorpion crown, Selqet was essentially a scorpion goddess. Scorpions were, not unreasonably, feared by the Egyptians, but like other fierce or deadly creatures such as crocodiles and cobras, they also were worshiped in, it is tempting to suppose, a gesture of propitiation. One of the earliest kings took the name Scorpion, so it also would appear that the Egyptians saw scorpions as creatures possessing some degree of power.

Thoth- The ancient Egyptian god of writing and knowledge, Thoth was most often represented as an ibis, although he was also upon occasion depicted as a baboon. Like many Egyptian gods, Thoth could be represented as the animal itself, or as a human form with the head of an ibis. In Egyptian religion, Thoth was present at the Weighing of the Soul in the hereafter, the scribe who wrote down the verdict when a deceased person's heart was weighed in the scales against the feather of Ma'at, the goddess of truth and justice.

Wadjet (Edjō)- See above under *Animals and Plants: serpent*

A large costume pendant in goldtone metal and soft enamel, showing a seated queen holding a lotus blossom to her nose. The queen, only identifiable as such by her name in the cartouche, is meant to represent Ramesses II's Great Royal Wife Nefertari, whose beautifully decorated tomb in the Valley of the Queens was found in 1904 by the Italian archaeologist Ernesto Schiaparelli. It is widely considered to be one of the most beautiful, if not *the* most beautiful, of the tombs in the Valley of the Queens. However, damp and leaching have ruined many of the wonderful tomb paintings that decorate the walls of the tomb, and it has recently undergone extensive restoration and attempts at conservation. In the tomb's paintings, Nefertari is most often depicted wearing the vulture crown with solar disk and horns in scenes with various deities including Hathor, Isis, Neith, and Thoth. In this pendant, however, she is more informally attired; often the lotus is held by women in banqueting scenes. Although not as well known as the similarly-named Nefertiti, Nefertari appears much more frequently in Egyptian art and architecture thanks to the prolific building program undertaken by her husband. Unmarked; measures 2.25" x 2.625". This was never meant to be an expensive piece of jewelry, and should probably sell in the $10-$25 range.

Kings and Queens

Numerous Egyptian revival objects depict kings and queens, foremost among them Cleopatra, Nefertiti, and Tutankhamun, shown in the introduction, pages 11-13 and chapter one, pages 25-30. However, many ancient scenes on temple and tomb walls showed kings performing rituals, such as offering to the gods, or undertaking almost obligatory feats of strength, such as smiting enemies or hunting in chariots–these scenes appearing even in tombs or on temples built by kings known not to have gone into battle, such as Tutankhamun. Such scenes, not unlike those showing daily life but used specifically to depict pharaohs and their queens, appear occasionally in Egyptian revival jewelry and other decorative objects. Given that these scenes are very formulaic, repeated over and over again in reign after reign, it is often very difficult to assign a name to the pharaoh depicted. Unless, that is, the helpful copyist has included the royal name, as is the case with costume pendant depicting Ramesses II's Great Royal Wife, Nefertari. In other revival objects, such as the ivory letter opener shown below, the king is portrayed as a static figure, arms crossed in a mummy-like pose.

A small charm in 800 silver gilt and enamel, in the form of the head of a queen wearing the vulture crown. Marked for silver content; approximately .625" long. These charms are fairly available, and can often be found for $30 or less.

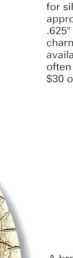

A brooch in 18K gold, enamel, and diamonds, possibly of French origins c. 1900. The queen, in enamel against a textured background that somewhat resembles crocodile skin, wears a modified vulture crown set with small diamonds; while the vulture's wings and tail are present, its characteristic head is missing. *Courtesy of Skinner, Inc., Boston and Bolton, MA.*

An Art Deco compact in silver and guilloche enamel, with a hand-painted scene of a king wearing the red crown of Lower Egypt (here unaccountably in blue) and holding what appear to be two unidentified offerings. Random hieroglyphs complete the front of this Egyptian revival piece. The reverse contains Tutankhamun's prenomen in a cartouche, dating the compact to after 1922. Marked for silver content; measures approximately 1.5" in diameter. In very fine condition with no dings to enamel or metal and with the original tiny powder puff, this sold for $450 in an online auction.

Certain scenes were repeated over and over again on temple walls and royal tombs, seeming to be almost obligatory. Thus even on monuments of pharaohs not known to have engaged in warfare, the scene of smiting the enemy can be found, the very image seemingly a significant, perhaps symbolic, ritual associated with defending Egypt against her foes. One of the often-repeated royal scenes is the chariot scene, with the pharaoh (wearing the blue crown associated with warfare) in his chariot, bow strung and pulled back, horses rearing in excitement. This scene is also a popular Egyptian revival motif, occurring on cufflinks and earrings, vases and jars. Here it appears in gold against a dark blue background on a humidor, probably c. 1920-1930, from Austria–or, very likely, Bohemia in the present-day Czech Republic. The side shown here has a pharaoh, wearing a scarf or streamer below his crown in the fashion set by Akhenaton, Nefertiti, Tutankhamun, and Ankhesenamun during the Amarna period. This pharaoh also rides in his chariot, but this time with bow lax, horses relaxed. In between the two pharaohs are incised (and illegible) hieroglyphs. The top is decorated with winged disks, possibly scarabs, and cobras. Measures 10.25" high (including top) and 5" in diameter. Incised on the bottom Austria 3104, with an unidentified mark. Sold at auction for about $75.

A pair of earrings with vintage Czech glass squares depicting a pharaoh in his chariot. Similar scenes are found on monuments of Ramesses II and Tutankhamun, though the latter almost certainly never went into battle. While the glass is vintage, it may be that the findings are newer. Such Czech Egyptian revival glass–in the form of scarabs, lotus blossoms, pharaonic scenes, mummies—comes up frequently at auction, either loose or in settings, and is usually quite affordable.

A set of cups and saucers with a medley of Egyptian revival motifs, including a pharaoh in his chariot. Marked PORCELAINE EGYPTE F.M. 7 CO. These mugs have a very minimal value.

A pair of costume earrings in the form of pharaohs' heads, possibly made in Czechoslovakia c. 1930-1940. These dimensional faces, with the king wearing the *nemes* headdress, appear on many items, including desk sets, clocks, vases, and other useful or decorative items. Some are found on objects manufactured by the Benedict company in their Karnak brass line, for which please see chapter three, pages 138-139. It is not clear whether Benedict made these faces themselves, or bought them from a supplier. Similar earrings are easily found, and tend to sell for under $10.

A letter opener in ivory, in the form of a pharaoh, probably c. 1930. Although not precisely representing a mummy, the pharaoh has arms crossed in front–a pose usually reserved for embalmed kings. Unmarked; approximately 10.75". About $40. The ancient Egyptians imported ivory for use in inlays for furniture and for making small items such as palettes and jars for cosmetics and unguents. It was apparently highly prized then as it has been in the recent past; a number of ivory objects were found in Tutankhamun's tomb.

A14K gold and porcelain ring, with the hand-painted head of an Egyptian queen wearing the vulture crown. Probably c. 1900, based on the style of the ring and the quality of the painting. This was purchased for approximately $240 in an online auction.

A ceramic brooch with the head of a pharaoh in profile, probably c. 1930. The brooch, like a number of other Egyptian revival items, has a Greek key pattern forming a border. Rather unusual and most likely hand-made, the brooch sold for approximately $65 in an online auction.

An unusual pharoah stickpin, possibly from the Art Deco period, with the pharoah's face represented by a blue glass cabochon. This is undoubtedly meant to represent a royal Egyptian figure, however; a somewhat stylized *nemes* headdress is present, along with the ceremonial beard. This small pin sold for approximately $25 in an online auction.

Three very similar brooches, probably c. 1910-1920, in silver, semi-precious stone, and enamel, in the form of winged pharaohs. While winged goddesses were fairly common in ancient Egyptian art, winged pharaohs seem to be a more modern contrivance. The main difference between these three brooches is the material from which the pharaoh's face has been carved: The upper one appears to be in rock crystal; the lower one is in lapis lazuli; and the center one is in a translucent reddish purple stone, possibly amethyst or garnet. These brooches are not uncommon; however, they seem not to come up with great frequency at auction. When they do, they sell for about $150-$200. *Upper brooch private collection; lower brooch courtesy of Robin Allison.*

Another brooch depicting a winged pharaoh, this one also wearing the traditional striped *nemes* headdress, and holding a stela with a cartouche containing the name Kheperre (possibly meant to read Nebkheperure, Tutankhamun's prenomen). Although the brooch is in brass, it is nicely detailed–albeit with wings that belong more to a Renaissance cherub than a winged pharaoh. Measures 2" x 2" and is unmarked, with a c-clasp. *Courtesy of Shelly Foote, Ventura, CA.*

A bracelet in 800 silver gilt and enamel, undoubtedly from Egypt as export or tourist jewelry, probably c. 1930. The central element of the bracelet is a queen wearing the vulture headdress, flanked by lotus blossoms. Unlike the other elements, the hand of Fatima, an Islamic good luck charm, was not borrowed from ancient Egypt. The bracelet appears to be missing an ankh, but nevertheless sparked rather intense bidding, finally selling for around $165 in an online auction.

A buckle, probably brass, with an Arabic inscription (not uncommonly found on tourist jewelry) in the center and the head of a queen wearing the vulture crown on either side. This is fairly representative of tourist jewelry, which can be found with a fair amount of regularity in online auctions. Pieces such as this usually sell for under $40, although with competitive bidding they can go for more; this one sold for approximately $38 in an online auction.

Mechanical pencil in silver and enamel, in the form of a pharaoh wearing a kilt and striped *nemes* headdress. Such pencils come up frequently at auction, and seem to have been made by the hundreds if not thousands, possibly to be worn on chatelaines (although the fashion for these would seem to have waned by the 1920s, when these pencils were most likely made). In general, they sell for about $65-$150, depending on condition.

A bracelet by the Portuguese company Topazio, n.d. but likely mid-century, in sterling silver. The angular cuff bracelet has a design of a pharaoh's head framed by serpents and lotus blossoms. Topazio is possibly best known for its filigree silver and enamel peacocks, which appear quite often at auction; this bracelet is much less frequently seen. *Courtesy of Robin Allison.*

A winged pharaoh in 800 silver and enamel, which formed part of a chatelaine hook. The pharaoh wears the traditional *nemes* headdress with uraeus serpent, a ceremonial beard, and a broad collar. Present are the usual revival colors in somewhat worn enamel. The asking price for the entire chatelaine–of which only this portion was in the Egyptian revival style–was $175.

Mummy! Mummy! Has Anyone Seen My Mummy?

Mummies, so closely identified with ancient Egypt, actually occur infrequently in Egyptian revival jewelry and decorative arts. Possibly this is because they furnish too grim a reminder of death, or possibly they are not deemed attractive enough or symbolic enough to make their way into Egyptian revivals. And, as a point of fact, mummies were not unique to ancient Egypt; the South American Incas and other Andean cultures mummified their dead as well.

However, there are a few Art Deco and vintage mummiform objects, including charms and charm-like propelling pencils, to be found. An Austro-Hungarian pendant, possibly c. 1890, had an enameled mummy case, the only Austro-Hungarian Egyptian revival piece Dale has seen in many years of collecting. (Unfortunately, Dale slept through that particular auction, giving profound and disappointing credence to the motto "You snooze, you lose.") A more modern Egyptian revival mummy is a porcelain Limoges box, which consists of a mummy case that opens to reveal a smaller porcelain mummy.

Two pair of earrings, possibly from Czechoslovakia (although this might be a good place to note that many vendors tend to attribute a Czech origin to Egyptian revival costume jewelry, whether such attributions are well-founded or not), in the form of mummy cases. These were purchased at auction for approximately $15 each pair.

A charm in silver and enamel, in the form of a mummiform coffin that opens to reveal a small, removable mummy. These charms, in spite of their small size (approximately .75" in length) sell well at auction, usually for about $100-$150. Although mummy jewelry is not as commonly found as that with other Egyptian motifs, a number of charms seem to have been made in the form of mummy cases. Limoges makers also manufactured small boxes in the shape of sarcophagi or mummy cases, with removable mummies.

An advertisement in the May 9, 1923 *Jewelers' Circular*, for a mummy case charm that opens to reveal a removable mummy. The charms on either side of the movable charm appear not to open. The charms were manufactured (by this company at least) in both bronze and silver.

Pyramids and Obelisks

The gods who were before rest in their pyramids, and likewise the noble and the glorified, buried in their pyramids.
Ancient Egyptian "Song of the Harper"

Obelisks and pyramids were, before the Napoleonic survey of Egypt, the most visible remnants of ancient Egypt. Even Europeans who had never had the privilege of traveling to Egypt could visit obelisks carried away by conquering Roman emperors and generals, and set up in Rome's squares. The first modern study of hieroglyphs, by Athanasius Kircher, was done using texts copied from such an obelisk. Prince Wilhelm of Hesse, when he opened the spa Wilhelmsbad, included a pyramid as the "shrine" to the mineral springs that fed the healthful baths.

It is probably no accident that the most famous American Egyptian revival building, the Washington Monument, is in the form of an obelisk. So was a monument erected in memory of Vermont's Green Mountain boys.

Unlike the pyramid, which was not unique to ancient Egypt–the central American Maya built numerous pyramids on top of which they constructed temples to their gods–the obelisk was completely Egyptian. It is sometimes said that Queen Hatshepsut had stone-cutters create the first obelisk, hacking it out of a single large block of stone, allthough other sources list earlier obelisks. But whenever it first made its appearance, the obelisk was quite clearly an outgrowth of the pyramid; in form, it is an elongated, sloping square column topped by a small pyramid.

The most famous Egyptian pyramids, although not the only ones built by the Egyptians, are the three great pyramids at Giza. These were built during the Fourth Dynasty in the Old Kingdom necropolis outside of the then-capital city of Memphis. The largest pyramid, that of Khufu (Greek Cheops), was the oldest of the Seven Wonders of the Ancient World, and is the only one of those wonders to have survived.

The first pyramid built by the Egyptians is thought to be that of the Third Dynasty ruler Djoser, constructed at Saqqara. It was supposedly designed by the great Egyptian sage Imhotep (later deified and revered as the god of, among other things, medicine) as an outgrowth of the *mastaba*-type tomb. It was in the form of a step pyramid–that is, it had different levels of varying size, the largest at the bottom and smallest at the top–and thus resembles a number of different *mastabas* stacked one on top of another. The pyramid with smooth, sloping sides was a later development. Pyramids were also built during the Middle Kingdom, though on a much smaller scale.

In ancient Egyptian mythology, the pyramid was associated with the *benben*, or phoenix, which supposedly built its nest atop it. Herodotus wrote of this mythological bird, saying that it had plumage that was partly golden, partly red, and was in size and shape the same as an eagle. He then went on to say that he himself had not seen this bird, as it appears only once every five hundred years, on the death of its parent bird.

Pyramids can be found on vases (often in modern desert scenes) and in three-dimensional charms, but oddly enough obelisks seem to be as commonly found in Egyptian revival jewelry and silverware. Most notably, a pyramid appears on the reverse of the United States one dollar bill, where it has an unblinking eye in its capstone, very likely a Masonic symbol.

The obelisk, an enduring symbol of ancient Egypt, was used in this advertisement to sell synthetic stones, the implication being that the synthetic stones would stand the test of time as well as the obelisk had done. An obelisk, known as "Cleopatra's Needle," was installed in New York's Central Park in the 1880s. Other obelisks, in Paris, London, and Rome, were often the most visible signs of ancient Egypt to be had before the exploration of Egypt by Europeans and Americans began in the early 19th century.

An unmarked silver (possibly 800 silver) souvenir spoon with a handle in the shape of an obelisk inscribed with hieroglyphs, with an engraved "travelog" scene of pyramids and Nile boats in the bowl. A fair number of Egyptian revival items were made in Egypt and purchased as souvenirs, though not all are as conspicuously tourist-oriented as this spoon. Unmarked; 4.75" long. It was purchased for about $10 in an online auction.

A pendant in sterling silver in the form of an obelisk with hieroglyphs. Like the obelisk-handled spoon, this was very likely made in Egypt either for export or for the tourist trade.

Obelisks are occasionally found in jewelry (as in the pendant above), but here an obelisk—complete with hieroglyphs and cartouches—decorates each side of a majolica teapot. The angular piece has a rather Arts and Crafts–like look to it, but is unmarked except for the number 2 on the bottom, making it impossible to guess its origins. Measures 9" high with lid. The teapot, with some chipping, cost about $65 in an online auction.

A small box from Limoges, France, in the form of a pyramid that opens to reveal a removable mummy. These boxes, often available new online, but also occasionally found in catalogs, usually sell for around $100-$200, though they can sometimes be bought for much less in online auctions. The hieroglyphs on the pyramid spell "pyramid" in allphabetic signs.

That Sphinx!

Next to the winged scarab, the sphinx is probably the motif most frequently encountered in Egyptian revival decorative arts. It appears on clocks, on bookends, on china, in jewelry and other trinkets.

Occasionally, the Great Sphinx is depicted, but almost always in its idealized, undamaged state, not with the ruined face it currently displays. The exception is when the Great Sphinx appears in scenes of modern Egypt, in which case it is sometimes, but not always, shown in its present guise.

A brooch in sterling silver and enamel or glass, showing a sphinx, c. 1930. The frame also has two kneeling female figures in the lower corners flanking a winged disk with vultures' heads. Marked STERLING TOP; 1" x .875". The blue background has, in addition to the sphinx, various hieroglyphs. This is similar to the brooch with images of Egyptian stamps in the introduction (page 13) which, like this brooch, may have been created in etched glass rather than enamel (it is hard to tell the two apart, as enamel is basically glass fused to metal). In very good overall condition, it sold for approximately $130 in an online auction.

A vintage brooch in sterling silver, possibly c. 1940-1960, with an abundance of Egyptian motifs, including two sphinxes back-to-back above a winged scarab flanked by serpents, and a stylized lotus blossom. In decorative arts other than jewelry, the sphinx may be the ancient Egyptian motif most frequently depicted–it occurs on clocks, bookends, paper weights, desk sets; in gold, silver, iron, brass, bronze, pottery, and glass. Occasionally, as in this instance, it is combined with other motifs. Measures 1.875" x 1" and is marked STERLING; has a safety clasp rather than a c-clasp. At auction, prices for such pieces range from about $50 to $150, depending on size, weight, age, and other factors such as craftsmanship.

A gold-filled ring with a bas relief sphinx (shown as a face resting on lion's paws) in full frontal view, set against polished agate. Carved geometric designs decorate the ring's shank. Top measures approximately 1" x .675". *Private collection.*

A sphinx regimental brooch in platinum and diamonds of various cuts, including old European, old mine cut, and rose cut, with a sapphire eye, recumbant on a base that reads "EGYPT." (The person who bought this brooch later mentioned that the base was added, and engraved on the reverse with a regimental number, hence its being labeled regimental.) While the recumbant sphinx is typically Egyptian, this sphinx also displays Greek influence in that she is obviously female, although she wears the usual *nemes* headdress. This brooch sold for $2115 at auction. *Courtesy of Skinner Inc., Boston and Bolton, MA.*

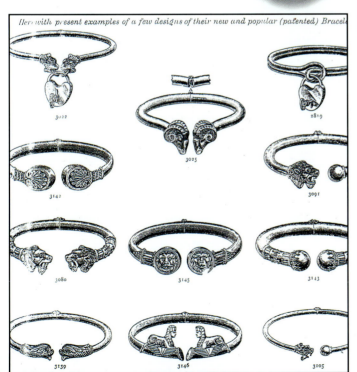

An advertisement for a line of Victorian bangle bracelets, many of them revival in style, including a bracelet ending in twin recumbant sphinxes. Other bracelets are decorated with the heads of fish, lions, and rams; with anthemions (stylized palmettes or honeysuckle); or with granulé work characteristic of Etruscan and Greek revival jewelry. Unfortunately, the date of the ad, as well as the name of the company whose wares it advertised, is missing. The jewelry, including the heart-shaped locks, is typical of late Victorian, however, so the ad probably appeared between the 1870s and the 1890s.

An advertisement for the jewelry manufacturing firm Waite, Thresher & Company, of Providence, Rhode Island, n.d. The sphinx shown in the ad is actually a trademark, although the ad does direct the reader to "Ask to see our new line of 'Sphinx' stiffened gold jewelry. Equal to solid gold." It is fairly clear from this wording that the company's (gold-plated) jewelry was being compared in durability to the sphinx; whether or not the firm actually made jewelry in the form of sphinxes is unknown. However, the sphinx trademark does resemble the sphinx pins made by N.S. Meyer shown here.

Two sphinx pins in base metal and enamel, with a sphinx in profile holding a lamp. Although they are obviously not the same caliber as the regimental sphinx brooch sold by Skinner, Inc., they nonetheless resemble it in form. Marked on the reverse N.S. MEYER, INC. NEW YORK, these pins also are marked with a shield, possibly indicating that they also were badges for the military or a fraternal or other type of organization. Measure approximately 1.125" x .875", with a fairly minimal value of perhaps $5 to $10.

A magnificent 19th century Egyptian revival clock in marble and bronze, with obelisk garnitures. Like many Egyptian revival clocks, this Egyptian-inspired clock has a recumbant sphinx on top, as well as smaller winged figures–possibly Greek sphinxes–perched on either side of the dial. Such clocks, often with garnitures, are not impossible to find, but even the most affordable of them usually sells for at least $1200, and many–such as this one–sell for ten times as much. However, modern replicas in molded resin can be purchased for much less. *Courtesy of Mark Slotkin, Antiquarian Traders, Beverly Hills, CA.*

A covered silverplated dish by Simpson, Hall, Miller, c. 1885. Other than the finial, which is in the form of a sphinx, there is little to mark this as being in the Egyptian revival style; the legs are in the form of heads and legs of deer, an animal probably much dearer to the hearts of Victorians than ancient Egyptians. The chased design is geometric, and includes anthemions and rosettes, but these could just as well have been borrowed from ancient Greece as ancient Egypt. Marked SIMPSON HALL MILLER & CO. WALLINGFORD CONN. TRIPLE-PLATE 2000, with the added number 199 etched by hand. This sold for about $74 in an online auction.

A blown glass Christmas ornament in the form of a sphinx, by well-known ornament designer Christopher Radko. Over the years Radko has done a number of Egyptian ornaments, including one of Ramesses II, and a mummy. Depending on size and availability, these sell in the $20-$55 range. The sphinx and Ramesses II can often be found online; the mummy is older (around 1994) and appears less frequently. One dealer offered the mummy ornament with an asking price of $125. Signed RADKO MYSTERIES OF ANCIENT EGYPT.

It's Alive! It's Revived! (But Is It Egyptian Revival?)

The Egyptians keep to their native customs and never adopt any from abroad.

Herodotus, *The Histories*

Because of its long history of isolation, Egypt's art and motifs were distinct, and stylistically different than those of other cultures, even neighboring ones. Although aspects of Greek art, especially sculpture, were influenced by Egyptian conventions,[7] and the Greeks borrowed at least one iconic Egyptian motif, the sphinx, the reverse is, with a few exceptions, simply not true. The Assyrian cherub, a mythical creature with the body of a bull, wings, and the head of a bearded king, is also thought to have originated with the Egyptian sphinx, and then been given characteristics more in keeping with Assyrian culture. And, like the Greek sphinx, it is sometimes found mistakenly identified as Egyptian revival, or juxtaposed with Egyptian motifs.

Egyptian civilization, its rather stiff hieroglyphic writing, its theriomorphic or half-animal, half-human gods, its papyrus columns and its pylons, its artistic conventions, is perhaps more distinctive than that of any other period or place. Even the canons for depicting men and women on flat surfaces were distinct: Because ancient Egyptian artists wished to show as much of the human body as possible in their paintings and bas reliefs, they showed the face in profile, but with a full eye; the torso was shown in a frontal view, with the arms and hands in profile; and the lower portion of the body, its kilt (or dress), legs, and feet, were again shown in profile. Unlike other cultures,[8] Egypt owed little to outside influences. As Herodotus noticed during his stay in Egypt, the Egyptians did not readily borrow from other cultures.[9] Actually, the reverse is true: When the essentially Greek Ptolemaic dynasty ruled Egypt, its rulers largely adopted the Egyptian religion and symbols rather than imposing their own upon the country bequeathed to them by Alexander the Great. The Egyptians did occasionally adopt material culture

from other lands, as evidenced by early cylinder seals borrowed from Mesopotamia, and later such innovations as the chariot borrowed from the invading Hyksos, and iron from the Hittites, but the fabric of their civilization remained more-or-less intact in its own distinct weave from earliest records until the adoption of Christianity and, later, Islam. The Greek geographer Strabo (c. 64 B.C. to c. 25 A.D.) described the Egyptians as both self-sufficient and hostile to outside influences (2001: 27). Strabo wrote: "Now the earlier kings of the Aegyptians, being content with what they had and not wanting foreign imports at all, and being prejudiced against all who sailed the seas, and particularly against the Greeks...set a guard over this region [the harbor of Alexandria] and ordered it to keep away any who should approach..." Alexander the Great, however, seeing the advantages of Alexandria's natural harbor, decided after conquering Egypt to fortify and use it.

In fact, its religion and symbols were so unique to Egypt that at times outside observers viewed them with disbelief, as did the Roman natural historian Pliny the Elder, when he described the Egyptian deification of the scarab beetle.

However, the fact that Egyptian art and motifs were so distinctive does not mean that Egyptian revival motifs cannot be confused with decorative motifs from other cultures. Not unnaturally, when Europeans first started to adopt the designs of an ancient and barely understood land, they made mistakes in interpreting and applying them. Thus many "Egyptian revival" objects included sphinxes that were more Greek than Egyptian in nature

Fairly early on, *The Jewelers' Circular* warned against the wholesale borrowing of Egyptian symbols without really understanding them. The overlap of Greek design, where borrowed from Egyptian (the most notable example being the sphinx but also extending to other aspects of art, such as the harpy and the *kouros* statues), adds to the confusion. All too often Classical revival jewelry and other decorative objects are mistakenly labeled Egyptian revival. And even when an item does contain genuinely Egyptian elements, such as the Simpson, Hall & Miller silver-plated dish shown on page 97, with its believably Egyptian recumbant sphinx on the lid, it is sometimes found with other elements that are not at all Egyptian, such as the deer feet on the Simpson, Hall & Miller dish. (One diadem found in Egypt, with the gazelle's heads associated with lesser royal women flanking the head of what might be a deer, even though its barbed antlers are not a realistic depiction of deer antlers, has been identified as being of Hyksos—and therefore of foreign, Asiatic—origin. Otherwise, deer are absent in Egyptian art, though they were of course popular in Victorian decorative art.)

The tendency to label the stylized and exotic as Egyptian revival extends beyond Classical revival. In the course of her research for this book, one of the authors found the following erroneously identified as Egyptian revival:

• **Figurines in the form of Thai dancers**, with their unusual headwear and trousers gathered at the ankles, and their very stylized hands and feet bent at angles to the wrist and ankles;

• **A bracelet from Peru**, more Inca revival than anything remotely Egyptian;

• **A neo-Aztecan warrior** with feathered headdress identified as Egyptian;

• **A wall pocket by the Japanese firm Hotta Yo Shoten** showing a supposed Egyptian whose stylized features and kimono appear most Japanese;

• **A necklace with flat oval carnelian disks** engraved with Chinese characters, said to represent scarabs;

• **The Syracuse china plate**, shown below, which looks more Minoan or Mycenaean revival than Egyptian;

• **A quintessentially Victorian cherub** in a pendant that owes much more to Renaissance putti than Ramesside tomb painting.

A drawing of a Greek sphinx, taken from an ancient Greek vase. Here the sphinx is again obviously Greek: female, winged, and seated rather than recumbant. From Edwards, *Egypt and Its Monuments.*

A sterling silver pendant with a repoussé design of a head with wings that was listed as Egyptian revival, even though this appears to be a very standard Victorian cherub. Nor do the other elements of the design–feathery swirls, flowers– appear to be Egyptian-inspired. The seller, however, claimed that is was a winged scarab (!) holding a stylized lotus blossom between the tips of its wings, similar in style to items made by Blackinton. Marked STERLING; 2.125" x 1.875". It sold for approximately $30.

A pair of candlesticks by Fitz and Floyd, in the form of sphinxes. While these were sold as Egyptian revival–and advertisements for jewelry and other items from the late 19th and early 20th centuries show similar sphinxes touted as Egyptian revival–this form really belongs to the Greek or Graeco-Roman revival. Egyptian sphinxes had the head of a man, or in some cases were ram-headed, and were not winged. The Great Sphinx, according to accounts of early Greek travelers, had a spread-winged falcon perched behind its head, and this may be the reason the Greeks thought of the sphinx as winged. The Greek sphinx was female, as are the sphinxes shown here. The hairstyles, too, are much more in the Greek and Roman style than the Egyptian. These are 10.5" tall, of Japanese manufacture, and marked on the bottom FITZ AND FLOYD, INC. © MCMLXXVII FF. The date marks them as having been made during the last tour of Tutankhamun's treasures in the 1970s. They sold for approximately $65 in an online auction.

A blue jasper cameoware vase purportedly of German origins; n.d. Like many of the more famous Wedgwood cameoware pieces, this one has a Classical scene with a woman offering a returning warrior (complete with shield and spear) a laurel crown, as another woman, seated and holding a parasol, looks on. The garments, the laurel crown, the hairstyles all come from ancient Greece. However, beneath the small Classical tableau is the head of a winged pharaoh, complete with *nemes* headdress. This once again shows the ease with which Classical and Egyptian motifs are intermingled, or confused. Vase measures approximately 5.5" high; its only marking is the number 3891. This vase, unlike similar Wedgwood vases, is not particularly valuable (it sold for $20 in an online auction) and is shown primarily for its interesting mixture of Greek and Egyptian motifs.

A heavy restaurant plate by Syracuse china, with a design depicting what was said to be a dancing Egyptian. Aside from the face, with its eye shown as from the front rather than in profile, there is nothing remotely Egyptian about this figure. The jutting nose, the floral diadem, the trailing plumes, the long wavy hair, the broad shoulders, the wasp waist, all look more Minoan or Mycenaean than Egyptian. Stamped SYRACUSE CHINA 92-H U.S.A.; 10.5" in diameter. Although restaurant china is collectible, this plate appears to have a minimal value of perhaps $5-$10.

A sterling silver match safe, sold by an online dealer as vintage Egyptian revival, but in reality new, and not at all Egyptian in appearance. The designs are rather stylized, but not in the angular way found in ancient Egyptian art, and there is not a single recognizable ancient Egyptian motif. It seems that this match safe was made in Egypt and imported by the dealer, and thus its sole claim to Egyptian revival status.

A bracelet, almost undoubtedly a tourist piece from Egypt, with a mixture of motifs: The center link shows a seated pharaoh or god, with a camel on either side; pharaoh heads wearing the *nemes* headdress are next to the camels, and two Assyrian cherubim decorate the end links. This shows that not even the Egyptians themselves are entirely certain as to what constitutes an Egyptian revival theme.

An Egyptian revival clock with obelisk garnitures. The obelisks, the winged scarabs, the striding Egyptians, and the hieroglyphs all show this set to be Egyptian revival in intent, yet the clock is crowned with an Assyrian cherub rather than the usual sphinx.

A jug made by Doulton Lambeth for the John Dewar & Sons distillery company, perhaps late 19th century. The jug has a design in black against tan of geese and cattle, embellished with rosettes of varying sizes. Below this animal frieze is a geometric design of stripes and what appear to be cuneiform wedges. While geese and cattle certainly played an important part in Egyptian life (a customary offering request was for "a thousand of bread and beer, of cattle and geese"), the wedges and the stylization–elongated, with musculature showing–of the animals give this jug a look of the much rarer Assyrian revival style. Approximately 5.5" high; marked on the bottom with the incised ROYAL DOULTON SILICON ENGLAND 6687 Td 224092. On the front is lettering in black: BY ROYAL WARRANT TO HER MAJESTY THE QUEEN John Dewar & Sons Limited DISTILLERS PERTH NB. This collectible jug sold for $100 in an online auction.

Also frequently identified as Egyptian revival are the myriad maidens found in Art Nouveau and later Art Deco art. It seems that any figural piece depicting a woman in a long flowing dress, with or without a head covering, is liable to be labeled Egyptian revival.

Finally, there is the misidentification of modern Egyptian (or even Arabian) motifs or scenes as Egyptian revival. In many cases, these show camels being ridden past the great pyramids of Giza, or the Great Sphinx, or both. Possibly these might be considered marginally revival in nature, although they seem more like they belong in a separate category, possibly a "travelog" or "tourist postcard" genre. In still others, however, the pyramids turn out to be tents, or rather indistinct triangular mounds that might represent pyramids, but might equally well represent mountains. How do we classify these items? The answer, as the many camels and mosques said to be Egyptian revival shows, is not entirely clear.

A teapot in the shape of a camel and its rider, sold online as Egyptian revival. Camels, however, were not used in ancient Egypt, and the real Egyptian revival note is the camel's blanket, which has a design of ancient gods, possibly the jackal-headed Anubis. Unmarked; approximately 9.5" wide, and 7.75" high. It was purchased in an online auction for $48, although previously the seller had listed it with a reserve of over $100, which went unmet. This teapot was probably made in Japan by Gold Castle.

A condiment jar and matching salt and pepper shakers, from Czechoslovakia probably c. 1920. The jar, with lid and spoon, was purchased first, and the salt and pepper shakers showed up in a later auction (and were listed as being from Japan). The jar is 5.25" high, the shakers approximately 2.5" high. The jar is marked on the bottom Made in Bohemia with the number 49 painted in gold and the number 522 engraved in the porcelain. The shakers are unmarked, but clearly go with the condiment jar, as both show the same rather unusual desert scene with a tent seemingly about to blow over in a strong wind. Another tent at first glance might appear to be a pyramid, but a closer inspection shows that it is not. Thus the set is more in the "Bedouin" style, rather than Egyptian revival, but both the jar and the salt and pepper shakers were described as Egyptian revival by separate vendors. The jar sold for about $65, the shakers for about $40.

A plate by Wedgwood, probably c. 1930, decorated with a desert scene including a camel and rider passing by triangular mounds that could equally well be mountains or pyramids. Even if these were taken to be pyramids, however, this would still be more of a "travelog" than an Egyptian revival piece. Marked WEDGWOOD.

A covered jar (possibly a cookie or biscuit jar) by Hollingshead & Kirkham, perhaps better known as H & K, early 20th century. This pottery, also known as the Unicorn Pottery, was located in Tunstall, Staffordshire and produced a line of "Egyptian" items such as this jar; other items include tableware such as plates and mugs. Decorated with a hand-painted desert scene complete with camels and pyramids, this is one of those pieces that really fits under the "travelog" heading. Many such travelog items, including bracelets with scenes of modern Egypt, are labeled Egyptian revival without being based on ancient Egyptian themes or motifs. Stamped in gold MADE IN ENGLAND H & K TUNSTALL, with illegible numbers and the pottery's unicorn logo; 6" tall, 5.5" in diameter. It was bought in an online auction for approximately $54. Other items in this line, such as plates and cups, usually sell for less, often between $10 and $35.

A bracelet in 800 silver, probably made and purchased in Egypt as a tourist souvenir. The various links all show facets of modern Egyptian life: a mosque, a palm tree, a camel, and Nile boats. This last is the only motif that looks Egyptian revival, this because Egyptian boats used today resemble those used in ancient times.

Byzantine Woman

While it is fairly clear that some so-called Egyptian revival pieces are not truly Egyptian-inspired, there is one theme that seems especially indeterminate. This is the "Byzantine woman" found in jewelry and other decorative objects–possibly inspired by Art Nouveau artist Alphonse Mucha's well-known *Zodiac* print. (They are, one might say, *mucha* Mucha.)

The Byzantine woman can be found in enameled and un-enameled jewelry produced by Newark, New Jersey makers c. 1900, most notably by the Alling Company. Alling made Byzantine woman stickpins by the hundreds, if not thousands; their Byzantine woman bracelets, lockets, pins, and lorgnettes are considerably harder to find but still more available than true Egyptian revival pieces. Typically, the Byzantine woman is shown in profile, with hair that is not as wavy as that found on many Art Nouveau women, and not as straight as that found on Egyptian revival women. She conventionally wears an elaborate diadem or headdress (this headdress, when found in 14K jewelry can be, but is not always, adorned with diamonds, or diamonds with other precious gemstones). One common feature of this headdress is a circular dangle hanging from the diadem, although it occasionally is a bit more elaborate, and has a different shape.

An artist's copy of Alphonse Mucha's *Zodiac* print, which may be the prototype for the many Byzantine women created by the Alling Company and other jewelers c. 1900. *Art work courtesy of Katherine Scattergood.*

A gold-filled brooch with an enameled Egyptian queen. Aside from the vulture headdress and the blue cloth covering her hair, she is very much the same as the Byzantine woman: She has the same fine, rather expressionless features, the same detail to eye and brow, the same delicate enameling. Interestingly, her eye is shown in profile rather than fully rendered as in ancient Egyptian art. This may have been made as a costume brooch, although the quality of enameling is not entirely consistent with this hypothesis, and it may have been created as a prototype for a more expensive piece, such as the pendant shown on page 8 in 14K with diamonds. Unmarked; approximately 1.125" in diameter. This sold for $400, reflecting the scarcity of Egyptian queens in Newark enamels as well as the high quality of the enameling rather than any real intrinsic value.

A photograph of actress Pauline Frederick, dressed for her role as "the siren Potiphar's wife." Although her diadem bears the uraeus serpent, it is otherwise almost identical to those depicted on Byzantine women in jewelry and art. This photograph appeared in the April, 1913 issue of *Redbook. Courtesy of Shelly Foote.*

An advertisement for Palmolive soap that appeared in *The Youth's Companion*, April 17, 1919. The opening lines of the text for this ad read: "The beautiful women of Ancient Egypt were well versed in toilet arts, but they knew that radiant cleanliness was the crowning art of all. They chose Palm and Olive for their most important toilet requirements." While it is very clear from the text that the accompanying art is meant to depict an ancient Egyptian woman–her hand reaching up to catch a falcon about to land–her diadem is that of the Byzantine woman, complete with circle dangle. Only the uraeus serpent marks it as being Egyptian. This ad provides an incontrovertible link between the Egyptian and the Byzantine woman, making it even harder to decide whether or not the Byzantine woman should be included with Egyptian revival jewelry. (Additionally, this ad shows that Egyptian themes remained popular during the period right before the discovery of Tutankhamun's tomb.)

A locket, a brooch, and a stickpin in 14K gold and enamel (and, in the locket, diamonds and emeralds). All have the beautifully enameled Byzantine woman, complete with elaborate headdress, curling hair falling beneath the pin and stickpin, a small curl at the back, and delicate features. Unmarked locket measures 1.625" in diameter. Recently, the locket has sold for about $2400, the brooch (without diamonds) for $1200, and the stickpin in the $600-$800 range–although rising prices for such enamels may push these estimates higher. *Courtesy of Robin Allison.*

A package for Aida cigarettes, the name taken from the opera by Giuseppe Verdi composed in honor of the opening of the Suez Canal. Although the name conjures up the ancient Egyptian milieu in which the opera was set, the woman on the package looks every bit the Byzantine lady rather than the ancient Egyptian princess.

A brass buckle with a peacock glass dangle, clearly intended to be Egyptian revival as it is decorated with stylized lotuses and hieroglyphs. The central element on each disk, however, is an Egyptian woman whose headwear combines elements of the Classical (the tiara-like diadem in front) with Egyptian (the *nemes*-style flaps hanging down from the diadem), and a cockade-like effect at the side that belongs to neither genre. This buckle sold for approximately $45 at auction.

Two Byzantine woman stickpins in 14K, enamel, and pearls and, in the one on the left, small diamonds, c. 1900. This is a slightly different version, with curls forming the bottom edge of the stickpin, which has the profile cut out rather than set against a circular gold background. The diadem too is a bit different, but still easily identified as Byzantine in nature. The pearl at the top of the diadem seems almost analogous to the uraeus serpent on the Torini bracelet. Marked for Alling Company; measure approximately .5" x .625". These stickpins usually have a dealer price in the $600-$800 range.

A brooch that seems to have managed to find the perfect blend of Art Nouveau, the Aesthetic Movement (and its obsession with peacocks), and Egyptian revival. This Art Nouveau woman goes the Egyptian queen's vulture crown one better, and wears the much more elegant peacock as a crown. *Courtesy of Robin Allison.*

A stickpin in 10K gold and small diamonds (or, possibly, pastes), with the head of what appears to be an Egyptian woman wearing a *nemes*-style headdress, and what almost looks like a fan behind her, but which might be a winged solar disk, a fanciful halo, or an unusual addition to the headdress. However, no matter what the disk behind her head represents, she is fairly clearly Egyptian, with Art Nouveau/Byzantine woman overtones. This was purchased from a dealer for approximately $90.

However, compared with the Egyptian revival brooch shown above, the differences seem almost nonexistent–aside from the headdress. The Egyptian queen wears the vulture crown associated with Isis and the Great Royal Wife over a cloth enameled in blue. The Byzantine woman wears a diadem. Otherwise they are virtually identical: the same delicate yet rather unexpressive features, the same detail in the eyes and brow, the same unsmiling mouth. A comparison of the Byzantine woman with the Egyptian queen in 14K gold by the Italian maker Torini shown here, and in silver by William Link (chapter three, page 144) shows even greater similarities. Link's Egyptian queen has the same lock of hair curling beneath the frame as Alling's Byzantine woman. She too wears a diadem with a circular dangle. In fact, the only hint that she is Egyptian rather than Byzantine is the uraeus–the serpent found, often side-by-side with the vulture goddess Nekhbet's head, on Egyptian crowns. The queen in the Torini bracelet has the straight hair usually associated with Egyptian women, but also wears a diadem with a circular dangle, with a uraeus serpent at the front. In addition, she has a small curl in back, very similar to the curl on Alling's Byzantine women.

The differences between the Byzantine woman and the Egyptian revival woman is blurred as well in the silver slide locket shown here, in which the Byzantine woman has long straight hair rather than the wavy hair worn by the more typical Alling Byzantine woman. If she wore a vulture crown, or an obvious uraeus on her diadem, there would be no doubt that she was meant to represent an Egyptian queen.

A slide locket in 935 silver and enamel, presenting yet another variant on the Byzantine woman: Here she has long, flowing hair, is shown in three-quarter view rather than in profile, and adds flowers to the fillet of her headdress. Still, she is very much the Byzantine woman–unless, of course, one interprets the upward curving element at the front of the fillet as a uraeus serpent, in which case she could be viewed as an Egyptian revival woman. Measures 2" x 1.375". *Courtesy of Robin Allison.*

A bracelet in 14K gold and turquoise, by the Italian maker Torini, probably fairly recent. Here the central element is an unenameled face in profile, with the long, straight hair associated with ancient Egyptian hairstyles–with the addition of a small curl at the back and a circular dangle, both of which are usually associated with Byzantine women. However, here the curving element at the front of the diadem seems fairly clearly meant to represent an animal's head (it looks like a uraeus serpent, but might have been intended to be a vulture's head). Should she be considered Egyptian revival, or Byzantine? Marked TORINI 14K. This bracelet was sold for about $600 by an internet dealer.

A pendant in 18K gold, enamel, and diamond, by the Spanish firm Masriera y Carrera, c. 1923. While this is one of the Art Nouveau "nymphs" for which Masriera was known, here she also seems to have elements of the Egyptian revival: The leafy branch held in one hand is static and stylized, much as it would have been rendered in Egyptian art; the scarf flowing behind her is very reminiscent of the scarves worn by the men and women during the reigns of Akhenaton and Tutankhamun (these are seen in Amarna-style furniture from the Boy King's tomb, although a return to the orthodoxy of Amun worship and the removal of the capital back to Thebes put an end to the fashion). Given that this was made shortly after the discovery of Tutankhamun's tomb, it is very tempting to see Egyptian influence in it–whether or not the designer intended it to be there or not is another matter.

And then there are the candlesticks, identified by the seller as Egyptian revival. The figures appear at first glance to have little of the Egyptian revival about them: Their costumes seem more Roman army issue, c. 35 B.C., than Egyptian kilt. But they wear an unusual headdress, with a fillet from which hang pieces of striped material that might be taken as a variant of the *nemes* headdress. And that worn by the female figure seems to have a winged scarab in front. How should they be classified? This seems to be one of those cases where imagination created a hybrid that is not truly Classical revival or Egyptian revival, but falls somewhere in between. And, without a guide to the designer's intention, it is almost impossible to determine if these candlesticks were meant to portray Egyptian figures, or something else altogether different.

While some motifs might be found in ancient Egyptian culture or art, such as cats, lions, leopards, and dogs, they are not exclusively associated with Egypt in the way that, say, the scarab beetle is. The Egyptians did use the lizard as a hieroglyph for the word **sh3** "many".

No. 95. Height, 17½ inches. $23.00

An advertisement by the Wm. Rogers Manufacturing Company showing an Egyptian revival epergne. The base is formed by an ancient Egyptian male wearing a version of the *nemes* headdress, a broad collar, and a kilt (although this is somewhat more flowing than kilts represented in Egyptian art, and probably was inspired more by Victorian tastes than ancient Egyptian dress). Interestingly, although this rather buff young man was probably meant to represent a slave bearing a torch, his garb is more befitting a king. The advertisement was placed in an 1885 *Jewelers' Circular and Horological Review. Courtesy of Shelly Foote.*

A pair of figural candlesticks in cast iron, c. 1890. The figures, a young man and woman, are dressed in rather fanciful costumes possibly meant to indicate Graeco-Roman attire, but with headdresses that appear rather more inspired by ancient Egypt. Although they were sold as Egyptian revival, it is not clear that whoever designed them intended them as such. When compared with the Egyptian revival epergne shown in the Rogers advertisement, they seem even less Egyptian in nature: The Egyptian figure in the ad wears an Egyptian headdress and a kilt typical of ancient Egyptian dress. Unmarked; 10.5" high. The pair sold for approximately $850 at auction.

One way to decide whether or not an item is Egyptian revival is to test it against Egyptian art itself. Familiarity with the conventions and motifs used by the Egyptians is a good way to determine if an object represents Egyptian revival, or some other, possibly fantastical, revival.

Makers & Manufacturers

Egyptian revival jewelry and decorative items were made over the course of the last two centuries, and were almost certainly manufactured by scores, if not hundreds, of individuals and companies. It is therefore impossible to compile a comprehensive list, with representative examples, of makers who created Egyptian revival goods. Because it is a style not associated with any one particular type of decorative object, items can be found in a wide variety of materials and forms, including—but by no means limited to—china, glass, pottery, silver, gold and other metals; plates, cups, saucers, bookends, vases, flatware, tea sets, and clocks. The list below, then, is not intended to be exhaustive. Rather, it is meant to provide those interested in collecting Egyptian revival with the names of some of the major manufacturers and some idea of what types of items to look for. Because information about certain companies, especially those located in former Soviet bloc countries, can be difficult to obtain, for some makers there will be few facts provided other than the country of manufacture. Also, because some items are marked with a country's name but not that of the manufacturer, or as in the case of Japanese items, in a writing system not read by the authors, some items are listed only by their country of origin. This applies especially to some of the jewelry and china made in the former Czechoslovakia (now the Czech Republic and Slovakia) and Japan (formerly Nippon).

For ease of reference, items and their makers are divided into two categories: 1) China, Glass, and Pottery; and 2) Jewelry and Metals. All entries, except the first in each category which is devoted to a leading manufacturer, are in alphabetical order by maker.

China, Glass, and Pottery

Probably no other manufacturer is as closely associated with Egyptian revival as the venerable Staffordshire firm founded by Josiah Wedgwood. Wedgwood is perhaps best known for its jasperware, often in a light blue known as Wedgwood blue, decorated with bas relief scenes based on Classical Greek and Roman art in, usually, white. However, Josiah Wedgwood's love of antiquity led him early on to embrace Egyptian motifs and themes as well. Twenty-five years before the Napoleonic expedition to Egypt, Wedgwood was creating cameo portraits of the Ptolemies and scenes based on Egyptian mythology such as "Isis with Sistrum." Wedgwood also used Egyptian motifs including a queen's crown with cow's horns, solar disk, and plumes; hieroglyphs; lotus blossoms; and sphinxes. These designs were executed in white against black basalt ware, which Wedgwood sometimes referred to as "Egyptian black," or in white biscuit ware.[1] Wedgwood also used the story of Antony and Cleopatra with, among other things, a cameo of the death of Cleopatra.

Wedgwood was successful enough to found not only his own factory, but also his own town, which he named Etruria, after the ancient home of the Etruscans–an indication of his love for things ancient. He was well-connected enough to be granted access to collections of wealthy and powerful patrons, such as the Duke of Marlborough, in his quest for source material for his firm's designs. Unfortunately, he died in 1795, three years before Napoleon's Egyptian adventure, and thus did not live to witness the outpouring of material from the Napoleonic survey and later expeditions. His son, Josiah Wedgwood II, carried on his father's tradition, however. Later Wedgwood Egyptian revival pieces include not only Egyptian motifs, but Egyptian forms such as the canopic jar, as well.

Some of Wedgwood's early Egyptian revival pieces are in what is known as *rosso antico* (antique red), which has a deep red, almost terra cotta base with designs applied in black. These and other early pieces are highly sought after, and at auction–online or off–usually bring high prices. Because of the durability of the materials developed by Josiah Wedgwood, such pieces are not as uncommon as one might expect given their age. Often, however, they do not come to market complete undamaged. The *rosso antico* cup and saucer shown below have a couple of small pieces, such as a bird's head, missing from the applied black design. Once-lidded pieces often have missing lids, or lids that have been broken and mended. Even such damaged pieces command high prices at auctions–two nineteenth century Wedgwood pieces sold in an auction at Skinner's Boston auction house for over $1600 even though both were damaged–and antique Wedgwood in mint condition sells for even more. Recently a vase in *rosso antico,* in perfect condition and probably c. 1805-1810, sold for over $1600 in an online auction. The rarer pieces in cane can also sell for a considerable amount.

Wedgwood continues to make Egyptian revival ceramics, and these continue to be of interest to collectors. A recent online auction of a desk set, from a limited edition of five hundred, brought a winning bid of over $3000, even though the set was from the 1990s. Most of the newer Egyptian revival pieces are in black basalt ware, mostly with *rosso antico* appliqués but occasionally with the design in gold. A few, usually more expensive because of more limited production, are also in cane, with *rosso antico* appliqués.

Although Wedgwood arguably produced more Egyptian revival pieces and designs than any other company, it should be noted that in a 1948 exhibition of Wedgwood at the Brooklyn Museum, only three out of more than six hundred items had Egyptian themes or motifs (Chellis 1949: 261).

A black basalt ware creamer, in what Josiah Wedgwood referred to as "Egyptian black," probably c. 1800. Although not obviously inspired by ancient Egypt, such ware is often labeled Egyptian revival, probably because of Josiah Wedgwood's name for it. Measures approximately 5.75" x 4.75" x 3"; marked simply WEDGWOOD in incised letters, pointing to an early date. Because they are extremely durable, there are more of these pieces than one might expect; however, they do not appear all that frequently at auction, and when they do often sell for several hundred dollars.

A cup and saucer in Wedgwood's *rosso antico*, c. 1800. *Rosso antico*, literally antique red, is usually a deep red, almost terra cotta, with raised black cameo designs. Here the designs are winged disks, *ba*-birds (with ram's horns), sphinxes, rams' and cows' heads, dogs, owls, canopic jars, various other vessels, an offering table, and a sistrum. Considering their age, the cup and saucer are in remarkably good condition, with only a couple of pieces of the design missing. It's hard to believe that these designs were individually appliquéd, and they undoubtedly were not created in such a time-consuming fashion, but the few breaks–such as a missing head on a bird–are all level with the body of the cup, and the area where the piece is missing is stained black. The handle is also decorated, with a non-representational design. The inside of the cup has a glossy finish, unlike the matte exterior. The saucer, which is old-fashioned and lacks a center indentation for the cup, is 5.25" in diameter. Both pieces are marked simply WEDGWOOD (although the cup, from a closed Wedgwood museum, has an accession number). They were purchased for about $305 in an online auction; larger pieces, such as vases, usually go for much more. A *rosso antico* vase in perfect condition recently sold for $1600 in an online auction, and from a dealer might sell for twice as much. A Boston auction house sold two pieces in less-than-optimal condition (one container was missing its lid) for about the same amount.

The Egyptian revival *rosso antico* vase has similar winged disks, birds, and other Egyptian designs, along with a geometric design towards the base, and a Greek key design on the base (showing yet again the confusion, even among well-informed devotees of ancient Egypt such as Josiah Wedgwood, between the Egyptian and the Classical). The inside of the vase has a similar glossy finish. It is identical to one c. 1805 that sold for $1600. *Courtesy of Bart Phelps, Sacramento, CA.*

Two pieces in *rosso antico*, probably also c. 1800, by Wedgwood. The handled vase on the left owes its inspiration to ancient Greece: The women's hair, the lyre, the draped clothing are all Classical rather than Egyptian, as likely is the very shape of the piece itself. However, the lidded dish on the right, with the rare white bas relief cameos, is definitely inspired by ancient Egypt. It has the same prominent winged disk motif and the same geometric design as the *rosso antico* vase with the black cameos. The wonderful crocodile on the lid also looks as if it came from an Egyptian tomb; it is stiff and somewhat stylized, but a fairly faithful rendition of a crocodile for all that. The ancient Egyptians worshiped the crocodile as the god Sobek. *Courtesy of Bart Phelps, Sacramento, CA.*

A cup and saucer in Wedgwood's very rare cane jasperware. The cup, with a less rounded shape than the *rosso antico* cup, has the same black winged disk, along with an owl and a papyrus plant hieroglyph. The cup also has the same zig-zag decoration near the bottom as the *rosso antico* cup. The saucer is similarly deep and flared, and it too lacks a center indentation for the cup–probably dating it to around the same period as the other cup and saucer. In the 18th and early 19th centuries, tea was actually drunk from the saucer rather than the cup, which explains the shape of the saucer. *Courtesy of Bart Phelps, Sacramento, CA.*

A teapot from a very nice Wedgwood *rosso antico* set. The teapot has the by now very familiar winged disk, crocodiles, a cow's head, canopic jar, and bird decorations, as well as the geometric design. The lid also has a crocodile handle. *Courtesy of Bart Phelps, Sacramento, CA.*

If imitation is the most sincere form of flattery, then this vase was fully intended to flatter Wedgwood's *rosso antico* cameoware. It is in the same terra cotta red as *rosso antico*, with the same Egyptian-themed designs in raised black (except where the paint has worn off). The scene, repeated on both sides, shows an enthroned pharaoh in the presence of gods, including a sphinx wearing the double crown and holding a canopic jar, and a falcon-headed god probably meant to represent Re-Harakhty. Other elements include a bird holding a *was*-scepter and various stylized blossoms. Probably the nicest design feature is the handle, which at the top curves around a rosette and at the bottom ends in a stylized lotus blossom. Approximately 12" high; impressed on the base with W S & S 104. This vase, in good condition with some missing black paint and an old, almost invisible repair to one of the handles, sold for approximately $175 in an online auction–showing that even copies of Wedgwood's extremely collectible Egyptian revival cameoware have a market.

A lidded jar in black with white reliefs, probably late Victorian or Edwardian. The jar (possibly meant to be used as a biscuit jar, humidor, or other type of canister), has a design that apparently shows architects or surveyors taking measurements, along with various other Egyptian motifs such as rosettes, crocodiles, a solar disk between bovine horns, and the familiar winged disk. Marked W LAMB & SONS COMPLIMENTS WEDGWOOD and is 6.5" high. The lid has been broken and mended, as is often the case with pieces this old; in some cases, similar jars are even missing their lids and yet sell well at auction. This one was purchased for $200.

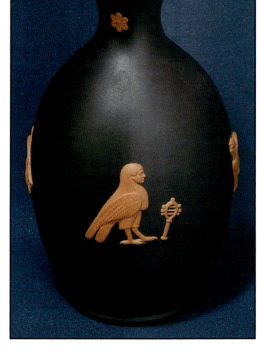

A more modern black jasperware vase with terra cotta cameos, these much less elaborate on this small piece (which measures approximately 4" high) and include a *ba*-bird, a sistrum, and rosettes. This vase can be found online for approximately $100.

A very interesting canopic jar in black jasperware with terra cotta cameos, from the 1970s. Gone is the usual winged disk, replaced by a disk flanked by serpents along with other familiar themes including a canopic jar, double crown, rosettes, offering table, sphinx, and various hieroglyphs. The second register, however, contains Greek astrological signs, including the scales, scorpion, and centaur found in today's astrology. The lid to the jar, with the head and shoulders of an Egyptian wearing the *nemes* headdress, has features that also look more Greek or Roman than Egyptian. *Courtesy of Bart Phelps, Sacramento, CA.*

A small dish in black jasperware, with gold cameo sphinx, which is more Greek than Egyptian, sitting upright rather than lying in a recumbant position, and having wings. This probably dates to the 1970s, that is, to the last tour of Tutankhamun's treasures in the United States.

A plate in Wedgwood's hard-to-find yellow (sometimes referred to as "cane") jasperware, with terra cotta designs including a queen in profile holding a cone of incense (the queen, wearing a short wig in the fashion of the late Eighteenth Dynasty, is probably Tutankhamun's wife Ankhesenamun). Around her is a design of alternating winged disks and what appear to be cow's horns (but which are possibly meant to be cobras) with solar disks. Measures approximately 7" in diameter; marked WEDGWOOD MADE IN ENGLAND. Although this plate is probably of fairly recent manufacture (at a guess, from the 1970s) it sold for a little over $150 in an online auction.

Adams & Company–This company, based in Pittsburgh, Pennsylvania, manufactured Early American Pattern Glass (EAPG) in a mixed Classical and Egyptian revival pattern often referred to as "Pyramids and Parthenon." They made a number of different items in this pressed glass pattern, including the compote and pitcher shown here. One informed source (which can be found online at www.patternglass.com) believes that pattern glass, which was manufactured only in the United States, and then only between 1825 and 1910, was produced in as many as three thousand patterns. A major appeal of this glass was that it could be bought in matched sets, so that an entire table could be set with pressed glass plates, glasses, and various serving dishes in the same pattern (although some patterns were not produced with a full range of tableware). While produced as an inexpensive alternative to cut glass or crystal at the end of the nineteenth century, today these items can command fairly impressive prices, especially glasses or plates in matched sets (an online catalog offered a set of four matched goblets in a non–Egyptian revival pattern for $225), although smaller pieces can be had for as little as $8-$10 in online auctions. All of these pieces probably date from the 1880s.

One interesting, and beautiful, aspect of this glass is that it can over time turn purple from exposure to the sun. This purple can range from a pale amethyst to a fairly deep, almost royal purple. A favorite possession of one of the authors is a dark purple ketchup bottle found by her father in the Nevada desert, clearly after prolonged exposure to ultra-violet rays. However, not all purple pieces are old, and not all old pieces are purple. As this glass becomes increasingly collectible, and therefore pricey, it has become a target of those who reproduce, or even market as genuinely antique, faux EAPG. One trick of these forgers is to create glass that has been artificially "sun-purpled." Legitimate purveyors of this reproduction glass, however, such as the L. E. Smith glass company, market their wares as new.

The online source also notes that "sun-purpled" pattern glass, while it may appeal to those who love the color, is essentially worthless; colorless pattern glass is valuable *only* in its original colorless state.

A pressed glass pitcher by the Adams Company, late 19th century, in the "Pyramids and Parthenon" pattern. This pitcher actually has three separate designs, the third being of a sphinx next to a ruined column. Rosettes decorate a band at the top and also the divisions between the three designs. This pattern shows the apparent confusion of Greek with Egyptian motifs. It comes up fairly often in online auctions–Adams must have made thousands of these pieces–and depending on size and condition, they usually sell for between $8 and $65 for larger pieces. A set of dessert plates listed recently had an asking price of $115, while a bowl sold for $15, a celery dish for $8. Measures 6.25" in height.

Another piece in the "Pyramids and Parthenon" pattern, this one a compote by Adams Company, also late 19th century. As an additional feature, it has a small dimensional sphinx resting on the base. Measures 7" in height, approximately 22" in circumference at the widest point. This piece sold for about $65 at auction.

Baccarat–This well-known French manufacturer of fine crystal was established in 1764 in France's Lorraine region. Like so many other makers of fine crystal and china, Baccarat began by manufacturing utilitarian items in glass, such as windowpanes. The company's first lead crystal oven was put into production in 1816, and since then Baccarat has become noted for its fine crystal stemware and decorative items. The company has produced the sphinx shown here, as well as an Egyptian cat; both can be found easily online, in a range of prices from about $120 to $165. The dark crystal cats seem to evoke more interest than the clear ones, and thus often have a higher asking price.

Bohemia–see below under *Czechoslovakia*

Boston & Sandwich–According to a knowledgeable and informative online source (this one can be found at www.barn-stable.com; these sites are highly recommended for beginning collectors of EAPG, whether Egyptian revival or not), Boston & Sandwich, also referred to as Boston Sandwich, was one of the better known New England–based pattern glass manufacturers. It was founded by a wealthy Bostonian, Deming Jarves, in 1825, in the Cape Cod town of Sandwich, Massachusetts, which Jarves had visited on vacation. In some ways, Jarves was pattern glass's equivalent of Staffordshireware's Josiah Wedgwood: Interested in developing new techniques and materials, he produced the first pressed and laced glass in this country. He made both utilitarian products, and those noted for their artistic merit. His experiments also added to the repertoire of colors used in EAPG. Unfortunately, this bread platter is the only piece of Boston & Sandwich glass we could find in an Egyptian revival pattern. This tray, probably c. 1875, is what is sometimes called the Egyptian bread plate pattern (referring to its shape rather than its decoration), in the "Cleopatra" motif.

A clear lead crystal paperweight or statuette by the noted French crystal manufacturing firm Baccarat, in the form of the Great Sphinx. Measures 4.5" across, 3" high; marked BACCARAT FRANCE on the bottom, with a goblet, decanter, and tumbler enclosed in the circle formed by the words. Of relatively recent manufacture, sphinxes exactly like this one have sold for about $90-$125 in online auctions. Baccarat also makes Egyptian cat figurines (or paperweights) in both clear and dark lead crystal. These seem to be more desirable than the Baccarat sphinx, and often sell for about $175-$250 in online auctions.

A pressed glass plate in the "Egyptian" pattern (referring to the shape of the platter) and "Cleopatra" design by the U.S. maker Boston & Sandwich, c. 1880. In addition to the scene, of an Egyptian woman gazing at pyramids and palm trees in the distance, it bears the legend "Give Us This Day Our Daily Bread," frequently found on 19th century bread plates. The prices paid for this particular piece range from $65 to $225; the "Temple" motif, based on the Mormon temple, in Boston & Sandwich's Egyptian pattern is apparently considerably harder to find; one dealer listed it online for $700.

Brush-McCoy–The Brush-McCoy pottery began life as the J.W. McCoy Pottery Company, but the name was changed in 1911 when George Brush (having lost his own pottery to a fire) joined McCoy's company. After J.W. McCoy's death, the name was changed again (in 1925) to the Brush Pottery Company. During the early part of the twentieth century, the pottery produced pots, umbrella stands, and vases that exhibited nicely blended glazes and finely modeled decoration, as in the Egyptian revival umbrella stand shown here, with its nicely sculpted lotus and papyrus blossoms, its glaze in browns and greens, and its incised hieroglyphic decoration. Like many other potteries of that time, it also produced utilitarian objects such as stoneware and chamber pots.

Carlton Ware–Carlton Ware, manufactured in Stoke-on-Trent, Staffordshire, began as Wiltshaw & Robinson around 1890 and in 1906, when the company added a line of china, began marking its products with the Carlton Ware stamp. Although some of its output seems rather charmingly kitschy, with dishes shaped like lettuce leaves or waterlily pads and cruet sets in the form of crinolined ladies, during the Art Deco period Carlton produced fine lusterware china, in patterns that often reprised motifs from ancient or exotic cultures such as the Aztec, Egyptian, Japanese, and Persian, or translated them into fine Deco-style designs. The company was disbanded around 1990. Their Egyptian revival pieces remain highly collectible and sought after, and are correspondingly priced.

An attractive umbrella stand by the Brush-McCoy art pottery company, c. 1920, with a design of stylized lotus and papyrus blossoms, along with small (not particularly authentic) hieroglyphs in rectangular cartouches at the top. The glaze as well as the piece itself has a nice Arts and Crafts look to it. Marked 75 on the bottom; stands 17.125" high and is 11.875" in diameter. It sold for approximately $385 in an online auction. This piece comes up occasionally at auction, and seems to sell in the $350-$450 range.

An Egyptian jar by Carlton, probably c. 1925. The lidded jar, in dark blue with polychrome Egyptian designs including a winged Isis, a frieze of lotus and papyrus blossoms, hieroglyphs, and a seated ram-headed god (probably Khnum), measures 7.75" in height. Marked on the bottom in gold with hieroglyphs and a seated god and CARLTON WARE, and in black with Carlton's falcon in a circle topped with a crown and the words W & H STOKE-ON-TRENT CARLTON WARE MADE IN ENGLAND 2711, this last number hand painted. Although there are several flaws– the lid has been broken and mended and there are two or three minute chips in the glaze–this jar sold for approximately $250 in an online auction; a jar in perfect condition would be expected to bring more. Unlike the Carlton "Egyptian fan" pieces, this design appears seldom at auction; however, it does not seem to be as highly sought after as the former pattern.

Denby Ware–Manufactured in the Derbyshire town of Denby for which it is named, Denby Ware was begun by a British entrepreneur named William Bourne c. 1806, who recognized the exceptional quality of local clay discovered there. William gave the job of running his new enterprise to his son Joseph, and for the first years of its existence the Denby pottery was known as the Joseph Bourne company. It originally produced salt-glazed jars and other containers for liquids such as beverages, ink, and medicines. When glass bottles became cheap enough to replace ceramic containers, Denby branched out, producing kitchen- and tableware with richly colored glazes stamped DANESBY WARE. It continues to manufacture tableware as Denby Langley china, in patterns with exotic names such as Kismet, Marrakesh, and Luxor, many of which still use Denby's trademark colorful glazes.

Doulton Lambeth–see below under *Royal Doulton*

Julius Dressler–Julius Dressler's firm, established around 1880 in the Czech city of Biela, Bohemia, made highly decorated pottery. Much of its output was in the Vienna Secessionist style, the Austro-Hungarian style influenced by the Arts and Crafts movement. Some of the company's pieces, however, are in the Egyptian revival style. The company closed in 1944. Their pieces are marked with an engraved JDB, for Julius Dressler Biela.

A Denby Ware plate said to have been inspired by Tutankhamun's treasure, probably c. 1972. A central scene shows daily (royal) life in ocher, tan, orange, yellow, turquoise, red, and white, with a border of geometric elements and stylized lotus blossoms. The reverse bears a legend that reads: "This royal servant is depicted in an Egyptian fishing and hunting scene. The border pattern is one of the most popular of the period" (presumably referring to the Amarna period rather than the late 20th century). Measures 10.5" in diameter; marked DENBYWARE MADE IN ENGLAND Limited Editions, Egyptian Collection "THE KING'S FISHERMAN" NUMBER 1467. The companion plate has a design entitled "THE QUEEN'S HANDMAIDEN." These plates come up fairly frequently in online auctions, where they sell for between $30 and $100 for the set of two (a recent dealer's asking price for the set was $150).

A vase by the Czech maker Julius Dressler, c. 1900, decorated with four mummiform figures, with very sculptural heads, the rest of the mummy being rather flat and decorated with bands of hieroglyphs. Hieroglyphs also fill in the spaces between the mummies; as in so many cases, these are not real hieroglyphs but are creations of the maker's imagination. The top of the vase has geometric and vaguely Egyptian decoration, in dark blue, green (instead of the more usual turquoise), and orange (rather than the customary red). The hieroglyphs in addition include white and pink. The vase is 8.625" tall; marked J B D Julius Dressler Biela. It sold for approximately $125 at auction.

An amphora-ware pitcher by Julius Dressler. Like the vase by Dressler, this is in matte bisque ware, with only the Egyptian-inspired decoration glazed. This pitcher has a stylized pharaoh's head as its main decorative element, with a cartouche-like oval flanked by serpents, invented hieroglyphs, and geometric designs. Stamped JDB CZECHO-SLOVAKIA for Julius Dressler Biela, with an incised number 8117. Approximately 9.5" high. This was purchased for about $100; Dressler's larger pieces, some in the Art Nouveau style, command prices in the four figures.

Egyptian Porcelain Company–The Egyptian Porcelain Company, founded in Cairo in 1942, bills itself as producing Limoges china. It makes Egyptian revival cups, plates, ashtrays, and other souvenir items. These demi-tasse cups are decorated with a hand-painted Egyptian queen. Each piece is marked on the bottom FM PATÉ ET ÉMAIL LIMOGES FONDÉ EN 1942 SCULPTURE FATHI MAHMOUD MADE IN EGYPT. Items from this company turn up from time to time in auctions, but generally sell for far less than genuine Limoges would bring.

A set of demi-tasse cups by the Egyptian Porcelain Company, decorated with the head of an Egyptian queen and hieroglyphs. This company, founded in Cairo, Egypt in 1942, is said to produce Limoges china, but its wares do not seem to be nearly as collectible as Limoges items from France. Marked PATÉ ET ÉMAIL LIMOGES FONDÉ EN 1942 SCULPTURE FATHI MAHMOUD MADE IN EGYPT. The set of six cups and saucers sold for approximately $45 in an online auction.

An Egyptian Limoges ashtray with the design of a queen holding lotus blossoms, which also form a border around the edge. The queen is not identified (the cartouche next to her contains unreadable glyphs, as does the inscription to her right) but she is wearing what appears to be a long scarf that hangs down her back, which might indicate that she is supposed to represent Nefertiti or her daughter Ankhesenamum (these scarves seem to have been worn primarily during the reign of the heretic king Ahkenaton, Nefertiti's husband and Ankhesenamun's father). Measures 7.375" square; marked Fine Royal Porcelain E.G.P. CO. T. LIMOGES. It was purchased for about $6 in an online auction, possibly reflecting the low collectibility of Egyptian Limoges, or the lack of demand for ashtrays, or both.

Falcon Ware–see below under *Goss Falcon Ware*.

Fulper Pottery–Founded in 1814 in Flemington, New Jersey by a potter named Samuel Hill, Fulper Pottery was known as Hill Pottery until its acquisition by Abraham Fulper in the 1860s. Like many such companies, it began by producing utilitarian goods such as drain pipes and storage jars. In the 1880s, when Abraham's sons inherited the business, the pottery became Fulper Brothers (or Fulper Brothers & Company). The company was incorporated as Fulper Pottery Company in 1899. One of their more successful products at that time was a patented "Germ Proof" filter for their water crocks, the forerunner of the water cooler and similar filters used in developing countries where the potability of the water supply is questionable. Around this time, Fulper also began experimenting with the art pottery popular then, producing notably a line of Chinese-inspired decorative objects and their Vasekraft art ware. The company also worked on developing new glazes, hiring experts to replicate ancient celadon and chinese blue glazes. In 1910, William Fulper hired ceramic engineer Martin Stangl to develop new products and glazes; among these was the Vasekraft lamp. Eventually, Fulper Pottery created a line of open-stock solid color faience tableware, which was named after Stangl. The company, run by Stangl after William Fulper's death, continued to make art pottery inspired by, among other things, Classical styles during the 1920s and 1930s. This Egyptian revival powder jar is just one of a number of such pieces produced by them; it appears occasionally at auction, where it usually sells well.

One online source notes that Chinese copies of some of the more famous and collectible Fulper and Stangl designs have recently come on the market. This source also states, however, that in recent online auctions vendors have very carefully noted that this is not original Fulper ware. Still, it is probably best to be cautious, and inquire about the origins of any Fulper ware; that from China is usually marked with a small (and removable) MADE IN CHINA sticker.

Goebel Company–This German company is known primarily for its collectible Hummel figurines of cherubic children, which it began manufacturing in 1936. Based on the art work of talented Franciscan sister Maria Innocentia (nee Berthe) Hummel, who died in 1946 at the age of 35, these figurines rank as among the most widely collected collectibles ever. However, Goebel's craftsmen also create, among other things, animal figurines, jars and canisters in the form of monks, and dolls. In addition, they turned their talents to creating a realistic recreation of the famous bust of Nefertiti (see page 26), discovered in 1912 by Borchardt and now residing in the Berlin Museum. Like most reproductions of Nefertiti's bust, Goebel has restored her missing left eye.

Goss Falcon Works–Falcon Works, founded by William Henry Goss in the Staffordshire city Stoke-on-Trent, was the first to produce porcelain miniatures with heraldic crests. A number of these are in forms borrowed from ancient Egyptian jars and lamps, and are marked on the bottom as models of Egyptian pottery. This one is marked with a stamp MODEL OF EGYPTIAN WATER JAR RD No 569836. It also has the company's mark, a falcon, and its name, W.H. GOSS. These tiny items seem to be very collectible, and turn up frequently in online auctions. During the early part of the twentieth century, the company faced stiff competition from other Staffordshire companies marketing heraldic miniatures. Similar Egyptian-inspired jars were manufactured by the Carlton, Grafton, and Botolph companies; their miniatures also frequently appear in online auctions. The price range for these miniatures seems to vary widely.

A crested miniature based on an ancient Egyptian water jar, by the Staffordshire-based Goss Falcon Works, the first to produce such miniatures. About 2" high; marked with black stamp on bottom MODEL OF EGYPTIAN WATER JAR RD No 569836 and the company's falcon mark, as well as the company name W.H. GOSS. Prices for this company's miniatures, as well as those of their rivals, such as Grafton Company and Botolph, seem to vary considerably in online auctions, but usually fall in the $10-$50 range. This one was purchased for about $20.

A covered trinket or powder jar by Fulper, probably c. 1930. The lid of the jar is decorated with a kneeling Egyptian woman who here has red hair, but in other examples of this piece has the more expected black hair (although mummies of blond and redheaded Egyptians have been found). The woman is dressed in clothing that owes more to Hollywood imagination than ancient Egyptian fashion, but she is still recognizable as Egyptian–or, possibly, Byzantine, if the two can be said to form separate categories. Marked FULPER in a cartouche with what appear to be the stylized letters E S in a triangle; approximately 5.5" in diameter, 7.625" high. These boxes appear at auction upon occasion, although not frequently; this one sold for $325 after fairly competitive bidding.

Haynes Ware–Haynes Ware was made in Baltimore, Maryland by D. F. Haynes & Sons (earlier known as D. F. Haynes Chesapeake Pottery Company). Among other things, Haynes produced an Egyptian line, as well as a Mycenian line with scenes of knights and forests. The Egyptian line is not, strictly speaking, Egyptian revival in its purest form–that is, using designs inspired by ancient Egypt–but rather falls more into the "travelog" genre. Early (pre-World War I) pieces in the Egyptian line feature a hand-painted desert scene with a rider on camelback, pyramids, and palm trees; this covered cannister is probably later, and the decoration likely applied using the transfer process. The line was made during the early years of the twentieth century, although the pottery had been in existence since 1881. Pieces in this line are marked on the bottom HAYNES WARE EGYPTIAN DECORATION. An earlier hand-painted Haynes Egyptian beer mug was offered for sale at $45, but this piece was acquired in an online auction for less.

A covered jar by the Haynes pottery company, with an Egyptian desert travelog scene (most likely applied with transfers or transfer printing) complete with pyramids, palm trees, a camel, columns, an ancient portal, and modern fellahin. Probably dates to around 1920-1930, and is marked on the bottom HAYNES Ware Egyptian Decoration. No 632. Measures approximately 6.5" high, with a diameter of 5.25". In very good condition, a reasonable price for this jar would be around $25-$65.

Japan–The Japanese, with a long tradition of making china and porcelain, and with a booming business in exports to the west before the outbreak of World War II as well as later during its post-war reconstruction, not unnaturally turned their talents to creating the Egyptian revival dishes and decorative items popular with their occidental customers. Having their own ancient traditions not related to Egypt or Greece, and having been largely closed to outside influences until the opening of Japan in the mid-nineteenth century by American Commodore Perry, they were probably less interested in Egyptian antiquities than those studying ancient Egypt in the west. They also probably had far fewer examples in books and museums to draw from as prototypes. Thus at times their renditions of Egyptian motifs are even less reliable than those produced by European and American makers.

Like some of their counterparts in the west, Japanese manufacturers did not always place their company's name on their wares. Also, for many of us, their brand names are not entirely familiar, the exceptions being Noritake and Mikasa (this latter not actually a single firm, but rather something of a conglomerate). Therefore Japanese wares have been put together in a single section.

A number of the Japanese Egyptian revival ceramics were made as "incidental" items, rather than dinnerware per se. One can find sets of nut bowls, fruit bowls, candy dishes, and other items made in Japan. Those manufactured before World War II are often marked "Nippon" rather than "Japan." Although the quality of these pieces exported from Japan is often excellent, with rare exceptions–such as a Noritake humidor recently offered for sale with a reserve of over $400–Japanese Egyptian revival china is reasonably priced.

A set of small bowls and a larger bowl, possibly for nuts or candy, from Japan c. 1930. The bowls, edged in a light green, are decorated with hieroglyphs. This set sold for approximately $50.

A square serving dish from Japan, with the head of an Egyptian wearing a headdress that appears to combine a Byzantine diadem with a *nemes* headdress. Each side is painted with a stylized lotus, and the top has a border in red and dark blue with white accents. Measures 6" across with handles; marked on bottom with an M inside a laurel wreath, and Hand Painted NIPPON. An identical dish was offered for sale recently for $85, though this was purchased for about $40 in an online auction.

Lenox–This New Jersey-based company is among the better-known American producers of fine china, including tableware and decorative objects. The company was founded by Walter Scott Lenox, who originally produced one-of-a-kind art pieces in an ivory glaze, but in 1902 began producing fine china dinnerware. The company succeeded in spite of competition from older, more established European firms, and was the first American firm chosen to have its china displayed in France's National Museum of Ceramics, in Sèvres. Although not particularly noted for Egyptian-themed goods, Lenox has put out a line of Egyptian cats, as well as several figurines of Egyptian figures, including Cleopatra.

A cat by Lenox, intended to represent the ancient Egyptian cat goddess Bastet; this figurine is sometimes referred to as "Bastet's Beauty." Perhaps the most Egyptian feature of this cat is its winged scarab collar, supposedly in 24K gold, with red and blue accents. Stands about 5.5" high; marked © LENOX ® 1995. These figurines appear quite frequently at auction, along with the myriad other cats created by Lenox; they are also available new online, with an asking price usually around $30.

A figurine of Cleopatra by Lenox, complete with–what else?–cat and stool accessories. In addition to their dinnerware, Lenox produced a number of collectible items in porcelain. Cats especially seem to have been popular with this maker, including a series of Egyptian cats. Lenox also produced a pair of Antony and Cleopatra figurines. Figure stands 8.75" high. Marked Cleopatra THE LEGENDARY PRINCESS FINE PORCELAIN LENOX™ 1990, with a sticker identifying it as being handcrafted in Taiwan. Unlike the Lenox cats, the figures of Cleopatra do not appear all that frequently at auction. This particular Cleopatra figurine, however, was recently offered for sale by a dealer with an asking price of $135.

Limoges–see below under *Tressamanes & Vogt*
McCoy–see above under *Brush-McCoy*
Minton–The Minton china factory was built in the 1790s by Thomas Minton. Located in the English town of Stoke-on-Trent, home to many other Staffordshire pottery and china makers including Josiah Wedgwood's original factory, Minton's factory began producing bone china said to equal that of the French Sèvres china, which influenced Minton. Minton also became noted for their "Willow Pattern" china, based on a Chinese legend. Though not particularly known for Egyptian-inspired china, Minton did produce a pattern called "Luxor" in the 1920s and 1930s, one of many such patterns inspired by–or at least named for–the 1922 discovery of Tutankhamun's tomb. The pitcher, with a design that might be considered a stylized lotus, is earlier, probably dating to the late 1800s. Then, as now, Minton catered to a wealthy clientele; some of their newer china sells for as much as $300 for a single saucer, though Minton china can be found for less in other patterns and in online auctions. Minton also produced decorative tiles, such as the one depicting Antony and Cleopatra (introduction, page 11).

Monmouth Western Pottery Company–see below under *Western Stoneware Company*
Pickard–Based in the Chicago, Illinois, area and often grouped with that city's art pottery studios, Pickard was founded in 1898 by Wilder Pickard. Pickard originally hired artists to decorate china blanks imported from Europe, and his company produced beautiful hand-painted dishes such as the lotus-patterned double-handled bowl shown here, which dates to c. 1905-1910. Around 1910 Pickard began manufacturing its own china. The company made the then-fashionable "Luster Papyrus" china, here in a jardiniere that seems to have an Art Deco look, around 1930. The firm, which is still owned by Wilder Pickard's descendants, remains in the business of producing fine china, including its "Luxor" pattern, as well as institutional china.

A jardiniere in Pickard's "papyrus and luster," probably c. 1930 with a design of papyrus blossoms in Egyptian revival colors with an Art Deco flair–the red is more magenta and the turquoise more aqua than usually found in Egyptian revival items. Unmarked; stands 5" high, measures 4.5" in diameter at the mouth. This item appears occasionally at auction, and often sells for $130-$170.

A pitcher by the British china manufacturer Minton, dated 1864, with a hand-painted design of stylized lotus blossoms in red, black, and gold, and geometrical borders in the same colors. Marked on bottom MINTON in a rectangle superimposed on a globe; date mark (a raised lozenge), signed with D 1551 711 painted in red, and an undeciphered impressed mark; 7.5" tall and in good overall condition except for a small chip at base. Sold for $50 in an online auction, but from a dealer would probably be priced in the $100-$200 range.

A double-handled dish by Pickard with a hand-painted lotus design, c. 1905-1910. It measures 12" long overall (including handles), with the bowl itself being 7.625" long and 6" wide. Marked PICKARD CHINA and signed by the artist LEACH. This piece has come up twice at auction recently, although it is said by Pickard collectors to be difficult to find. A footed bowl in this pattern, with some noticeable damage, sold recently for $75 in an online auction. This piece, in fine condition, sells in the $200-$350 range.

Red Wing Art Pottery–One of a number of potteries that sprang up in Red Wing, Minnesota at the end of the nineteenth century, Red Wing Art Pottery was one of the ceramics companies in this country that seem to have been inspired by the Arts and Crafts movement, creating artisan wares with a variety of influences, including that of ancient Egypt. This jar, in Red Wing's "Egyptian" style, is one of a number produced by them and other companies, including Uhl (for which see below). Often these Egypt-inspired wares have glazes in Egyptian revival colors, such as this one in dark blue. Uhl also produced similar items, and without looking at the stamp it can be hard to tell them apart. Red Wing's potteries went out of business in the late 1960s. Marked with a blue stamp RED WING ART POTTERY, with what appears to be an incised 955.

Rosemeade–Rosemeade pottery, one of a number of wares produced in the United States by art pottery firms such as Rookwood, Roseville, Van Briggle, and Weller, was manufactured between 1940 and 1961 by the Wahpeton Pottery Company, located in Wahpeton, North Dakota. It produced a number of items, among them their popular and very collectible salt and pepper shakers in the form of animals. The salt and pepper shakers shown here are three of a set of four in the shape of the canopic jars in which embalmed viscera were placed in the tomb in ancient Egypt. This particular Rosemeade item seems to come up at auction infrequently, and is possibly sought after not so much by collectors of Egyptian revival but by those who collect Rosemeade in general. Probably made c. 1950, these salt and peppers demonstrate once again that Egyptian revivals did not take place only during the Victorian and Art Deco periods.

A double-handled vase by Red Wing, n.d. This type of vase, usually with one or two handles, is labeled "Egyptian," referring presumably to the general form of the piece. Similar vases and jars were made by Uhl, and are also called "Egyptian." In many cases, these vases are in Egyptian revival colors, including a bluish-green, red, and dark blue–as here. Stamped RED WING POTTERY; stands about 15.5" high. These pieces appear fairly frequently in online auctions; larger ones such as this often sell in the $75-$125 range. A Red Wing "Egyptian" double-handled vase in the harder to find reddish maroon had a dealer's asking price of $175.

Three out of a set of four Rosemeade salt and pepper shakers in the form of canopic jars. Canopic jars, found in Egyptian burials as early as the Fourth Dynasty, held the organs removed from a mummified body and themselves embalmed. Although the earlier canopic jars were rather plain, in the Eighteenth Dynasty the lids were given either human form (as in Tutankhamun's canopic jars) or the form of one of the four sons of Horus, each one assigned to guard a different organ or set of organs. The deities were: Hapi, in the form of a baboon, who guarded the lungs; Duamutef, in the form of a jackal, who guarded the stomach; Khebesenuef, the form of a falcon, who guarded the intestines; and Imsety, in the form of a human, who guarded the liver. These salt and pepper shakers fairly faithfully recreate the ancient jars in miniature (although some people seem to find the idea of using containers that look like those used to hold embalmed organs rather distasteful). Unmarked, but one of the shakers has a small metallic tag that reads ROSEMEADE POTTERY. These were purchased in two separate auctions, with Imsety and Khebesenuef bought together in the first auction, and Duamutef purchased later. Despite the fact that they came up for sale separately, these salt and peppers are not seen frequently; they seem to sell for $100-$200 apiece.

Rosenthal–This German china company was founded by Phillip Rosenthal. Like Pickard, he began business by buying blank china, which was then hand-painted by his wife and sold door-to-door. In 1891, Rosenthal founded a factory in Asch (in Bohemia) and began producing his own china. By the beginning of World War II, Rosenthal had acquired ten companies in various German towns such as Kronach, Selb, and Waldenburg. After the war, Rosenthal's son returned to Germany and revived the family's business, which is still in existence, producing fine china tableware as well as decorative objects such as animal figurines.

The company also produced Egyptian revival figurines during the Art Deco period. Today larger figurines, such as the standing Egyptian woman, can sell for up to $800-$900 at auction, although this one was acquired in an online auction for considerably less. The figurines have the Rosenthal mark, the company's name divided by an X.

A figurine by Rosenthal with a seated Egyptian woman–identifiable as such by her stiff, straight hairdo and fillet formed of flowers with dangles on either side–gazing at a frog, probably c. 1930. Measures 5.125" x 3" at the base, and 4.75" high. Marked on the bottom with a large X topped by a crown, with ROSENTHAL in script bisected by the X; also marked with what appears to be SELB-BAVARIA. This small figurine sold at auction for about $170, a fraction of what the larger standing Egyptian woman by this maker usually commands.

Another Art Deco female figure by Rosenthal, this one standing with arms raised high, in a position often seen in dancing girls said to be, rightly or wrongly, Egyptian. This woman has marked similarities with the seated Egyptian figure shown here, especially in the way her skirt is decorated: Both have scattered gold circles formed by dots. This woman is less obviously Egyptian than the other Rosenthal figurine, but is invariably described as such. Approximately 18" tall and signed with Rosenthal's mark. These figures appear not infrequently at auction, online and off, and sell for a fairly wide range of prices, with $380 at the lower end, and up to $900 at the higher end.

Royal Doulton–The business that produces Royal Doulton china was founded in 1815 by John Doulton and John Watts in the town of Lambeth, England and was at times known as Doulton Lambeth (which name appears on some of their Egyptian revival pottery). Another of the innovators in ceramics, Doulton introduced various techniques and glazes, including the beautiful *rouge flambé* (a technique allowing oxygen in controlled amounts into a kiln, where it reacts with certain metal oxides in the glaze to produce a shadowy effect against a red background). The company's first output consisted largely of salt-glazed utilitarian items such as jars and pitchers, as well as sanitary pipes for use in plumbing intended to reduce the outbreaks of cholera prevalent in the early nineteenth century. The Lambeth plant closed in 1956, but the company continues to produce fine china and collectible figurines. Some of their late nineteenth and early twentieth century wares included Egyptian revival motifs, and they also created a lovely figurine of an Egyptian woman with a harp, which appears to be extremely hard to find.

An Egyptian-themed plate by the British china manufacturer Royal Doulton, c. 1928, with a scene of an enthroned pharaoh offering to what appear to be various gods (possibly including Osiris), with the figure of a queen and her attendant behind them. A geometric design of stylized lotus and papyrus plants forms the border. The plate is marked on the front EGYPTIAN POTTERY, with PERSONALLY CONDUCTED TOURS EGYPT in a small red circle at the bottom; the reverse is marked with a lion above a crown, ROYAL DOULTON ENGLAND encircling a quatrefoil design, and a hand-painted D 3419 along with a small undecipherable mark. Measures 10.5" in diameter. An almost identical plate (except that instead of EGYPTIAN POTTERY PERSONALLY CONDUCTED TOURS EGYPT it was marked TUTANKHAMEN'S . TREASURES . LUXOR and also had two jars instead of a longer hieroglyphic inscription) sold recently in an online auction for $95. A teapot with this design was offered for sale by an online dealer for about $210, while a bowl in this line, with a hunting scene, recently sold for about $140 in an online auction.

A pitcher from the British firm Doulton Lambeth c. 1895, with a pharaoh spout and cameo decorations in a band around the middle, as well as a winged scarab where the handle attaches at the bottom. The cameos show the seated figure to be wearing a crown with a uraeus, on a chair with lion-shaped legs before a table piled with offerings, and holding a cup in an upraised arm. The hieroglyphs, rather meaningless, are those of the mouth hieroglyph indicating the letter **r**, a thin line that may represent a flat loaf of bread, two jars, a circle, and a cup; to the left of the **r** is what appears to be a fold of cloth. All of these, except for the letter **r** (which here may stand for the word *jmy-r* "overseer"), are usually present in stelae requesting offerings for the dead. A typical offering inscription reads: "May the king grant a boon [of] one thousand of bread and beer, cattle and geese, fine linen to [title and name]." This pitcher measures 7" in height, amd is 13" in circumference. Marked on the bottom with incised ROYAL DOULTON ENGLAND around the quatrefoil symbol, the lion above a crown, the words Ad. No. 127031 212 and two illegible marks. It was purchased for about $50. Larger pitchers in this line can sell for as much as $150.

A figurine of an Egyptian woman by Royal Doulton, n.d. but fairly recent. A much older c. 1885 Royal Doulton figurine of an Egyptian woman had an asking price of over $1200 in an on-line auction; the figure was also considerably larger than this one.

While the tan and cream Doulton pitchers come up fairly frequently at auction, items in this rarer combination, with blue added to the earth tones, are harder to find. This one, a jardiniere, stands 8.25" high, and is c. 1881-1890. It is decorated with a procession of Egyptians divided by large lotus blossoms in blue. Stands approximately 8.5" high, with a diameter of 8.25" at the top. Marked DOULTON LAMBETH SILICON. It sold for approximately $40 in an online auction.

Schafer & Vater–A German company founded in Thuringia in 1890 by Gustav Schafer and Gunther Vater, this firm produced finely textured bisque ware suitable for painting and other decoration. Their line was extremely varied, including dresser sets, bobble-head dolls, match strikers, and Kewpie dolls. Many of their wares, sometimes referred to as "fairings" because they were given as prizes at fairs, were intentionally comical. They also produced a number of Egyptian revival pieces, such as an Egyptian nodder (or bobble-head doll), and an Egyptian woman holding out a tray, as well as this vase with an Egyptian princess and her attendant. Their mark, incised on the bottom of the vase, is a nine-pointed star and a crown.

A jasperware trinket holder (or possibly a match holder or vase) in pink with gold accents, by the German firm Schafer & Vater, in the form of two Egyptian women, the seated one wearing the queen's vulture headdress and holding a harp, the other standing. Measures approximately 5" x 6"; incised on bottom with Schafer & Vater's mark, a crown above a nine-pointed star, and the number 6133. Schafer & Vater were noted for their comic wares, but also produced several Egyptian designs, including a bobble-head Egyptian girl match striker, and a vase with the face of an Egyptian girl holding an Egyptian doll. Their items are considered collectible, and generally bring anywhere from $75-$250; a large pitcher with a Classical motif recently for sale had an asking price of $224. This particular item was purchased for approximately $78 in an online auction; the asking price for the Egyptian bobble-head match striker was $110.

A fish plate by the Limoges company Haviland, probably c. 1890, with a hand-painted scene of an overseer speaking to an Egyptian couple, the Nile River and a barque in the background. A set of a dozen such plates was offered for sale by an online dealer for approximately $1200, but this single plate was bought for around $60 in an online auction. Measures 7.25" square; marked C F H over G D M in green.

Tressemanes & Vogt–Tressemanes & Vogt was located in the French town of Limoges, noted for its hand-painted Limoges enamels and fine china, which the town continues to produce. Among other things, Limoges is the generic name for small hand-painted collectible china boxes in unusual shapes made by several companies there; for examples of Egyptian-themed Limoges boxes please see the introduction (page 9) and chapter two (page 94).

The Egyptian revival teapot, with a winged scarab, and the jardiniere or fernier with a lotus design, were as might be expected both painted by hand. Both pieces are stamped with T & V inside a box, with LIMOGES under the box.

Other notable Limoges china manufacturers include Haviland, which did produce some Egyptian revival items, such as a set of twelve fish plates each painted with a different scene of ancient Egyptians by the Nile (offered for sale at $1800).

A Limoges teapot by Tressamanes & Vogt, decorated with a winged scarab and geometric designs in light blue, red, green, ocher, yellow, white, and black, with stylized lotus blossoms in gold around the base. Measures approximately 7" across, 6.5" high including the handle; marked T & V LIMOGES FRANCE but otherwise not signed by the artist. This firm's mark was used in the late 19th and early 20th centuries, meaning that this particular piece probably dates from c. 1900, but was possibly–like the ferner shown here–decorated a bit later. In mint condition, this teapot might reasonably sell for about $125-$250.

A ferner made in Limoges, France and dated 1919, also by Tressamanes & Vogt, with a design of lotus blossoms and buds in pale lavender, green, yellow, and white against a gold rim. Measures approximately 3" in height, 7.25" in diameter; marked in green on the bottom T & V LIMOGES FRANCE for the Tressamanes & Vogt company, with the artist's initials F.J. and the date. In almost flawless condition, and a book piece (it appears on p. 333 of the *Collector's Encyclopedia of Limoges Porcelain*, Third Edition, by Mary Frank Gaston), this piece might reasonably be priced from about $150 to $300.

130

Uhl Pottery–The Uhl Pottery Company, variously known as the Indiana Pottery Company and the A. & L. Uhl Pottery Company, was founded in the middle of the nineteenth century in Evansville, Indiana by a German immigrant named August Uhl. The pottery, later run by other members of the Uhl family, began by producing utilitarian items and only during the twentieth century turned to producing decorative dinnerware, vases, and a smattering of hand-turned items. The pottery, by then located north of Evansville in Huntingburg, Indiana, closed in 1944 following a prolonged strike by the plant's workers. Interest in this company's products has been slowly growing, leading to the formation of an Uhl Collectors Society in 1985, and although prices for most Uhl pottery have not reached those commanded by pieces from America's "art pottery" companies such as Roseville and Weller, rare and one-of-a-kind items have sold in the four-figure range.

The Uhl line referred to as "Egyptian" is usually Egyptian revival in the sense that it may have been inspired by the form of ancient Egyptian pottery; rarely is it decorated with Egyptian motifs. However, Uhl's "Egyptian" pieces are often in colors consistent with Egyptian revival, including a lighter blue, red, and very dark blue. The unglazed flower pot is adorned with what appears to be a winged pyramid. Similar "Egyptian" vases, with similar glazes, were also manufactured by the Red Wing pottery.

Victoria Porcelain–The Victoria Porcelain Factory was operated by Schmidt & Company in Altrohlau, Bohemia. From 1919 until 1939–that is, the period between World War I and World War II–the factory stamped its ware with a crown logo surrounded by the words VICTORIA Czecho-Slovakia. The company produced attractive porcelain dinnerware, tea sets, and incidental sets such as this sandwich or dessert set. Their designs were hand painted, as in these plates, in lusterware. This design really falls into the "travelog" category rather than true Egyptian revival.

An unglazed pot by the Uhl Pottery, with an unusual Egyptian revival design of a winged pyramid flanked by serpents.

A set of sandwich or dessert plates and serving tray by Victoria China, with scenes of pyramids, palm trees, and men on camels. This set is probably hand-painted rather than done in transfer as each plate has a slightly different version of the scene. Marked on the bottom with a crown mark, and Victoria CHINA CZECHOSLOVAKIA in green.

131

Walther & Sohne–Walther & Sohne, of Radeburg, Germany, produced quality pressed glass. Their "Egyptian" vanity set, which sometimes includes candlesticks in addition to the tray and covered jars, frequently turns up in auctions, and was probably produced in some quantity during the 1930s. The set was made in a variety of colors, including green, pink, and clear (untinted). The tray features a (presumably Egyptian) woman gazing out at a vista of pyramids (or mountains). The larger jars have lids with sculpted glass seated women with wavy hair. Although pieces from this set are not difficult to find, they usually sell well.

An "Egyptian" vanity set by Walter & Sohn, consisting of a tray in blue glass, and a covered dish with a figure of a (presumably Egyptian) woman. These two pieces were sold separately at auction, although in most cases dealers do sell these sets together. Besides a ring holder and small covered jars, the set sometimes includes candlesticks in the form of a woman.

Weller Pottery–Weller Pottery was founded by Samuel Weller in 1872, in Fultenham, Ohio, and moved to Zanesville, Ohio, in 1888. In 1895, Weller began producing, in addition to utilitarian items, art pottery. Not coincidentally, Weller around this time also began collaborating with William Long, one of the founders of the successful Lonhuda Pottery (but Weller, having learned what he could from Long, minimized his role in the company, perhaps forcing him out). Weller was a major force in American art pottery, and produced a number of lines including the Eocean and Etna. Recognizing that the company's production of hand-incised ware, as in their popular Dickensware—based on the illustrations of Charles Dickens's works engraved by hand on clay—was too expensive, Weller developed lines of embossed ware to replace the hand-incised ware. Among these lines were Weller's Burntwood and Claywood. The "Assyrian/Egyptian pharaoh" vase shown here is in Weller's Claywood, which is somewhat paler and less golden-brown than their Burntwood.

Western Stoneware Company–Located in Monmouth, Illinois, from the early 1900s until 1985, the Western Stoneware Company is often known simply as Monmouth, or Monmouth Western. It produced heavy, durable goods such as jars and planters. Like other potteries in this country inspired by the Arts and Crafts movement, it produced some of the "art pottery" prevalent during the early decades of the twentieth century. However, most of its output appears to have been utilitarian, and often with rather drab glazes such as in the planter shown here. Western Stoneware also produced crockery such as cookie jars and bean pots with a shiny brown glaze on top and matte bisque on the bottom. Its mark was a maple leaf with the words WESTERN STONEWARE.

A Weller claywood vase, c. 1910, often referred to as an "Assyrian" vase but also sometimes referred to as an "Egyptian pharaoh" vase. However, the male figure resembles an Asiatic (from Palestine, Syria, or Mesopotamia) rather than an Egyptian–the long, heavy robe, the flat-topped cap, and the full beard are garb belonging to Egypt's Eastern enemies and vassals. But the columns (which seem to be in a stylized lotus design) and the winged orb are Egyptian in style. One possibility might be that this design was taken from an Egyptian scene of a foreign dignitary come to pay court at Memphis or Thebes. However, it could simply be that Weller's designer unknowingly juxtaposed Egyptian and Asiatic themes. Unmarked, though found in books on Weller pottery; stands 9.5" high. This vase shows up somewhat infrequently in online auctions; in its most recent appearance, it sold for $200.

A planter or jardiniere from the Western Stoneware Company, with the same design of a *ka* found on the vase by this company, shown in chapter two, page 54. The **ka** is enclosed in a winged orb, a not uncommon Egyptian revival motif, with a frieze of stylized lotus blossoms decorating the lower half of the planter.

133

Jewelry and Metalware

With the rediscovery of Egypt, Egyptian motifs soon became moderately popular in architecture and the decorative arts. The taste for Egyptian revival jewelry, however, seems to have developed somewhat later, and can probably be dated to around the middle of the nineteenth century–a time when archaeological revivals of all types formed one of the most dominant trends in jewelry in England, France, Italy, the United States, and elsewhere.

During the nineteenth century, Egyptian revival jewelry seems not to have enjoyed the popularity accorded other revivals. A recent auction of vintage and antique fine jewelry had approximately a dozen pieces in the Etruscan revival style, but only one in Egyptian revival. The Art Deco period, though, saw an increased interest in Egyptian revival jewelry while other revival genres practically disappeared. This was probably due in part to renewed interest in ancient Egypt following the discovery of Tutankhamun's astounding treasure, and in part to the fact that Egyptian revival jewelry used the bright, contrasting colors then fashionable (although it may be the case that the colors became fashionable because they were used in Egyptian revival jewelry, as one source posits, rather than the other way around).

However, other items in metal, especially silverware, *were* popular in Victorian times. Gorham, the leading producer of American silverware at the end of the nineteenth century, introduced a number of Egyptian-themed patterns around 1870 (lending some credence to the claim that there was an Egyptian revival inspired by the opening of the Suez canal). Other silverware companies, such as Whiting Davis, followed suit, producing Egyptian revival patterns around 1885.

Because some firms that manufactured jewelry, such as Blackinton, also at times made other items in metal, or vice versa, we have decided to discuss jewelry and other metal items in a single section. With the exception of Gorham, firms making jewelry, other items, or both are listed below in alphabetical order.

Gorham Silver Company–Based in Massachusetts, Gorham silver falls strongly within the tradition of excellent silversmithing and jewelry making, for which New England has been known since before the American Revolution. Patriot Paul Revere, of Longfellow's "one if by land, two if by sea" fame, is probably this country's most famous silversmith, but he was only one of many master craftsmen and designers the region produced. And the tradition continued throughout the nineteenth century. Although most of the country's gold jewelry was created in Newark, New Jersey, a great deal of the silver flatware, jewelry, and other decorative objects produced in the United States came from Connecticut, Massachusetts, and Rhode Island. Firms such as Meriden, Charles M. Robbins Company, the Shepard Company, and Watson Company created the country's silver and silverplate, some of it in Egyptian revival designs.

Probably no American company produced as many Egyptian revival patterns as Gorham, founded in the early 1800s by Jabez Gorham, an ambitious jeweler and silversmith. When his first company, a joint venture, failed, he set up in business for himself as "Jabez Gorham, Jeweler." Despite his accomplishments–he produced fine filigree work and created a gold chain named for him–his company struggled until 1831, when he had the happy idea of producing the newly popular coin silver spoons. These were a success, and Jabez Gorham, and later his son John, went on to preside over a company that dominated American silverware production. The company was noted for its excellent and innovative design as well as its craftsmanship, and was offered commissions that took it beyond craft into art, as when it was asked to create the statue of Theodore Roosevelt that stands outside New York's Museum of Natural History.

Though it would be unfair to claim that Gorham was to Egyptian revival silverware and jewelry what Wedgwood was to Egyptian revival ceramics and decorative objects (Gorham did not develop new materials or techniques, as Wedgwood had done, nor was the company ahead of the times in its preference for Egyptian motifs, as Wedgwood had been), nevertheless Gorham did create a number of Egyptian-themed silverware patterns, which also appeared in tea sets, salts, and baskets. Among the Egyptian revival patterns introduced by Gorham around 1870 were the "Isis," "Lotus," "Egyptian Revival" (or "Sphinx"), and "Silence."

Like most other Egyptian revival objects, Gorham's Egyptian patterns were probably not produced in great quantity, and they are correspondingly difficult to find, and expensive once located. Online auctions of Gorham Egyptian revival flatware and other items usually provoke very competitive bidding, with resultant high prices.

Victorians had a taste for heavy, sculptural silverware, not only in the Egyptian revival but in other themes as well. Gorham and other silver manufacturers created wonderfully dimensional pieces, some with birds' nests, squirrels, stags' heads, saints, and Native Americans, among others. Gorham's "Egyptian Revival" (or "Sphinx") pattern especially is solidly in this tradition, but its other Egyptian designs also have a nice heft, and this may be another factor contributing to the high price of Gorham Egyptian revival silver.

Not all Gorham Egyptian revival flatware comes to market in acceptable condition. Gorham's "Isis" pattern, for example, has an interesting appliquéd winged serpent at the junction of the handle with the bowl or the blade; at times this is missing. And though the "Isis" flatware is distinctive in other ways–the squared section on the handle, for example, is unusual–it lacks true Egyptian flavor without the appliqué. Yet it appears that some dealers do not necessarily feel the need to point out the missing signature element when listing items in this pattern.

Possibly because Gorham was known for producing Egyptian revival designs, some Gorham patterns are often misidentifed as Egyptian. This is especially true of the Gorham "Ivy" flatware, which is often mistakenly described as "Egyptian Ivy"–sometimes with the descriptor "aesthetic" listed next to the name. While it may have been inspired by the Aesthetic Movement, there is precious little of Egypt in this pattern; and in reference books on silverware, it is usually listed simply as Gorham "Ivy."

Gorham also made Egyptian revival jewelry, such as the silver stickpin shown here. In many ways, the Egyptian head on the stickpin looks as if it would be right at home at the end of a fork handle.

A sterling silver three-piece tea set, c. 1870, by Gorham, with sphinx feet, applied Egyptian faces and rosettes, and sphinx finial. The set includes a creamer (4.5" tall), uncovered sugar (3.75" tall), and covered tea pot (6.75" tall). Weighing between fifty and sixty ounces, the set sold for approximately $2700 in an online auction.

A small ladle in Gorham's "Silence" pattern, with two small sculptural seated Egyptian figures–which might easily have come off a temple wall, so strongly do they resemble hieroglyphs–perched above the gold-washed bowl. This is the only piece any of us has seen in this pattern, and as it is not described in most guides to silverware, it is taken on trust (in the dealer who sold it) that "Silence" is the name Gorham gave to this design. Probably c. 1870, the date of most other Gorham Egyptian revival patterns. This piece had an asking price of about $1200, probably based in part on the scarcity of this pattern, and the overall silver content.

Sugar tongs in Gorham's "Isis" pattern, c. 1870. The small applied winged disk–possibly flanked by serpents–is an integral part of the design, though items put up for sale or at auction it is occasionally missing. These sugar tongs and other items in the "Isis" pattern appear in online auctions; the sugar tongs most recently offered in an online auction sold for $225. However, dealers will usually ask about twice as much for this or a similar item. Pieces in this pattern are usually fairly hard to find, although they do occasionally come up at auction. Knives and forks seem also to sell in the $225-$400 range, while larger serving pieces go for $600-$1000. A creamer and sugar in the "Isis" pattern had a dealer's asking price of $3000.

A teaspoon in Gorham's "Lotus" pattern, also c. 1870. Like most other Gorham Egyptian revival patterns, this one is somewhat hard to find, and usually commands a fairly high price from dealers and at auction. The "Lotus" pattern seems to be a bit more easily found than most Gorham Egyptian-inspired patterns, however; a nutpick sold recently at auction for $125, and six teaspoons in this pattern sold for $400, while a pair of "Lotus" salt cellars sold for $1100.

Another Egyptian revival pattern by Gorham, with a very sculptural bust of an Egyptian wearing the *nemes* headdress. The name of this pattern, which like a number of other Gorham patterns is not listed in some of the more standard reference books, is not certain; the dealer who sold it listed it merely as "Egyptian Revival," while another dealer in discontinued china and silver listed it as Gorham's "Sphinx" pattern, which was first available in 1869. This latter identification seems more likely, as Gorham is known to have produced a "Sphinx" pattern. This serving spoon was purchased online for approximately $850; a sugar sifter was offered for sale by an online dealer for $900, and a gravy ladle was offered for $1000. Usual marks for Gorham.

A stickpin in sterling silver by Gorham, in the form of a pharaoh's head that would look very much at home as the finial on a serving spoon (which perhaps it once was).

A teaspoon in Gorham's "Ivy" pattern, which is often listed as "Egyptian Ivy." Although this pattern debuted c. 1865, just before Gorham created a number of Egyptian revival designs, there is nothing very Egyptian about this particular pattern, which is listed simply as "Ivy" in reference books on silverware. Frequently this pattern is also described as "Aesthetic," which seems a much better descriptor than "Egyptian." However, even articles on Gorham silver do use the name "Egyptian Ivy," and the pattern is also listed this way by a number of online dealers. These spoons, which contain much less silver than many other Gorham pieces of the same vintage, sold for approximately $50 each; serving pieces can be found online ranging from approximately $310 to $700, with ice cream spoons at $99 and forks at $179. This pattern is usually much easier to find than true Egyptian revival patterns; it is carried by online dealers and comes up fairly frequently at auction. Usual marks for Gorham.

Alvin–During the late nineteenth century, Alvin made sterling silver flatware in the newly popular Art Nouveau designs, as well as traditional Victorian designs. The company later became part of Gorham. During the 1920s, Alvin was one of a number of companies that, inspired by the discovery of Tutankhamun's tomb, marketed a pattern with the name "Luxor." This pattern, however, seems more Egyptian in name than design, with a motif that is not particularly derived from ancient Egyptian art.

An advertisement for Alvin silver-plate, showing the company's "Luxor" pattern in the sugar spoon found here.

A silver-plated sugar spoon in Alvin's Luxor pattern, which debuted c. 1924 and is clearly one of the many items inspired by the discovery of Tutankhamun's tomb in 1922. However, the design appears more Classical than Egyptian, and is rather restrained, with two modest swirls at the end, and a striated border. The only part of the design that does seem inspired by ancient Egypt is the group of four buds in the center of the handle that, if examined closely, resemble stylized lotus blossoms. Marked ALVIN PATENT; 6.125" long. Silver-plated flatware in this pattern seems still to be available new, and ranges (both new and vintage) from about $9 for a teaspoon to about $35 for a larger serving piece.

A small clock in brass by the Benedict Company, c. 1895, with works by the Waterbury Clock Company, which was owned by Benedict. Shaped something like a tombstone, the clock has the same pharaoh's head found in the blotter shown here. Measures 5.5" x 7.5"; marked on back BENEDICT MFG Co. along with various patent dates, the latest of which is 1894. The dial is marked WATERBURY CLOCK CO U.S.A. While most Egyptian revival clocks (such as the one shown on page 96) are quite expensive, with online auction prices usually over $500, and dealer prices of $12,000, $15,000, and even $25,000 for clocks with garnitures (usually in the form of obelisks) not unheard of, this modest clock sold at auction for $75. The pharaoh's head decoration can also be found in other items, such as a letter tray and blotter.

Benedict Brass Company–This company, founded in 1812 by Aaron Benedict to manufacture brass buttons during the War of 1812 (when obviously the United States army could no longer buy them from Great Britain), evolved into the Benedict & Burnham Company around 1830. Like many other American producers of brass goods, Benedict Brass was located in Connecticut's Naugatuck Valley, sometimes referred to as "Brass Valley."

The company manufactured a line devoted to items in the Egyptian revival style, which they called Benedict Karnak. Some of the pieces in this line reflect Arts and Crafts–inspired design, and it is not clear exactly when production of the line began. Benedict produced goods such as desk sets, candlesticks, and vases in their Karnak line, some of which are decorated with the pharaoh's heads shown here, while others have scarabs or a winged goddess. Apparently some of their items, apparently were silver-plated. The company continued to produce buttons, some of which were in the Egyptian revival style.

The company also owned the Waterbury Clock Company, which manufactured the works for this clock, which is in a marked Benedict Karnak Brass case.

A rocking blotter that matches the Benedict clock. Unmarked; it was purchased for approximately $45 in an online auction.

An advertisement for the Benedict Brass Company's "Karnak" line of Egyptian revival items. This advertisement appeared in The Jewelers' Circular, August 25, 1923, a year after the discovery of Tutankhamun's tomb–again showing the influence the extraordinary find had on 1920s design.

A brass letter holder with an applied winged scarab, from the Benedict Company's Karnak line. Marked BENEDICT KARNAK BRASS 2815, with the company's diamond logo. Measures 5" x 5" (including the lion's paw feet) x 2.25"; it sold at online auction for approximately $45.

R. Blackinton Company–The R. Blackinton Company produced sterling silver items, including match safes, perfumes, small silver evening purses, and jewelry. Like many other companies, it drew inspiration from the finds of jewelry made in Egypt during the late nineteenth century, and began to produce jewelry and purses with Egyptian themes, especially the ubiquitous winged scarab, as seen in the purses and brooch shown here. Blackinton also created men's tie clips with Egyptian designs.

An eyeglasses case and small purse by the Blackinton Company, c. 1880. The purse is decorated with an engraved design of winged scarabs and lotus blossoms. Interestingly, the Blackington scarabs hold lotus blossoms between their wings. Marked STERLING BLACKINTON CO; the eyeglasses case is also marked with the number 3392. *Courtesy of Robin Allison.*

Another small sterling silver purse by Blackinton, this one also decorated with a design of winged scarabs. This was purchased for $450 from a dealer on the internet.

A Blackinton ad showing, bottom center, a silver case with a winged scarab holding a lotus blossom instead of the usual solar disk; the design is remarkably similar to that on the purse, eyeglasses case, and brooch shown here. *Courtesy of Shelly Foote.*

A brooch in sterling silver by the R. Blackinton Company, n .d., in the form of a winged scarab and lotus blossom, reprising the design found on the eyeglasses case and larger purse. Marked with Blackinton's mark and the number 3392. *Courtesy of Robin Allison.*

140

Hattie Carnegie–One of America's best-known marketers of costume jewelry, Hattie Carnegie began as a hat designer, later hiring designers to create a line of costume jewelry. Items with her name on them often had a fun and unusual style which, unfortunately, is not as readily seen in her Egyptian revival pieces as it is in her more whimsical pieces, such as rhinestone-studded tigers and zebras. Her company created scarab brooches, earrings, and necklaces in the bright revival colors of blue, red, and turquoise. These seem to be especially sought after, and bidding for them at auction is usually fairly intense. The revival necklace shown here, with its face-to-face falcons, scarab, and other Egyptian elements, appears to have been based on a pectoral from the tomb of Twelfth Dynasty princess Sithathoriunet although it is somewhat less complex in design. Hattie Carnegie's early pieces are signed with her initials, H.C., but her later pieces are signed with her full name.

An Egyptian revival costume necklace in goldtone metal, white soft enamel, and faux pearls, by famed costume jewelry and fashion designer Hattie Carnegie, probably c. 1970. As noted elsewhere, a great deal of Egyptian revival jewelry always fell into the costume jewelry niche, but in the 1960s Egyptian revival costume became especially popular–and today is often considered very collectible. This pendant depicts two falcons face-to-face, flanked by two cobras, and with a cartouche spelling out the name Khakheperre, the prenomen of Sesostris II. Measures 3.25" x 3.25"; marked in an oval on the reverse © HATTIE CARNEGIE. Egyptian revival jewelry by this maker appears to be quite desirable, and her pieces often sell for over $150 in online auctions. Her colorful dark blue, turquoise, and red scarab jewelry usually sells for even more, with a demi-parure sometimes bringing as much as $300-$400.

A drawing of a pectoral found in the Twelfth Dynasty tomb of Princess Sithathoriunet at Lahun, also bearing a cartouche with the prenomen of Sesostris II, very likely the inspiration for Hattie Carnegie's Egyptian revival pendant. The pectoral also has the god Heh holding the sign for "year" in each hand, presumably wishing Sesostris II a very long lifetime. The tadpole representing the number 100,000 dangles from Heh's arm.

Miriam Haskell–Possibly the country's best-known designer of costume jewelry, Miriam Haskell made a fair number of Egyptian-style pieces, some of which–such as her bib necklaces–sell in the four figures (a Haskell bib necklace by her head designer, Larry Vrba, had a dealer's asking price of $2500). However, she created pieces in many different styles, some in the Egyptian revival genre, including more affordable stickpins and pendants such as the one here. The pharaoh's head necklace shown here, and the pendant in the form of Tutankhamun's head in chapter one (page 30) are fairly faithful renditions of Egyptian motifs. Her jewelry is usually marked with her name.

A necklace by Miriam Haskell in a synthetic resin-like material and gold-plated base metal, with a pendant in the form of a pharaoh's head in profile. Necklace is 29" long not including pharaoh's head, which measures 2.5" x 2. 375"; marked MIRIAM HASKELL in cartouche on pendant's reverse. This necklace is not typical of Haskell's most collectible pieces, which are heavily beaded, done in faux baroque pearls, or clusters and sprays of glass flowers; a reasonable price for it might be in the $45-$125 range, with $125 reflecting a dealer's price.

A gold-plated pendant by Miriam Haskell, with a pharaoh's head framed by lotus blossoms. Signed MIRIAM HASKELL; approximately 2.75" square. Again, this piece is not typical of her most collectible designs, but nonetheless sold at auction for $100.

Charles Horner–Charles Horner, basically the Henry Ford of Arts and Crafts jewelry, mass-produced and mass-marketed a number of stylized winged scarabs in the English city of Chester. Although many of his enameled items come to market with severe enamel loss, his pieces with undamaged enamel sell very well at auction, and are carried even by very high-end dealers. His scarab brooches have asking prices for as much as the high hundreds, although sometimes are purchased for less in online auctions. The scarabs were also made in pendant necklaces, which usually sell for more than the brooches, being slightly more elaborate. Horner's earlier pieces are marked not only with the British sterling silver hallmark (a lion) and the city of Chester's mark (a shield), but also with a letter indicating the year of manufacture. His maker's mark is C.H.

The reverse of the Charles Horner winged scarab, showing his maker's mark (his initials), the lion (for British sterling), the shield (for Chester) and the letter (for year of manufacture; here hard to read).

A winged scarab brooch by the British maker Charles Horner. Horner made these brooches, as well as necklaces with winged scarabs, by the hundreds over a number of years during the early part of the 20th century. They come up frequently in online auctions, and are also carried by dealers who specialize in antique jewelry. In online auctions, the brooches seem to sell for around $100-$300 (with a good deal depending on condition; many of Horner's items come to auction with fairly major enamel loss, but even those pieces with severe loss often will receive bids in the $90-$125 range), and the necklaces for about $250-$600. Marked with Horner's C.H. maker's mark, along with marks for British sterling and the city of Chester.

Judd Manufacturing Company–Based in Wallingford, Connecticut, the Judd Manufacturing Company made items in cast iron, including mechanical banks. They also made a number of figural bookends in the form of buffalo, horses, owls, and other animals, some with brass or polychrome finish. The company went out of business in the 1930s. While much of their output was typically Victorian or Art Nouveau, they also made a number of Art Deco Egyptian revival bookends, such as the ones shown here.

A pair of bookends by the Judd Manufacturing Company, c. 1920, with a polychrome design of a sphinx (wearing the vulture crown) against a pyramid, with a temple's columns and architrave adorned with a winged scarab behind the pyramid. Marked 9743. These were purchased for $200 in an online auction, reasonable for polychrome Egyptian revival bookends in good condition.

Krementz Company–This company, located in Newark, New Jersey, was possibly in business longer than any other jewelry-making firm in the United States, before it sold its various lines to Tiffany & Company and Colibri in the 1990s and ceased manufacturing. In its long history, it produced an astonishing number of pieces in Victorian, Art Nouveau, Edwardian, and Art Deco styles before turning largely to the manufacture of costume jewelry in the 1920s. However, among the things it did not produce in any quantity was Egyptian revival jewelry, although some of Krementz's Art Nouveau jewelry, such as the 14K gold, enamel, and opal pin in chapter two, page 61 did use stylized lotus blossoms very much in the Egyptian revival style. When scarab jewelry became popular in the mid-1960s, it did make some pieces with scarabs. The vermeil pendant shown here is an oddity; it contains the hieroglyph for *wr* (the word "great" in ancient Egyptian), and two rosettes which could be considered Egyptian motifs. The central element in the design, however, appears to be an astrological sign, and although the Egyptians were interested in astrology, astrological signs are not usually found in Egyptian revival pieces. Krementz's earlier mark was a shirt collar button that has been variously described as a two-handled umbrella, a fancy T with a line under it, a Y, and a mushroom. Later pieces, such as those shown here, are usually marked KREMENTZ on the pin; this pendant, however, is marked KREMENTZ on the back, and also marked STERLING SILVER.

Heinrich Levinger–Heinrich Levinger was a German jeweler based in the German city of Pforzheim (like Birmingham, England, and Newark, New Jersey, a major center of the country's jewelry manufacturing). His company made items in the Jugendstil ("youth style," Germany's equivalent of the British Arts and Crafts) as well as more traditional jewelry. He often made wonderful use of plique-à-jour enameling, as in this stylized winged scarab. His jewelry is marked with a maker's mark consisting of an H inside an L.

A pendant in silver, plique-à-jour enamel, mabe pearl, baroque pearl, and pastes, by the German maker Heinrich Levinger. This appears to be in the form of a very stylized winged scarab, with wings that almost resemble lotus blossoms. Marked with Levinger's maker's mark of an H inside an L. *Courtesy of Robin Allison.*

William Link–A sometime partner in the Newark, New Jersey, firm Angell & Link, William Link produced jewelry in the late nineteenth and early twentieth centuries. Not as well known as some of the other Newark makers, his company produced smaller pieces such as baby bib and lingerie pins, although it did manufacture larger items as well. The brooch shown here seems to fall between the Egyptian queen motif, and the Byzantine woman, and has elements of both.

An unusual pendant by the Newark company Krementz, probably c. 1965, in silver gilt, with two rosettes and what appears to be the hieroglyph for the word *wr* ("great") together with what looks like an astrological or alchemical sign. The pendant, with a rather rough texture, has also what seem designed to look like "tears" in an ancient papyrus manuscript around the edge. Measures 1.5" in diameter; marked on reverse (in script) Krementz STERLING. It sold for about $45 in an online auction.

A brooch in sterling silver by William Link, c. 1900. Link, a Newark maker perhaps not as well known as Alling Company, Bippart, Griscom & Osborn, Krementz, or Whiteside & Blank, made jewelry in 14K gold as well as sterling silver, sometimes in partnership with James Angell (as Angell & Link). Here an Egyptian queen bears a striking resemblance to Alling's Byzantine woman, with only the uraeus serpent on her coronet and the snakes forming the frame of the brooch giving away her Egyptian identity. Like Byzantine women, she wears a diadem with a circular dangle; unlike them, but like the Egyptian queen (possibly by Alling) shown in chapter two, page 104, she appears to wear a cloth or veil over her hair. *Courtesy of Robin Allison.*

Margot de Taxco–Margot van Vorhies Carr, who became closely identified with the silver jewelry-producing town of Taxco, Mexico, is almost invariably referred to by the name stamped on her work: Margot de Taxco. She produced sterling silver jewelry, much of it beautifully sculptural and some of it brilliantly enameled. Her original designs were based on themes from many different cultures including the Mayan and the Egyptian, and she also created a number of pieces with snakes and fish. She made jewelry in the 1940s through the 1970s, when her shop closed due to labor disputes. Her jewelry is always very well marked, including marks for a design (usually four numbers), and a Mexico sterling eagle (either the Taxco eagle 3 or her own personal eagle 16), as well as MARGOT DE TAXCO MADE IN MEXICO. She made Egyptian-themed jewelry in at least two different designs, including the one shown here and another with a brooch/pendant in the form of a stylized enameled queen's head wearing the vulture crown. Her jewelry, unlike much other silver jewelry from Mexico and other countries, usually has a very nice heft. Her designs continue to sell very well, with enameled jewelry in good condition commanding high prices. Lately, her molds have been used to create reproductions; these are most often marketed as such although a few dealers do try to conceal the fact that they are not selling originals.

Meriden Silver Plate Company–As its name suggests, Meriden Company, located in Meriden, Connecticut, manufactured silver-plated items. It was founded by Charles Casper in 1869, and in 1898 joined with four other silver manufacturers in Connecticut to form the International Silver Company. They produced tea sets and other silver-plated pieces such as the sphinx napkin ring shown here. Their mark included a lion rampant in a circle, surrounded by the company's name, with QUADRUPLE PLATE sometimes added, as well as a four-digit number identifying the pattern.

A demi-parure by noted Mexican jewelry designer Margot de Taxco, in sterling silver and enamel, comprising a necklace and matching earrings. The necklace, of stylized lotus blossoms in red, yellow, and black champlevé enamel, ends in a pendant with two Egyptians, who very much resemble the seated man hieroglyph, facing each other and slightly articulated with hinges at top, elbows, and knees. Each seated man is dressed in a striped kilt and wears a detailed broad collar. The earrings are a larger and more elaborate version of the stylized lotus blossoms that form the necklace's links. The necklace measures approximately 16" in length excluding pendant; the pendant measures 3.25" x 2.125"; earrings measure 1.5" x 1". Marked MARGOT DE TAXCO STERLING MADE IN MEXICO 5468, with an undecipherable eagle stamp. Margot de Taxco's jewelry is becoming harder to find, and correspondingly more expensive. A demi-parure such as this will probably sell for at least $800, and often considerably more if in fine condition. Another, different Egyptian demi-parure, with a pin/pendant in the form of a queen wearing the vulture crown and matching bracelet, sold in an online auction for almost $1000, even though it had suffered a fair amount of enamel loss.

A silver-plated napkin ring from the Meriden Company, probably c. 1880, featuring a sphinx with cartouches that are not really legible but might have been intended to contain the name Ramesses. Measures almost 2.5" high, 3.375" long; marked on bottom with shield containing scales and MERIDEN B. COMPANY 165. A reasonable price for this might be $100-$200, with $200 reflecting a dealer's price. A silverplated tea set by Meriden had an asking price of $750; however, napkin rings apparently represent a quite highly collectible group of objects, and often seem to sell for more than one might expect.

Piels Frères–The French firm Piels Frères marketed beautifully designed and very well executed costume jewelry, for which they won several awards at world's fairs at the end of the nineteenth and beginning of the twentieth centuries. Their designs included these Egyptian revival earrings and buckle. Occasionally dealers and other vendors attribute pieces of better costume jewelry to Piels Frères, but these identifications are never totally certain. In this case, the buckle is marked PF although the earrings–clearly sharing design features with the buckle–are not. Until she had seen the buckle, Robin was unable to attribute the earrings to Piels Frères, although as she had previously noted, they are much better designed and executed than most costume pieces.

A wonderful buckle in silver (or silver-plated metal), enamel, and paste, by Piels Frères, probably c. 1900. This buckle has almost all of the Egyptian revival motifs one could ask for and more–including an Egyptian woman or goddess, lotus blossoms and buds, serpents, and a winged scarab. All that's missing is the kitchen sphinx. Marked PF for Piels Frères. *Courtesy of Robin Allison.*

The matching earrings to the buckle, in the form of broad collars with cabochon (possibly faux) coral, scarab dangles, and owl terminals. The edge of the earrings is decorated with the exact same design of stylized lotuses, and the enameling on the collars reprises that of the element above the Egyptian woman or goddess on the buckle. While these earrings are not marked, it is fairly certain that they are also by Piels Frères. *Courtesy of Robin Allison.*

146

Redfield & Rice–An American company based in New York City, Redfield & Rice sold silver-plated items such as this Egyptian (or Greek) revival tea set. In the late 1890s, Redfield & Rice merged with the Apollo Company and Shepard & Rice to form Bernard Rice & Sons. This tea set could be termed either Classical or Egyptian, as this appears to be one of those instances where it is hard to distinguish one from the other. The woman on the lid, holding a harp or lyre, looks more Greek than Egyptian, with her upswept hair and draped clothing, but the lion faces could equally well be Egyptian or Greek, as could the anthemion and rosettes. The stiff, angular lines of the handles are more reminiscent of Egyptian revival, and the faces (here probably too small to be seen) in the legs are very much in the Egyptian revival spirit. The timing as well might indicate that Egyptian revival was intended, as this design was patented the year the Suez Canal opened. Marked REDFIELD & RICE NEW YORK SILVER PLATE 244 DESIGN PAT. OCT.5 1869.

Reed & Barton–One of America's best known silversmithing companies, Reed & Barton was founded in 1830 as the Taunton Britannia Manufacturing Company in Taunton, Massachusetts. Originally the firm manufactured goods in Britannia, a metal alloy similar to pewter. In 1837, with the addition of new partners, the name was changed to Leonard, Reed & Barton. Today the company remains in business, manufacturing sterling silver, silver plate, and stainless steel flatware as well as gift items and jewelry. This bracelet, with a scene from The Book of the Dead, is in their so-called Damascene© style. However, it is not truly damascene work, which uses darker metals inlaid in a lighter metal background to produce designs. The process used to manufacture this bracelet resembles enameling.

A bracelet in Reed & Barton's copyrighted "Damascene" style, with a judgment scene from the Book of the Dead, probably c. 1970s. This sold for approximately $40 in an online auction.

A silverplated tea set by Redfield & Rice, c. 1870. This set could be termed either Classical or Egyptian revival; this is one of those items which appears to combine the two. The woman with lyre finial looks very Graeco-Roman–her dress and hairstyle, as well as the lyre itself, look far more Classical than Egyptian–but the lion faces could equally well be Graeco-Roman or Egyptian, depending on one's point of view. Marked REDFIELD & RICE NEW YORK SILVER PLATE 244 DESIGN PAT. OCT. 5, 1869. The set sold for about $350.

Wm. A. Rogers Company- According to one source, the name Wm. Rogers —in several variations including Wm. Rogers, Wm. A. Rogers and Sons, and Wm Rogers Mfg Co —has been used for at least six (probably unrelated) lines of silverplated flatware dating from 1865 to as late as the late 1970s. William A. Rogers himself was a talented silversmith and a pioneer in the development of silverplating in the United States. After a dispute with the Meriden Britannia Company, William A. Rogers himself established a line of silverplate marked Wm.Rogers. However, his name, carrying as it did significant prestige due to his reputation, was appropriated by other companies during his lifetime and for many years after his death. These winged scarab teaspoons, marked Wm. A. Rogers (a name in use from about 1897 on), are identical to those depicted in the advertisement shown here. Possibly both were made by the same company, which marketed them under different brands, including William A. Rogers's often-pirated name. The same spoons, both marked and unmarked, come up with some regularity in online auctions, and can also be purchased from online dealers in retired silver and china patterns, often for under $10.

A silverplated demi-tasse spoon by the William A. Rogers Company, c. 1910, in that company's Egyptian pattern with a winged scarab terminal. Marked WM. A. ROGERS ONEIDA LTD. It sold for approximately $10 in an online auction.

An advertisement for restaurant flatware that, although not put out by the William A. Rogers Company, shows the identical winged scarab spoon–giving rise to the speculation that possibly the Rogers Company manufactured the spoons for this company; that a third company made them and sold to both companies; or that there was a significant amount of pirating of designs (and makers' names) in the early 20th century silverware trade. *Courtesy of Shelly Foote.*

Ronson Company– The Ronson Company, founded in the mid-1880s as Metal Art Company, is best known for its cigarette lighters, and in fact developed the first mechanical lighter, as well as the first refillable gas lighter and the first lighter with an adjustable flame. The company's founder, Louis Aronson, patented a process for electroplating base metal with precious metals, and also patented the first sulphur match, replacing the toxic phosphorus match. Even so, the company gave in to the clamor for Egyptian revival decorative objects in the 1920s, producing incense burners in the shape of a nubile Egyptian girl holding a covered basket shaped like a bird. They also produced an "Egyptian revival" cigarette lighter shaped like a camel. This incense burner can upon occasion be found at auction; the price seems to vary but one with the more common black finish can sometimes be bought for around $150-$200. One online dealer listed a gilded one with polychrome details in almost perfect condition for $500.

An incense burner by the Ronson Company (faintly marked on bottom but identified primarily from a guide to Ronson products) c. 1926. Of spelter, or pot metal, enameled black, the incense burner is a semi-nude Egyptian woman holding a covered container in the shape of a duck. Somewhat incongruously the woman's hair is styled with the sidelock worn by Egyptian children, especially royal princes. She also wears a broad collar with what appear to be lotus buds. Approximately 13" in length. This piece, in very good condition with only minor enamel loss (especially to the bottom) sold for about $185 in an online auction.

Shepard Company–As their 1908 advertisement in *The Jewelers' Circular* shows, the Shepard Company, located in Melrose Highlands, Massachusetts, produced nicely enameled jewelry including two winged scarabs, along with floral jewelry with an Art Nouveau look. Even the smaller of the two scarabs has a floral look, with petal-like decorations around the beetle's head. The Shepard Company was in business from approximately 1895 to 1923, using a maker's mark with an S inside a circle.

A winged scarab brooch in sterling silver and white, yellow, green, turquoise, and dark blue basse taille and champlevé enameling. It is identical to the one displayed in the advertisement for the Shepard Company shown here (although this brooch is marked STERLING only, with no maker's mark); measures 1.5" in diameter. It should sell somewhere in the $125-$250 range; this one was purchased in an online auction for $127.50.

A large winged scarab brooch by the Massachusetts-based Shepard Company, c. 1910, in sterling silver and enamel. The scarab, in the usual Egyptian revival colors with the addition of yellow, is shown in the advertisement for this company. This brooch might sell for around $150-$300. *Courtesy of Robin Allison.*

An advertisment from *The Jewelers' Circular* (April 15, 1908) for the Shepard Company's line of enameled brooches, including the two winged scarab brooches shown here. Scarabs remained popular in Egyptian revival jewelry during the late 19th and early 20th centuries. *Courtesy of Shelly Foote.*

Simpson, Hall & Miller–This company, based in Wallingford, Connecticut, was in business between 1866 and 1898, when it became one of four firms that joined to form the International Silver Company. Its maker's mark, three leaves with the bottom leaf enclosing the letter S, was used for some years after the merger. Simpson, Hall & Miller produced both silver and silverplate, such as this tea set.

A silver-plated tea set by Simpson, Hall & Miller, in the Egyptian revival style popular c. 1870. The set consists of a teapot, covered sugar, creamer, open waste bowl, and tray. Similar sets come up fairly frequently at auction, both online and off, and generally sell in the $400-$850 range.

149

Topazio- A Portuguese company perhaps best known for its peacock brooches with enameled filigree tails, Topazio produced a sterling silver Egyptian revival bracelet with its fairly sculptural design of pharoahs' heads set off by lotus blossoms and serpents (page 91). The bracelet is much less frequently encountered than the small, relatively inexpensive peacocks.

Whiting & Davis–Whiting & Davis is perhaps best known for its mesh handbags, which it introduced in 1876. Still in business today, Whiting & Davis continues to offer mesh handbags with a slightly more modern look, including a leopard print and bags with semi-precious gemstone handles. In the nineteenth century, probably c. 1880, they also made silverware, including an Egyptian revival pattern. They also produced some costume jewelry, including the Egyptian revival demi-parure shown here, and the chunky bracelet from the 1960s, when the movie *Cleopatra* created a minor Egyptian revival. Of the three, the latest is, oddly enough, the hardest to find as it was made in a limited edition; the demi-parure comes up at auction from time to time, and the silverware can be bought online from one of the companies that specialize in pattern replacements.

A demi-parure consisting of a necklace and matching earrings by Whiting & Davis, probably c. 1930. In gold-plated base metal, the necklace and earrings contain glass insets (very likely of Czech manufacture) with an Egyptian scene. The necklace in addition has a serpent slide. This set sold for approximately $75 at auction; it is fairly frequently available from dealers or at auction.

A sterling silver spoon by Whiting & Davis, in an Egyptian pattern probably c. 1875. The handle of the spoon is decorated with stylized lotus blossoms and a not incredibly distinct pharaoh's head at the end (which is, however, distinct enough to allow the striped *nemes* headdress to be identified). Measures 6.25"; marked STERLING PAT. APPL. FOR. This spoon sold for approximately $110; other items in this fairly available pattern had asking prices of $95 (for teaspoons) and $110 (butter picks, forks, ice cream spoons, mustard spoon, olive spoon) to $460 (vegetable serving spoon); a sugar sifter in this pattern had an asking price of $495.

A cuff bracelet by Whiting & Davis from the 1960s, when the movie *Cleopatra* sparked a minor Egyptian revival. The bracelet features appliquéd sphinxes, the central one viewed head on; the flanking standing sphinxes, though given an Egyptian king's head and a lion's body, suspiciously resemble Assyrian cherubs. Marked WHITING & DAVIS CO. MESH BAGS; also engraved K of M 63. It measures 1.25" wide, with a diameter of 2.5". Although a costume piece, it sold for approximately $150 in a competitive online auction.

Chapter Four
Collecting Egyptian Revival

Having been trained as an Eighteenth Dynasty scribe, I've always loved things with that special ancient Egyptian flair and collected them, rather haphazardly. Along the way, my collecting has included bed sheets and fabric imprinted with hieroglyphs, mummiform candles, Madame Alexander dolls in Egyptian costume, Margaret Jerrold Tutankhamun shoes, the occasional winged Isis or winged scarab brooch. When I decided to get serious about collecting Egyptian revival, I made a rather dismal discovery: It's just not at easy as one might think. In fact, learning to read hieroglyphs might just be a bit easier than finding–and acquiring–that antique Wedgwood Egyptian revival cannister, a wonderful Carlton Egyptian fan vase, or Gorham lotus pattern salt cellars.

The problem, as economists have said for years and as I finally accepted, is simply one of supply and demand. Egyptian revival jewelry and other decorative objects are collectible, scarce, and seemingly sought after. Bidding at auction on the nicer Egyptian revival necklaces or brooches that come up is spirited, and Egyptian revival pieces often go for more than the price suggested by their pre-auction estimate.

But there is good news, too: The internet makes it a lot easier.

Whereas before, collecting was almost of necessity opportunistic–a brooch might come one's way at one's favorite antique boutique, but it was very hard to look for and find a specific item–now one can actively search the internet for desired objects. For example, an internet search for Blackinton Egyptian revival silver turned up the small sterling purse shown on page 140. Other searches helped locate Gorham silverware and Wedgwood jasperware.

On the other hand, conventional shopping methods usually remain fairly unproductive. A visit to the largest antique fair in Portland, Oregon, this past summer, and a canvass of most of the dealers in jewelry and decorative objects present turned up only four Egyptian revival items: a Meriden sphinx napkin ring, a mummiform hatpin, a Victorian jewelry box, and a small Egyptian revival perfume. A search of the largest antique mall in Portland yielded one Wedgwood flow blue plate (marked "pearl ware") decorated with an Egyptian temple that vaguely resembles Queen Hatshepsut's temple at Deir el-Bahri. (On the other hand, it also resembles a Greek temple, to some extent; and if located on top of a mountain rather than on a riverbank, it might just as easily pass for Greek revival.)

What to Look For

While Egyptian revival jewelry and decorative arts never truly went out of style–and at times were immensely popular–items based on ancient Egyptian design, or its western translation, were never truly as popular as other revivals except during the Art Deco period. This is especially true in architecture (not of concern here) and jewelry.

The countless Victorian cameos based on classical Greek and Roman themes by far outweigh the lotus blossoms, sphinxes, and winged scarabs produced during the same period. Victorian Etruscan and Renaissance revival jewelry is, arguably, easier to find than Victorian Egyptian-themed jewelry, and was produced by master jewelers such as the Castellanis and Carlo Giuliano. Newark makers, who accounted for approximately 90% of the gold jewelry produced in the United States c. 1900, made comparatively few Egyptian revival pieces.[1] The majority of Newark pieces are traditional Victorian, Art Nouveau, or *beaux arts*. Many of them are in the form of flowers and leaves, birds and insects, ladies and tigers. Crescent pins, popular with Victorians and made by the hundreds by Newark and New York makers (including Tiffany & Company), were fashioned into so-called "honeymoon" pins with the addition of a flower or cloverleaf, enameled or not. I have seen exactly *two* Egyptian revival crescent pins in decades of looking. One, made by the Newark firm Crane Theurer and recently sold by a dealer, had a sphinx in a gold crescent, with an asking price of $200. The second had the profile of an Egyptian queen, wearing a very detailed vulture headdress, inside a crescent. In contrast, Byzantine ladies, manufactured in 14K gold most notably by the Alling Company, are found in great frequency in stickpins, although they are somewhat harder to find in lockets, brooches, and bracelets. Still, compared to the several lockets that Robin has seen over the years, not to mention a larger number of stickpins and brooches, American-made Egyptian queen pieces are extremely scarce. I have seen only two. One, in gold, diamonds, and enamel, possibly manufactured by Alling, shown on page 8, sold for $8,000. The second, perhaps a prototype for the more expensive gold pendant, was acquired in an online auction, and is shown in chapter two, page 104.

Silver Egyptian revival jewelry is a bit more plentiful. The Blackinton Company created brooches and small purses in the Egyptian revival style, as well as jewelry for men, such as tie clips. The Shepard Company, based in Massachusetts, produced winged scarabs in silver (for which please see their ad in chapter three, page 149, along with the Shepard Company winged scarabs). In Great Britain, Charles Horner and others also manufactured winged scarabs.

Art Deco jewelry seems to be the exception, in that relatively large numbers of Egyptian revival, or Egyptian-inspired, pieces were made compared with Classical, Renaissance, or Etruscan revival jewelry, which by then was almost entirely out of fashion. Scarabs and pharaohs, winged or otherwise, can be found fairly easily, as the three winged pharaohs, and the multitude of scarabs in chapter two attest. Egyptian revival pieces fit in somewhat with Art Deco tendencies, not so much in their design, but in their use of vivid colors. They remain somewhat easier to find, although it should be again noted that many supposedly Art Deco Egyptian revival pieces are not from the 1920s and 1930s, but were manufactured later.

A great deal of Egyptian revival jewelry, no matter what period it dates from, was costume. France's Piels Frères made some silver- and gold-plated costume pieces in the Egyptian revival style;

unfortunately, today their jewelry is as collectible, as scarce, and as expensive, as many non-costume items. Many other pieces were made in brass and glass, as opposed to gold or silver and gemstones. This is as true of Victorian jewelry as it is of Art Deco. During the 1920s and 1930s, many of the glass beads, scarabs, mummies, and other components for Egyptian revival jewelry were manufactured in Czechoslovakia, as were some of the brooches and necklaces. This jewelry, although costume, is quite collectible and often brings fairly high prices at auction.

Many costume Egyptian revival pieces seem to date from the 1960s, possibly inspired by the movie *Cleopatra*. These are often easier to find, yet even so command high prices. Those designed or marketed by Miriam Haskell, Hattie Carnegie, and William deLillo seem especially desirable, and thus less affordable.

Other Decorative Arts

Items other than jewelry can be even harder to find. Some companies, such as Blackinton and Gorham (both based in the United States), and Carlton and Wedgwood (based in Great Britain), did create items in the Egyptian revival style. However, it is not clear how many pieces of, say, Wedgwood's Victorian Egyptian revival jasperware were manufactured, or how many were sold–or remain in existence today. And while Wedgwood produced a variety of Egyptian revival pieces, these are still relatively rare compared to the number of Classical patterns in Wedgwood's jasperware. In silverware design, certain manufacturers, most notably Gorham, came out with several Egyptian revival patterns. Yet compared to the hundreds of other patterns available, the half dozen or so Egyptian patterns are almost lost. And once lost they are also, unfortunately, rarely found.

Many of them are also extremely expensive–with price often based on rarity and desirability. When pieces of antique china or pottery in the Egyptian revival style come up at auction, they are frequently damaged to some extent. Even so, they often seem to sell for more than pieces in other styles from the same period.

Where to Find It

As noted in chapter one, it is almost certainly true that one of the most reliable sources–at least for travelers and tourists–of Egyptian revival jewelry and decorative arts was Egypt itself. Many of the pieces shown in this book were acquired by the tourist lucky enough to visit Cairo or Luxor, brought back to Europe or the United States, and resold at estate sales or auctions. Today Egypt's shops, *souks*, and bazaars remain a good source of more modern Egyptian revival material, much of which is also exported and available over the internet.

Auctions, both online and off, can be a good place to look for antique or vintage Egyptian revival jewelry and other items. Often even non-internet-based auction houses advertise online, and a visit to their web sites can allow the interested collector to sign up to be notified about upcoming auctions. Auction houses also sell catalogs, but these can be quite pricey, and looking for facts online provides a less expensive–though possibly more time-consuming–alternative to paying $20 or $40 for the same information.

And many dealers in antiques and *objets d'art* have either web sites, or catalogs, or both. Browsing the internet can allow you to find those dealers who carry items you like, at prices you also like. Although these searches can take a while, it is still a lot more convenient than visiting store after store, only to come away disappointed–and tired.

Another useful and popular source, especially for reproductions of ancient jewelry, are museum shops. Some of these, such as the Smithsonian Institution, put out catalogs, which usually contain a fair number of items based on Egyptian themes, both in jewelry and other decorative arts.

A limited edition (to at least 3500, as this is number A3273, so not incredibly limited) statuette issued under the name of the famed Art Deco artist/designer Erté, and put out by the Franklin Mint. A number of companies, including the Franklin Mint, Royal Doulton, Wedgwood, Denby, and Lenox have put out limited editions of Egyptian revival "collectibles." However, it is not clear how well these fare on the secondary market. The exception appears to be Wedgwood. A limited edition Wedgwood writing set made in 2000, with one canopic jar and two smaller covered jars in a boat-shaped stand, sold recently in an online auction for over $3000. This "Erté" Isis, almost 10" tall from base of stand to top of headdress, sold for $100 in an online auction. Marked ERTE on the front of the base, and on the bottom ISIS Limited Edition, No. A3273 FINE PORCELAIN HAND PAINTED The Franklin Mint CRAFTED IN MALAYSIA © Sevenoaks Ltd.

For those who are willing to collect more modern Egyptian revival pieces, then replicas of older designs–often made in the original molds–might be acceptable. Some of these newer pieces, such as Sabino's Egyptian woman in glass shown in chapter two, page 79 are truly lovely and are much more affordable than the original Art Deco pieces would be, assuming that one could find them in the first place. Wedgwood continues to make Egyptian revival jasperware items, and these are usually–though not always,

especially if a limited edition is involved–more affordable than older Wedgwood.

Other sources of accessible, and for the most part affordable, Egyptian revival jewelry and decorative objects are those companies that market "collectible" items. Egyptian cats especially seem to be popular with these companies, which include Lenox, Royal Doulton, the Franklin Mint, Baccarat, and Fenton, to name just a few. These companies often advertise their collectible wares in magazines, and interested buyers can then purchase them via mail order. Usually these items are sold on the premise that, produced in limited editions, they will increase in value in the collectibles market. Buyers should be warned that this may happen, but it is not guaranteed, or even necessarily likely, to happen. However, there do seem to be some collectibles that hold their value well. Wedgwood, with its severely limited editions for collectors, seems to create cameoware that often goes up in price. Most of the time, though, collectibles should be purchased because they are appealing, not because they are good investments.

And Now for the Fine Print

There are, of course, pitfalls–as any would-be raider of the lost art is bound to discover. The problem of Greek and Roman (and Inca and Aztec) revival being misidentified as Egyptian has been discussed at length in chapter two. However, there are other dangerous areas where one can easily slip up, lose one's footing, and fall to earth with an often-expensive thud. Chief among the perils are overly enthusiastic attributions of unsigned objects to famous (or at least moderately well-known) makers; and equally enthusiastic dating of, say, a nice mid-century bracelet to the more collectible Art Deco period.

What's In a Name?

Name brands cost more, almost always. This is pretty much a given in the world of collecting, whether a signed Babe Ruth baseball card or a signed Pablo Picasso drawing is in question. A piece of unmarked jasperware from Germany does not have nearly the cachet of a piece of marked Wedgwood jasperware. However, even unsigned works that can be attributed to a famous maker, such as René Lalique or Louis Comfort Tiffany, can often sell for more than an un-attributed piece by an unknown designer.

But as those rotten imperialist Egypt-stomping Romans used to say, *Caveat emptor.* One thing learned during a long period of trial and error is that sellers are often very ready to attribute an unsigned Egyptian revival piece (or any other collectible, for that matter) to a well-known maker. Then, based on that attribution, to blithely assert that it *is* by that maker. In the course of researching this book, I found the following:

• A wall pocket said to be by Peters & Reed, even though it is unsigned; the seller never thought to mention that this might be a bit of a stretch.

• A costume necklace that just *had* to be by Piels Frères, because it was so nice.

• A bust of Nefertiti by McCoy or Haeger, that the seller blithely asserted was "unsigned but they both made a similar figurine" (notice the insidious *similar*–not identical, just sort of like it ... This is one instance where the "real McCoy" is not exactly the real McCoy, so to speak).

Thus it is essential to read the fine print, and never more so than when purchasing sight-unseen online. This is especially true when buying from an internet auction company. Not only does the auction company apparently not insist on vendors listing items that are new as new, rather than as vintage or antique, but it also apparently allows sellers to attribute items to famous makers at will. This can be a very costly–and ultimately time-consuming, when one decides to return the alleged McCoy or faux revival match safe–learning experience. Add this to the instances in which items that have nothing to do with Egyptian revival are listed as

such, and it does make the process of collecting Egyptian revival somewhat fraught.

Older *Can Be* Better

As with fine wines and fine women, age often improves–or at least makes an object more scarce and sought after. Egyptian revival jewelry and decorative objects are no exception. Indeed, why should they be? Most collectors of Egyptian revival, whether glass, pottery, jewelry, silver flatware, or silverplated tea sets, are already in love with the civilization that flourished for over three thousand years. For most of those three thousand years, the culture did its best to pretend that change did not occur, that life was immutable in this world and the next.

As with many other collectibles, age and scarcity can make a piece of Egyptiana more desirable. This is especially true with older ceramics and silver that, by their very nature, are fragile and did not survive without considerable damage. Older pieces of Egyptian revival Wedgwood ceramics are a good example. They probably were not made in significant quantity and, though remarkably sturdy as ceramics go, are breakable. They do get broken. Thus, older Wedgwood ware is hard to find and comes at a premium price.

The same is true of silver. A good deal of silverware has been melted down (especially during the 1980s when efforts to control the market led to inflated prices). Egyptian revival silver, unfortunately, was not immune. Antique Egyptian-themed silver can be both hard to find and costly.

Age Does Not Wither Her...

Unfortunately, Egyptian revivals often replicate Egyptian history: They tend to be somewhat unchanging and to use the same motifs over and over again. This creates a problem when it comes to assigning a reasonable date to a given piece and, accordingly, makes it difficult to determine how old a brooch or vase might be. Some items, such as revival pieces that are more obviously Victorian and less revival in nature–often with a queen's head or a scarab added to a more conventional design–speak for themselves. Other items are from well-known makers who, in this modern wired world, have web sites and accessible information about different periods and products. Still others can be researched in books written about the more collectible antiques and brand names.

Other items are more problematic to identify. A conventional but erroneous belief exists that there were two Egyptian revival periods for decorative arts, at least in the United States: the Victorian revival after the opening of the Suez canal in 1869, and the Art Deco revival after the discovery of Tutankhamun's tomb. These have been discussed in chapter one. This mistaken belief leads to the misidentification of items that are clearly *not* Art Deco being so labeled, with the result that most Egyptian revival objects are assumed to date from the 1920s and 1930s, if they are obviously not Victorian.

Unfortunately, this assumption is not even close to being true. It has led to mistaken dating and higher prices that are unrealistically based on the supposed antiquity of a piece. Therefore, when thinking about buying an "antique" Egyptian revival scarab, sphinx, or silver-plated tea set, it is wise to research the manufacturer well and to determine that the item in question is a genuine period piece.

Interest in Egyptian design remained strong throughout most of the nineteenth and twentieth centuries. Given past trends, it will very likely continue to be strong for some time. Even with all of the dramatic, headline-grabbing archaeological Egyptian finds of the nineteenth and twentieth centuries, the possibilities for new discoveries have not been exhausted. In the 1990s, Egyptologist Kent Weeks discovered an immense tomb at Luxor, built for the *bas* and *kas* of the sons of Ramesses II to dwell in for eternity. Who knows what thrilling new finds await discovery to stimulate more revivals?

Try to remember that if an item is in revival style, it is not necessarily Egyptian; and even if it is Egyptian revival, it is not necessarily old.

A Brief Overview of Ancient Egyptian Chronology

Although discoveries during the nineteenth and twentieth centuries would add immeasurably to the understanding of Egypt's long and glorious past, the chronology of ancient Egyptian history remains essentially as set out by the Egyptian priest Manetho over two thousand years earlier. Egyptologists also had other ancient Egyptian records to guide them. One, the Palermo Stone, is sometimes referred to as Egypt's oldest history book, and was quite likely one of the sources used by Manetho. It records the reigns of gods as well as humans, who were believed to have received the throne from its last divine occupant, Horus. This source, as well as other sources such as the Royal Canon of Turin, or Turin King List, name Menes as the first human king of Egypt. Yet other sources are king lists such as the one found at the temple at Abydos's Hall of Ancestors built by Seti I, the father of Ramesses II.

The Egyptians themselves, while meticulous recorders of their history, dated their records by the regal year of the king in power at the time. An event from the reign of Ramesses II might be dated "Year 12, day 19, third month of the Innundation during the reign of the Son of Re Userma'atre." (The use of the king's nomen, such as Ramesses or Tuthmosis, followed by the appropriate number, is a modern convention.) Thus Egyptian records are not given in years relating to some larger event, such as the Greek system of dating years by Olympiads, the Moslems' of dating of years before or after the Hegira, or ours dating before and after the birth of Jesus Christ. The chronology given below is that of modern historians using ancient records as a guide.

Modern chronologies of Egypt basically divide Egypt into three kingdoms, three intermediate periods, the late period, and the Greco-Roman period. The following is a brief overview of the chronology of Egypt:

Predynastic Period (ca. 5100 -3150 B.C.) Dates vary considerably. Those given by Sir Alan H. Gardiner in his *Egypt of the Pharaohs* are still accepted and used by some, but for the most part have been revised downward. The dates given here mostly follow those in Peter A. Clayton's *Chronicle of the Pharaohs*. The Third Intermediate Period is a fairly recent addition to most lists, having been identified by Kenneth A. Kitchen in *The Third Intermediate Period in Egypt*, first published in 1986 and recently revised.

Early Dynastic Period: Dynasties 0 to 2 (c. 3150-2685 B.C.) Egypt is united by Narmer (or Menes).

Old Kingdom: Dynasties 3 to 6 (c. 2685-2180 B.C.) The Great Pyramids of Giza are built by the Fourth Dynasty pharaohs Khufu (Cheops), Khafre (Chephren), and Menkaure (Mycerinus).

First Intermediate Period: Dynasties 7 to 10 (c. 2280-2040 B.C.) This period is marked by the collapse of centralized government and the rise of local chiefs known to historians as nomarchs; it ends with consolidation of power by Eleventh Dynasty nomarchs of Thebes named Intef.

Middle Kingdom: Dynasties 11 and 12 (c. 2040-1780 B.C.) This period is considered by some Egypt's cultural peak; its jewelry was never really equaled, and its language is considered the classical form of Egyptian.

Second Intermediate Period: Dynasties 13 to 17 (c. 1780-1570 B.C.) Another collapse of centralized government with competing dynasties; foreign kings known as the Hyksos (who introduce the horse-drawn chariot) rule from Lower Egypt, the first imposition of foreign rule on previously impregnable Egypt.

New Kingdom: Dynasties 18 to 20 (c. 1570-1070 B.C.) Egypt is once again reunited by a Theban overlord, Ahmosis, and the foreign Hyksos are expelled. The Eighteenth Dynasty is one of great power and wealth as Egypt expands to form an empire. Nefertiti and Tutankhamun are from the later part of this dynasty. Kings named Ramesses are prominent in the Nineteenth and Twentieth Dynasties, with Ramesses III (around 1180 B.C.) perhaps Egypt's last great pharaoh.

Third Intermediate Period: Dynasties 21 to 26 (c. 1070-525 B.C.) This is yet another period marked by disintegration of central power, which is first shared by Ramesses XI, ruling from the Nile delta, and the high priest of Amun, Herihor, in Thebes. This period also sees the rise of foreign rulers from Libya and Nubia, and the conquest of Egypt by Assyria.

Late Period: Dynasties 27 to 31 (c. 525-332 B.C.) Persians under Cambysses II conquer Egypt; after the death of Darius II and the restoration of rule by native pharaohs, Egyptian dynasties are weak and short-lived. The Persian king Artaxerses III reconquers Egypt in 343 B.C.

Ptolemaic Egypt:(332-30 B.C.) Alexander the Great (Macedonia's Alexander III) enters Egypt after his decisive defeat of the Persians under Darius III; he is crowned king of Egypt and adopts the names Meryamun (beloved of Amun) Setepenre (chosen by Re). After Alexander's death in 323 B.C., Macedonian kings nominally continue to rule Egypt with Philip Arrhidaeus and Alexander IV, but the true power in Egypt rests with Alexander's former general Ptolemy (to whom Alexander left Egypt in his will). Cleopatra VII and her son by Julius Casar, Ptolemy XV (Caesarion), are the last independent rulers of Egypt, which with their deaths becomes a province of Rome.

Notes

Introduction

[1] In the story of Oedipus, for example, the sphinx waylaid travelers at a mountain pass, asking them, "What has one voice, and in the morning walks on four legs, in midday on two, and in the evening on three?" Those who could not answer were strangled. Oedipus, the only one wise enough to answer the riddle correctly (the answer being Man, who crawls on all fours as a baby, walks upright in youth, and walks with the aid of a cane or stick in old age), freed Thebes of this menace. As at least one person has pointed out, the name given to the great sphinx, Kheper-Re-Atum, contains the Egyptian words for the sun at dawn, at midday, and in the evening; whether this is coincidental or whether it inspired the Greek riddle is anyone's guess.

[2] When Herodotus visited Egypt in the fifth century B.C., he mentioned the pyramids but made no mention of the sphinx, which oddity is perhaps best explained by assuming that the sphinx was then mostly or totally submerged under sand.

[3] Pope Sixtus V ordered that the large obelisk in St. Peter's Square be erected there in 1586; a large obelisk built for the pharaoh Tuthmosis III, brought to Rome by Augustus Caesar and later destroyed in an earthquake, was uncovered and moved to the Piazza di San Giovanni in Laterano in 1587. A few other obelisks, such as those in London and New York, were gifts from Egypt's Khedive (ruler) in the nineteenth century.

[4] George Boas, in his introduction to *The Hieroglyphics of Horapollo*, writes: "Colonna was undoubtedly led to insert hieroglyphs of his own invention in his book because of the vogue for Horapollo ..."

[5] This baffling book was itself the unlikely subject of a recent bestseller, *The Rule of Four*, by Ian Caldwell and Dustin Thomason.

[6] Cleopatra is said to have spoken eight or nine languages—although, perhaps inauspiciously, Latin was not one of them.

[7] All of the women of the Egyptian Ptolemaic dynasty were named Arsinoë, Berenike, or Cleopatra, just as all of the men were named Ptolemy. For convenience, modern historians have given both the queens and the kings of this dynasty numbers, though the Ptolemaic rulers themselves took soubriquets such as Soter ("savior") and Philadelphus ("lover of his sister/brother") by which they were known. Cleopatra had an older sister also named Cleopatra, the sixth of that name, and Cleopatra the last queen of Egypt was Cleopatra VII.

[8] After the death of the older Ptolemy, Cleopatra elevated the younger brother to the throne as Ptolemy XIV; Ptolemaic custom demanded that a male share the throne with his sister-wife.

[9] Echoes of Egyptian religion sounded in the writings of the ancient Greeks, most notably the myth of Isis and Osiris, which was recorded by Plutarch; but his was probably a late, syncretistic version of the myth and religion, which was adopted as a mystery cult by the Greeks and Romans.

[10] Hieratic was the cursive form of Egyptian for most of Egypt's history, and was for the most part used in place of the more formal hieroglyphs for everyday purposes, especially documents written on papyrus.

[11] Today only the limestone at the very top of the pyramid of Khefren remains; yet accounts by early travelers, such as Abd el-Latif, a twelfth century scholar, indicate that the casing was more-or-less intact when he visited the pyramids.

Chapter One

[1] As Adkins (2000: 10) notes: "If the British had found and destroyed the French fleet, the cream of France's intellectual and artistic talent would have been lost." However, members of the various disciplines were split up and traveled on different ships, so that if a ship sank, the leading minds in any given specialty would not all be lost at once.

[2] The Mamelukes were an army of largely kidnaped slaves trained as mercenaries who also for several centuries had ruled Egypt; the term refers to both the army formed by these slaves, and the clique that ruled Egypt.

[3] Theirs and earlier explorations are documented in Alan Winston's online article included in the bibliography.

[4] Manetho's history, however, did not survive intact; his *Aegyptiaca* is known only from other Classical sources, such as the writings of the great Jewish historian Josephus.

[5] For a thorough (and interesting) look at the various rivalries involved in the decipherment of ancient Egyptian, Lesley and Roy Adkins's book *The Keys of Egypt: The Race to Read the Hieroglyphs* is recommended.

[6] Champollion's Italian student and friend was Ippolito Rosellini, hailed by some as the father of Italian Egyptology.

[7] Earlier excavators, including the French Egyptologists Auguste Mariette and Gaston Maspero, were not noted for their methodology, despite the fact that they made a fair number of discoveries. As Fagan (1975: 278) states, "Mariette's discoveries were extraordinary, but excavated with complete abandon. He was mainly concerned with spectacular finds, which he needed to fill his museum and to satisfy the pasha. Dynamite was among his techniques; careful recording and observation mattered nothing, only objects."

[8] Although Schliemann's instincts and research proved to be correct, and ancient Troy was located near present-day Hissarlik, in Turkey, Schliemann destroyed much of the more recent layers of a site that had undergone a number of rebuildings during its long occupation. He thought that the Troy of the *Iliad*, Homer's Troy, was his Troy II. In fact, modern researchers now believe that Homer's Troy was Troy VIIa, much of which was destroyed by Schliemann in his haste to reach the "real" Troy. This again illustrates the sorry state of archaeology before Flinders Petrie.

[9] The French make a distinction, not so far as we know usually made elsewhere, between *Égyptomanie* or "Egyptomania"–a love of architecture and decorative arts in the Egyptian revival style–and *Égyptophilie* or "Egyptophilia"–a love of genuine Egyptian antiquities untranslated by modern designers or aesthetic trends. The former would be interested in the wonderful Japy Frères Egyptian revival clocks, the marvelous Sèvres Egyptian revival bowls, or the beautiful Limoges enamels of Egyptian queens; the latter would disdain all but the authentic artifacts–the stelae, the *ushabti* figures interred with the dead to ensure that the deceased was not called upon to work in the afterlife, or the canopic jars found in upper-class Egyptian burials–unearthed by archaeologists. However, as there are strict international prohibitions on the sale and export of such antiquities, collecting Egyptian revival decorative objects seems much safer!

[10] During the Eighteenth Dynasty, it appears that for a male to inherit the throne, he had to be the son of the Great Royal Wife (the true queen of Egypt) and the pharaoh. If he was the son of pharaoh with

a minor wife, he gained legitimacy by marrying a fully royal princess–that is, the daughter of the Great Royal Wife and pharaoh. Thus Tutankhamun married Ankhesnamun, a royal princess, daughter of the Great Royal Wife Nefertiti and Akhenaton and therefore of full royal blood. This type of brother-sister marriage was adopted much later in Egyptian history by the Ptolemies.

[11] Because ancient Egyptians did not write vowels, variant spellings of the names of Tutankhamun and other Egyptian kings are used: Tutankhamen, Tut-Ankh-Amen, Tutankhamon, Tutankhamun have all been used; because all are equally correct–or incorrect–it seemed best to use one variant throughout, except in quotations from sources that use alternate spellings. Similarly, Akhenaton's name has been variously spelled as Ikhnaton, Akhnaton, Akhenaten, and Akhenaton; again, a fairly arbitrary choice of spelling has been made. Further complicating matters are Greek variants of a few Egyptian royal names: Amenhotep is sometimes known as Amenophis; Tuthmosis is a Greek variant (of the Egyptian Djehutymes), but widely in use among Egyptologists, historians, and others.

[12] Desroches-Noblecourt also notes that one of the two items bearing Tutankhamun's name was a stela indicating that he had reopened the shrines of Amun, closed by the heretic Akhenaton: "But the stele no longer bears the sovereign's [Tutankhamun's] names for they were replaced by those of King Horemheb."

[13] Articles in various issues of *The Jewelers' Circular* make it clear that the bright colors favored in Art Deco jewelry–especially the bright primary colors red, dark blue, and turquoise as well as green and yellow–were inspired by the carnelian, lapis lazuli, turquoise, quartz, and greenish stone–jasper or serpentine–used in ancient Egyptian "cloisonné" jewelry.

Chapter Two

[1] It is known that proto-dynastic Egyptians borrowed from Mesopotamia; this can be seen in early Egyptian architecture, and the adoption of cylinder seals–useful for the mud tablets on which the Sumerians wrote, but totally useless on the stone on which the Egyptians carved their sacred signs, or the papyrus on which they wrote their hieratic–but such borrowings were the exception and, in the case of the cylinder seal at any rate, short lived.

[2] As a hieroglyph, the *ba*-bird was used to spell, and was likely semantically linked to, the words for "power" (*b3w*) and "virility" (*b33w*), and possibly to the words for "leopard" and "leopardskin" (worn as a sign of power by kings and high priests), and to the word for "hack up" or "hoe," all also spelled *b3*.

[3] Often this was the name of a dead pharaoh, used as a talisman, or worn in a spirit of reverence; in one scholar's analogy, these might have been worn in much the same way that modern relgious wear saints' medals.

[4] Earlier forms of The Book of the Dead, which is a fairly late invention, did exist. In the Old Kingdom, as the Pyramid Texts, these spells were intended to be used only by kings in their search for immortality. In the Middle Kingdom, with the democratization of burial customs, the Coffin Texts–a later form of the Pyramid Texts–were written on the boards of the coffins of wealthy and powerful nobles as well as those of royalty. The New Kingdom Book of the Dead was even more democratic, and was not restricted to nobility or royalty, although probably the great majority of Egyptians were never able to purchase the papyrus used in making the book, or to pay a scribe to record the spells and draw the pictures that allowed people to enter the afterlife and dwell there forever.

[5] The work, which was fairly controversial when released, is *Black Athena* by Martin Bernal, a classicist who is actually the grandson of the great Egyptologist Sir Alan H. Gardiner, whose *Egyptian Grammar* remains the standard reference book for Middle Egyptian.

[6] For much of Egypt's history, her pharaoh had five names, two of which were enclosed in cartouches. The five were: the Horus name; the Two Ladies (referring to the tutelary goddesses of Upper and Lower Egypt, Nekhbet and Edjö) name; the Horus of Gold name; the King of Upper and Lower Egypt name (in a cartouche); and the Son

of Re name (also in a cartouche). Modern historians and others usually refer to the king by the last name, or the nomen; but his King of Upper and Lower Egypt name (his prenomen) was probably the one used by his subjects and other rulers. Amenhotep III's prenomen, for example, is found in Akkadian texts from Mesopotamia.

[7] Richter (1964: 47-48) notes that before the mid-seventh century B.C. Greece produced no large stone sculptures, further stating: "It was evidently contact with the East that initiated the making of large stone sculptures in Greece." The Assyrian conquest of Egypt in 672 B.C. opened Egypt for the first time to Greeks and other foreigners. The archaic Greek *kouros* (youth or young man) statues in particular owed a great deal to Egyptian influence. Richter states that:

> A few types were adopted and repeated again and again. Chief among them were the standing youth (*kouros*) in a strictly frontal pose, the left foot a little advanced, the arms generally held close to the sides, occasionally bent at the elbows, the hands either clenched (with the superfluous stone left inside them) or laid flat against the body. The scheme is the same as that used in ancient Egypt, and the general shape, with broad shoulders, narrow waist, and small flanks, is also similar.

Richter then goes on to note slight differences between Egyptian and early Greek sculptures, notably that, while the Egyptian sculptures usually rested against a column or supporting pillar and wore at least a loincloth, the Greek *kouros* statues were freestanding and nude.

[8] The Aztecs, for example, owed a good deal to the Mayan and other earlier meso-American cultures; the Inca culture evolved from earlier cultures in the Andean region before them; the Babylonians and Assyrians built on Sumerian culture, as did Romans on Greek and Etruscan culture. But the Egyptians built a continuous culture from pre-dynastic times down through the Roman period.

[9] However, it has been proposed that some early Egyptian cultural motifs, such as the cylinder seal, were borrowed from Mesopotamia. Baumgartel (1965: 33) states that "A notable innovation of the [pre-dynastic] Naqada II Period was the introduction of the cylinder seal; it can only have come from Mesopotamia, where it was known much earlier." It is almost certain that the Egyptians borrowed this innovation, and then quickly discarded it: It was suitable for use on clay tablets, on which the Sumerians and later the Assyrians and Babylonians wrote; not at all useful for stone or papyrus, on which the Egyptians carved or penned their hieroglyphs. It is even supposed that the Egyptians borrowed the idea of writing from Mesopotamia. However, recent discoveries indicate that Egyptian writing might have preceded Sumerian. And the once widely accepted theory of a "Dynastic race," presumably Semitic, which brought civilization to Egypt and imposed it upon a native Hamitic culture is now thoroughly discredited. This theory was based in large part upon linguistic misapprehensions and a wrong interpretation of the similarity of Egyptian pronouns to those of Hebrew, Assyrian, and other Semitic languages. Egyptian is now known to be related to Semitic languages–both belong to the Afro-Asiatic family–and the pronouns are similar not because they were borrowed, but because they are cognates.

Chapter Three

[1] Josiah Wedgwood is known for several innovations in ceramics, among them basalt ware, so called because of it hardness and durability; jasperware, a fine-grained unglazed stoneware that was white in its natural state and colored with metallic oxides that were either added to the clay, or applied with a later dipping; and pearl ware, a pale cream ware with a bluish glaze.

Chapter Four

[1] However, it should be noted that Newark also produced few Gothic or Renaissance revival pieces. I have one Newark Renaissance revival–influenced brooch, the only one I have seen in years of collecting.

Bibliography

Addams, Jane. "The Unexpected Reactions of a Traveler in Egypt." *Atlantic*: February, 1914.

Adkins, Leslie and Roy. *The Keys of Egypt: The Race to Read the Hieroglyphs.* London, England: HarperCollins, 2001.

Allen, James P. *Middle Egyptian.* Cambridge, England: Cambridge University Press, 1999.

Andrews, Carol. *Ancient Egyptian Jewelry.* New York, New York: Harry N. Abrams, 1997.

Baikie, James. "The Resurrection of Ancient Egypt." *National Geographic Magazine*, vol. XXIV no. nine, September, 1913.

Barrett, Clive, *The Ancient Egyptian Gods and Goddesses: The Mythology and Beliefs of Ancient Egypt.* London, England: The Aquarian Press, 1991.

Becker, Vivienne. "Egyptian Revival Jewellery." *Antique Collector*, November, 1978.

Boas, George [trans]. *The Hieroglyphics of Horapollo.* Princeton, New Jersey: Princeton University Press, 1993.

Brackman, Arnold C. *The Search for the Gold of Tutankhamen.* New York, New York: Mason Charter, 1976.

Breasted, James Henry. *Development of Religion and Thought in Ancient Egypt.* New York, New York: Harper & Row, 1959 (originally published in 1912).

Carpenter, Rhys. *The Esthetic Basis of Greek Art.* Bloomington, Indiana: Indiana University Press, 1965.

Carrott, Richard G. *The Egyptian Revival: Its Sources, Monuments, and Meaning 1808-1858.* Berkeley, California: University of California Press, 1978.

Carter, Howard. *The Tomb of Tutankhamen.* New York, New York: E. P. Dutton, 1972 (first published 1923-1933 in three volumes).

Castellani, Alessandro. "Revival of Antique Jewelry." *The Jewelers' Circular*, February 1878.

Christie, Agatha. *An Autobiography.* New York, New York: Dodd Mead, 1977.

Clayton, Peter A. *Chronicle of the Pharaohs: The Reign-by-Reign Record of the Rulers and Dynasties of Ancient Egypt.* London, England: Thames and Hudson Ltd., 1994.

Coumbe, Clement W. "The Lion in Art." *The Jewelers' Circular*, Feb. 4, 1925.

de Morgan, Jacques. "The Dashur Explorations." *Harper's New Monthly Magazine*, no. 5, 1896.

Caldwell, Ian, and Thomason, Dustin. *The Rule of Four.* New York, New York: Bantam Dell, 2004.

Denon, Dominique Vivant. *Travels in Egypt.* London, England: Darf Publishers, 1986 (originally published as *Voyage dans la basse et la haute Égypte* in 1802, published in England in three volumes as *Egypt* in 1803).

Desrouches-Noblecourt, Christiane. *Tutankhamen: Life and death of a pharaoh.* London, England: George Rainbird Ltd., 1963.

D'Hooghe, Alain, Humbert, Jean-Marceau et al. *Égyptomanie: la passion de l'Egypte.* Paris, France: Les musées de la ville de Paris, 1998.

Diodorus Siculus. *Library of History.* Books I - II.34 [C.H. Oldfather, trans.]. Cambridge, Massachusetts: Harvard University Loeb Classical Library, 2004.

Duane, O.B. *Mucha.* London, England: Brockhampton Press, 1996.

Ebers, George. *An Egyptian Princess.* New York, New York: A.L. Burt, 1868.

Ebers, George. *Egypt: Descriptive, Historical, and Picturesque.* London, England: Cassell & Company, 1878.

Eckels, Claire Wittler. "The Egyptian Revival in America." *Archaeology*: 1950, vol. 5, no. 3: 164-169.

Edwards, Amelia. *Egypt and Its Monuments: Pharaohs, Fellahs and Explorers.* New York, New York: Harper & Brothers, 1891.

Erman, Adolf [ed]. *The Ancient Egyptians: A Sourcebook of Their Writings.* New York, New York: Harper & Row, 1966 (originally published in 1923).

Fagan, Brian M. *Quest for the Past: Great Discoveries in Archaeology.* Reading, Massachusetts: Addison-Wesley Publishing Co., 1978.

Fagan, Brian M. *The Rape of the Nile: Tomb Robbers, Tourists, and Archaeologists in Egypt.* New York, New York: Charles Scribner's Sons, 1975.

Faulkner, Raymond O. [trans]. *Ancient Egyptian Book of the Dead.* New York, New York: Barnes & Noble, 2005.

Florey, Kenneth. "Suffrage Colors and Alleged Suffrage Jewelry." *Maine Antique Digest* online at: www.maineantique-digest.com/articles/dec03/suff1203

Frankfort, Henri. *Ancient Egyptian Religion.* New York, New York: Harper & Row, 1961.

Gardiner, Sir Alan H. *Egyptian Grammar: Being an Introduction to the Study of Hieroglyphs.* Oxford, England: Griffith Institute, 1994.

Gardiner, Sir Alan H. *Egypt of the Pharaohs.* Oxford, England: Oxford University Press, 1961.

Gelb, I. J. *A Study of Writing.* Chicago, Illinois: The University of Chicago Press, 1969.

Gillespie, Charles C., and deWachter, Michel [eds.] *Monuments of Egypt: The Napoleonic Expedition.* Princeton, New Jersey: Princeton Architectural Press, 1987.

Gordon, Cyrus H. *Forgotten Scripts.* New York, New York: Basic Books, 1968.

Gott, Jonathan. *Isis and Osiris: Exploring the Goddess Myth.* New York, New York: Doubleday, 1994.

Hayes, William C. *Most Ancient Egypt.* Chicago, Illinois: The University of Chicago Press, 1964.

Hobson, Christine. *The World of the Pharaohs.* London, England: Thames & Hudson, 1987.

Hornung, Erik. *Akhenaten and the Religion of Light.* Ithaca, New York: Cornell University Press, 1999.

Humbert, Jean-Marcel. *L'égyptomanie dans l'art occidental.* Courbevoie (Paris), France: ACR Edition Internationale, 1989.

James, T.G.H. *Tutankhamun.* Vercelli, Italy: Friedman/Fairfax, 2000.

Jones, Owen. *The Grammar of Ornament.* New York, New York: DK Publishing, 2001 (originally published in 1856).

Jones, Owen. *The Grammar of Ornament: All 100 Color Plates from the Folio Edition of the Great Victorian Sourcebook of Historic Design.* Mineola, New York: Dover Publications, 1987 (originally published in 1856).

La Fontaine, Edouard. "A Forecast of Fashions." *Delineator* 2, 1908.

Martin, Richard A. *Mummies.* Chicago, Illinois: Field Museum of Natural History, 1969 (reprint of 1945 edition).

Mertz, Barbara. *Tombs, Temples and Hieroglyphs: A Popular History of Ancient Egypt.* New York, New York: Dodd, Mead, 1978 (first published in 1964).

Mertz, Barbara. *Red Land, Black Land: Daily Life in Ancient Egypt.* New York, New York: Dodd, Mead, 1978 (originally published in 1966).

Meskell, Lynn. *Private Life in New Kingdom Egypt.* Princeton, New Jersey: Princeton University Press, 2002.

Moffett, Cleveland. "In and Around the Great Pyramid." *McClure*, January 1902.

Müller, Hans Wolfgang, and Thiem, Eberhard. *Gold of the Pharaohs.* New York, New York: Barnes & Noble Books, 2005.

Murnane, William J. *Texts from the Amarna Period in Egypt.* Atlanta, Georgia: Scholars Press, 1995.

Naville, Eduouard. "The Cyclopean Mystery of Abydos." *Scientific American Supplement No. 2021*, Sept. 26, 1914.

Navrátilová, Hana. *Egyptian Revival in Bohemia 1850 - 1920.* Prague, Czech Republic: Aktion, 2003.

Nims, Charles F. *Thebes of the Pharaohs: Pattern for Every City.* London, England: Elek Books, 1965.

"Passages of Eastern Travel by an American." *Harper's New Monthly Magazine*: Vol. XIV.–No. 9, 1856.

Petrie, Sir William Matthew Flinders. *Egyptian Decorative Art.* Mineola, New York: Dover Publications, 1999 (originally published in 1895).

Petrie, Sir William Matthew Flinders. "The Treasure of Lahun: Beautiful Jewelry Ornaments and Tools Found in a Plundered Pyramid." *Scientific American Supplement No. 2051*, April 24, 1915.

Racinet, Auguste. *Racinet's Historical Ornament.* Mineola, New York: Dover Publications, 1988 (originally published between 1869 and 1873).

Redford, Donald B. *Akhenaten: The Heretic King.* Princeton, New Jersey; 1987.

Richter, G.M.A. *Greek Art.* London, England: Phaidon Press, 1967.

Romer, John. *Ancient Lives: Daily Life in Egypt of the Pharaohs.* New York, New York: Holt, Rinehart & Winston, 1984.

Romer, John. *Valley of the Kings.* New York, New York: Henry Holt, 1981.

Russell, Terrence M. [ed]. *The Napoleonic Survey of Egypt.* Burlington, Vermont: Ashgate Publishing, 2001 (originally published in twenty-four volumes as *Description de l'Éygpte*, between the years 1809 and 1828, edited by Edme François Jomar).

Shorter, Alan W. *The Egyptian Gods: A Handbook.* London, England: Routledge & Keegan Hall, 1981 (first published in 1937).

"Sir Arthur Evans and the Excavation of the Palace at Knossos." *Athena Review* Vol. 3, No. 3, 2003.

Sélincourt, Aubrey de. *The World of Herodotus.* London, England: Orion Publishing Ltd., 2001 (originally published in 1962).

Smith, William Stevenson. *Ancient Egypt as Represented in the Boston Museum of Fine Arts.* Boston, Massachusetts: Museum of Fine Arts, 1942.

Stearns, Wallace N. "Reconstructing Egypt's History." *National Geographic Magazine*, vol. XXIV no. nine, September, 1913.

Steindorff, George and Seele, Keith C. *When Egypt Ruled the East.* Chicago, Illinois: The University of Chicago Press, 1968 (first published in 1942).

Stone, Leo A. M.D. "The Scarab." *The Jewelers' Circular Weekly*, Oct. 4, 1916.

Strabo. *Geography.* Book 17 [Horace Leonard Jones, trans.]. Cambridge, Massachusetts: Harvard University Loeb Classical Library, 2001.

The Charles Pankow Collection of Egyptian Art auction catalog. New York, New York: Sotheby's, 2004.

Thorndike, Joseph J., Jr. [ed.]. *Discovery of Lost Worlds.* New York, New York: American Heritage, 1979.

Tonnellier, Paul. "Oriental Jewelry on the Stage." *Jewelers' Circular and Horological Review*, Feb. 8, 1893.

Trigger, B.G. et al. *Ancient Egypt: A Social History.* Cambridge, England: Cambridge University Press, 1999.

Vandier, Jacques. *La religion Egyptienne.* Paris, France: Presses Universitaires de France, 1944.

Wente, Edward [trans]. *Letters from Ancient Egypt.* Atlanta, Georgia: Scholars Press, 1990.

Wilson, John A. *Signs & Wonders Upon Pharaoh.* Chicago, Illinois: University of Chicago Press, 1964.

Wilson, John A. *The Culture of Ancient Egypt.* Chicago, Illinois: The University of Chicago Press, 1968 (originally published as *The Burden of Egypt* in 1951).

Winston, Alan. "Early Travelers and Explorers to the Pyramids." http://www.touregypt.net

Woldering, Imgard. *The Art of Egypt: The Time of the Pharaohs.* New York, New York: Crown Publishers, Inc., 1963.

Ziff, Larzer. *Return Passages: Great American Travel Writing 1780-1910.* New Haven, Connecticut: Yale University Press, 2001.

Index